Voyages of the Self

Oxford University Press wishes to thank
the Henry Luce Foundation for generously
assisting the publication of the trilogy
American Painting of the Nineteenth Century,
Nature and Culture, and *Voyages of the Self.*

Voyages of the Self

Pairs, Parallels, and Patterns in American Art and Literature

❧

Barbara Novak

OXFORD
UNIVERSITY PRESS

2007

OXFORD
UNIVERSITY PRESS

Oxford University Press, Inc., publishes works that
further Oxford University's objective of excellence
in research, scholarship, and education.

Oxford New York
Auckland Cape Town Dar es Salaam Hong Kong Karachi
Kuala Lumpur Madrid Melbourne Mexico City Nairobi
New Delhi Shanghai Taipei Toronto

With offices in
Argentina Austria Brazil Chile Czech Republic France Greece
Guatemala Hungary Italy Japan Poland Portugal Singapore
South Korea Switzerland Thailand Turkey Ukraine Vietnam

Copyright © 2007 by Oxford University Press, Inc.

Published by Oxford University Press, Inc.
198 Madison Avenue, New York, NY 10016
www.oup.com

Oxford is a registered trademark of Oxford University Press

Library of Congress Cataloging-in-Publication Data
Novak, Barbara.
Voyages of the self : pairs, parallels, and patterns in American art
and literature / Barbara Novak.
p. cm.
Includes bibliographical references and index.
ISBN-13: 978-0-19-530590-6
ISBN-10: 0-19-530590-6
1. American literature—History and criticism.
2. Art and literature–United States—History.
3. Painting, American.
4. Self perception in literature.
5. Self-perception in art. I. Title.
PS169.A88N68 2006
810.9'357—dc22
2006017218

9 8 7 6 5 4 3 2 1
Printed in the United States of America
on acid-free paper

For Brian O'Doherty

Contents

Preface

This book grew out of a paper delivered at a symposium at the Aspen Institute, Berlin, in 1989 and subsequently published in *American Icons* (Santa Monica: The Getty Center for the History of Art and the Humanities, 1992), as "Self, Time and Object in American Art: Copley, Lane and Homer." Parts of that essay, which contained some of the germinal ideas of the present volume, have formed the bases for the chapters on those three artists, now expanded to include longer sections on Jonathan Edwards, Ralph Waldo Emerson, and William James. "Whitman and Church: Transcendent Optimism and the Democratic Self" was first delivered as a lecture in Mainz, Germany, and subsequently printed in *Democracy and the Arts in the United States* (Munich: Wilhelm Fink Verlag, 1996) with a different title. The present chapter has been altered from that version. "Thoreau and Indian Selfhood: Circles, Silence, and Democratic Land" was offered in a different version as part of a Festschrift for my colleague Martin Christadler, which followed upon the Mainz symposium.

Acknowledgments

It is a pleasure to thank the countless individuals and institutions who have supported and inspired me over the long gestation of this book. Ellen Holtzman, Michael Gilligan, and the Henry Luce Foundation helped make *Voyages of the Self*—and the trilogy of which it is a part—a concrete reality. I am deeply grateful for their generous support. The Archives of American Art, The Morgan Library, and the Columbia University Rare Book and Manuscript Library kindly made their invaluable resources available to me. The Departments of Art History at Barnard College and Columbia University gave me the opportunity to develop and teach my ideas through continuing contact with students and colleagues. The challenges posed by the quality of my students, both undergraduates and graduates, kept me thinking aloud for decades about the problems posed by the self in American culture.

Judith Shapiro, President of Barnard, and Elizabeth Boylan, Provost and Dean of Barnard, have always encouraged and supported my work with a generosity I find humbling. My association as commissioner with the Smithsonian's National Portrait Gallery, its director, Marc Pachter, and its superb staff has been a constant reminder of the richness of our diverse culture.

With great good will Giles Gunn and David Moos forwarded parts of their own work that were relevant to mine. My German colleagues Heinz Ickstadt, Martin Christadler, Olaf Hansen, and Thomas Gaehtgens offered scholarly forums and exchanges that were always stimulating. Victoria Newhouse and Adrienne Baxter Bell read the manuscript and spurred me

on. Michael Remer offered welcome help when it was needed. A special thank-you to two remarkable women, Karen Fleiss and Ella Foshay, who have honored my work and teaching far beyond what I deserve.

Elda Rotor's sensitive editing and her appreciation of my writing and ideas made working with her a rare joy. Cybele Tom's precise and caring attention to details went far beyond her obligations. I much appreciate her ingenuity and persistence in pursuing all the photographic sources for the trilogy.

I want to honor Joellyn Ausanka's eagle copy-editing eye and scrupulous oversight of this book's production. I am most grateful for her help.

The energy and time the staff at Oxford University Press have devoted to this book, and to the trilogy, are an intrinsic part of it.

My family's patience and support during the long parturition of *Voyages* was crucial. Alan and Kate Novak and their sons, Jonathan and Adam, have always been there for me. My late parents, Sadie and Joseph Novak, sacrificed their own dreams for mine. I would not possess this "self" without their love and devotion. This book is joyfully offered to my husband, Brian O'Doherty.

B.N., 2006

Voyages of the Self

The supreme task of education is to take possession of one's transcendental self, to be at once the "I" of one's "I."

—Novalis

An American,
is a complex of occasions,
themselves a geometry
of spatial nature.

I have this sense,
that I am one
with my skin.

—Charles Olson

The Self is below, the Self is above, the Self is to the west, to the east, to the south, to the north. Truly the Self is this whole universe.

The man who sees and thinks and understands (vijñā) in this way has pleasure in the Self, plays with the Self, lies with the Self and has his joy with the Self; he becomes an independent sovereign.

—Chāndogya Upanishad

Introduction

Selfhood and mentality are the most sophisticated synthetic achievements of body and culture in the universe known to human beings.
——Ciaran Benson, *The Cultural Psychology of Self*

As Ciaran Benson has observed, the idea of self is of course an artificial construct, and definitions of self, however sophisticated, are varied, depending on the perimeters of the disciplines that seek to engage them, be they philosophy, psychology, sociology, religion, anthropology, or areas of literary or visual history. Just as I would hesitate to attempt a single paragraph defining art, I am reluctant to attempt a single definition of self, which clearly also involves matters of identity and consciousness. Yet the word is common enough even in everyday usage for a cultural community to agree, to some extent, on a kind of consensus. There is something within every human being that we commonly call a "self." Loss of that self is generally considered a grievous wound. Its willing surrender, on the other hand, can be considered, in religious and philosophical terms, a blessed arrival at another state of being. In some instances the idea of self is conflated with the idea of soul.

This book came into being out of my initial interest in what I have called the "erasure of self" so prized by the early American Puritan culture and in its visual manifestation in some images from the late eighteenth and mid-nineteenth centuries. I then discovered that the ostensible erasure of self was not so much a loss as a transfer, at times a transfer into matter or object, into "things," and through erasure of the artist's signature, "stroke," to an

ostensible larger self referred to by Emerson as the Over-Soul. So one subtext here might be the role of "things" as they relate to self in American culture. Another might be the persistence of a pragmatic attitude. The submersion and resurfacing of self depended for its dialectical variations on the philosophical and psychological "tones" of the images and texts examined. It depended as well, to a large extent, on the moment in time they occupied.

Visual language and written language are themselves both similar and different, and each requires sensitivity to the articulation of the specific medium utilized. Nonetheless, for all the variations, certain comparisons and pairings can prove to be enlightening, especially when drawn against a similar cultural context: Copley and Edwards, Lane and Emerson, Church and Whitman, Homer and James, Ryder and Dickinson, Pollock and Olson. Thoreau and the Indians opts somewhat out of the artist/writer format to deal with ideas of self in Native American culture and Transcendentalism. Out of such couplings, perhaps, we can begin to track the voyages of the self in America, in which the smallest and the most unique unit, the "personal" self, and its most salient characteristics in each artist or writer considered, contributes to and derives from the larger map of an American cultural context. That context is both pluralistic and defined by certain constants which it is hoped will be revealed to the reader as they reappear in the body of this work from the eighteenth century into the twentieth. In that sense, this is a narrative journey.

Copley and Edwards: Self, Consciousness, and Thing

The first mature American master, John Singleton Copley (fig. 1.1), offers us a plethora of *p*'s with which to explore the enigma of selfhood. To *philosophical* and *perceptual*, we might add the words *phenomenological, pragmatic, practical, provincial, primitive, precursor*, and even *puritanical*. Yet on some levels, Copley seems to have been far from a Puritan. Copley was an Anglican, born of Anglo-Irish lineage. His sensual handling of stuffs indicates an a-puritanical love of luxe. Yet he is practicing his art in Boston, a cradle of American Puritanism. He is painting portraits not only of Anglicans but mostly of Congregationalists, and he marries a Congregationalist, Sukey Clarke, whose father had his tea tossed overboard at the Boston Tea Party. Copley is working not long after the Great Awakening—indeed, he is a child in the crucial decade after the Awakening of 1740. Thus he is situated in time close to the Awakening's great theologian, Jonathan Edwards (fig. 1.2), who dies in 1758, five years after Copley's earliest paintings.

Like Edwards, Copley may be said in some ways to be a child of one of the age's dominant philosophers, John Locke. Edwards had discovered Locke perhaps as early as 1717,[1] and Locke, along with Newton, dominated his thinking throughout his life. Some scholars have claimed that he was also influenced by Bishop Berkeley, who came to America in 1728 to found a college for Indians in Bermuda.[2] Berkeley's visage was immortalized in America's earliest group portrait by John Smibert (fig. 1.3), in whose studio and art supply shop Copley saw some of his first examples—largely copies—of European art, including Smibert's copy of Van Dyck's *Portrait of Cardinal Bentivoglio*.

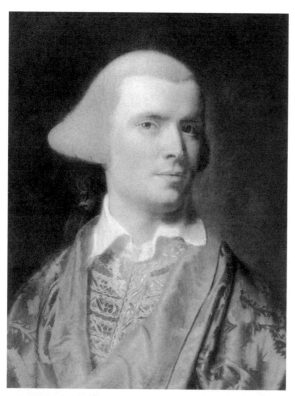

1.1 John Singleton Copley, *Self-Portrait*, 1769. Pastel on paper, 23³/₄ × 17¹/₂ in. (60.3 × 44.5 cm.). Winterthur, Del., Winterthur Museum and Country Estate.

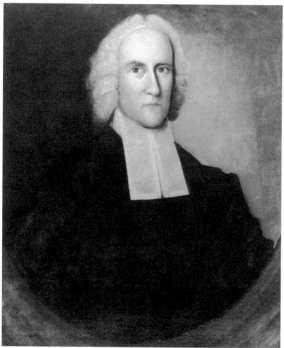

1.2 Joseph Badger, *Reverend Jonathan Edwards (1703–1758) B.A. 1720, M.A. 1723*, ca. 1750–55. Oil on canvas, 30¹/₂ × 25¹/₂ in. (77.5 × 64.8 cm.). New Haven, Conn., Yale University Art Gallery.

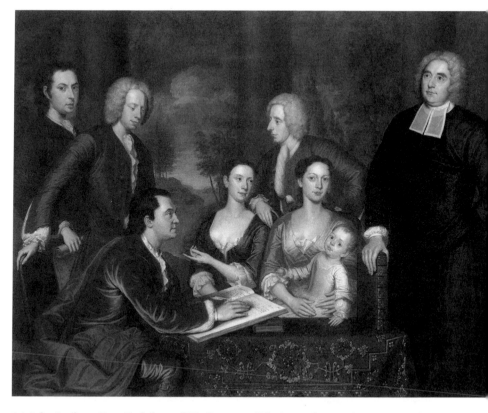

1.3 John Smibert, *Dean Berkeley and His Entourage* (*The Bermuda Group*), 1728–39. Oil on canvas, 69¹/₂ × 93 in. (176.5 × 236.2 cm.). New Haven, Conn., Yale University Art Gallery.

Whatever the effects of his scientific and philosophical reading, Edwards, like Copley, was an observer, and his experience of self through observation forms an important link between theology and science, just as Copley's observation binds together art and science.

The sensational and perceptual aspects of Edwards's observation revealed themselves early on in his famous "Spider Papers"[3]—an interest in this extraordinary insect that extends even into our own time with E. B. White's immortal Charlotte. With a clinical recording worthy of another part-time scientist, Leonardo, Edwards describes the "wondrous" way of working of the Spider, and the "multitudes of webbs [*sic*] made visible by the Dew that hangs on them Reaching from one tree, branch & shrub to Another and may be seen well Enough in the Daytime by an Observing Eye by their Glistening against the sun."[4]

Believed by some to have been written as early as age twelve, but perhaps over a period of four to seven years later,[5] the "Spider Papers" illustrate

Edwards's lifelong habit of observation, from the flying spider he shook off a bush ("hoping thereby to make him uneasy upon it and provoke him to leave it by flying . . . I whisked about a stick I had in my hand on all sides of the bush, that I might break any web going from it . . . and leave nothing else for him to go on but the clear air . . .")[6] to rainbows, light rays, atoms, and gravity.

The world, for Edwards, comprised the "wonderful suitableness of green for the grass and plants, the blue of the sky, the white of the clouds, the colors of flowers" consisting in "a complicated proportion that these colors make one with another, either in the magnitude of the rays, the number of vibrations that are caused in the optic nerve, or some other way. . . ."[7] He saw the world in terms "wholly of sweet mutual consents, either within itself, or with the Supreme Being."[8] Out of his interest in the science of sensation and perception, then, we might say that Edwards forged a theology that can be called "aesthetic" in its harmony and "agreeableness."

Edwards's "aesthetic theology" and Copley's "aesthetic scientism" had much in common. We have no direct proof that Copley read Locke, but he read art theory in the library of his stepfather, Peter Pelham, including Algarotti, who *did* read Locke.[9] We could also paraphrase Baxandall on Chardin and say that there was no need for Copley to read Locke: the culture was Lockean.[10] Edwards's Lockean philosophy of idea and matter is shared by Copley's canvases, which are, also, very pragmatic.

Copley's pragmatism relates to that of another key eighteenth-century American figure: Benjamin Franklin (also a sometime scientist who can be linked on a number of levels not only to Copley but to Edwards), who vigorously embodies a pragmatic, *how-to* strain in American thinking and practice. That strain can be seen too as part of the utilitarian tide that, as Thomas Cole was to maintain in 1838, set against the fine arts in America. In America, it generally has.

This was certainly so in Copley's time, when portraiture was the only art-making patrons found acceptable. It had the *useful* function of providing a likeness, but the idea of the practical and the useful also directed artistic procedure. The artwork was crafted with a kind of common sense. This notion of craft situates the artist between high art and the workingman's skill. Copley was sensitive to this issue. He wrote that it was mortifying to make art in a place where the artist was treated as no better than a shoemaker.[11] But he had no idea, as he had not yet been to Europe, what the art

of the great masters looked like. He felt acutely the provincial's distress at the ocean separating him from the artistic mainstream with no access to the studio training that would have taught him artistic formulae and conventions. So with little to go on but the ideational primitivism of the early limners, some English eighteenth-century mezzotints, and a few copies, he *invented* his art according to his idea of what great art would look like.[12]

In doing so, he defined attitudes and properties that can still be found in American art and culture today—for instance, the habit of solving problems freshly as if they had never been solved before, and approaching them with the practical query ultimately formalized by William James into a philosophical system: *Does it work?* As James stated it: "[Pragmatism's] only test of probable truth is what works best in the way of leading us, what fits every part of life best and combines with the collectivity of experience's demands, nothing being omitted."[13]

Yet if James's concern with certain pragmatic aspects of experience and being is foreshadowed by Edwards and Copley, the contemporary context of Lockean investigation set the stage for their own observations. Though Copley's astonishing achievement raises questions about the making of art that are difficult to answer, one is moved to look at this not only as an extraordinary triumph of the will but also as a visual product of the then current philosophical inquiry.

Copley's method of procedure, his validation of idea through sensation and experience, is a visual analogue to Lockean theory. Locke stressed Sensation— "this great source of most of the ideas we have, depending wholly upon our senses, and derived by them to the understanding."[14] As one look at his paintings will show, so did Copley.

Edwards noted: "The whole of what we any way observe whereby we get the idea of solidity or solid body are certain parts of space from whence we receive the ideas of light and colors, and certain sensations by the sense of feeling. . . . These parts of space, from whence we receive these sensations, resist and stop other bodies."[15]

This reveals a man intensely involved in the act of looking at something, of figuring it out. The regnant philosophy dealt with how the mind formulates ideas from sensations. As we read Locke and also Berkeley, the problem of how the external world is perceived is an urgent issue. For Perry Miller, the "coordination of utility and glory in the very act of perception was the great, the original and creative result of Edwards's deep immersion

in Locke."[16] Thus he was able, to an extraordinary degree, within the context of his time, to assert the "historic Protestant doctrine in full cognizance of the latest disclosures in both psychology and natural science."[17]

Observing like Edwards, Copley attempted to duplicate sensation on canvas. The concreteness of Copley's objects, the felt volume and dimension of his sitters, the sheen and gloss of silk and satin surfaces, represent a kind of sensational literalism, or vice versa (fig. 1.4). Out of his pragmatic responses, Copley mimics the process of perception. In so doing, his practice, relying on consciousness, reminds us that Locke, in a very provocative addendum of 1694 to the second edition of his famous 1690 *Essay Concerning Human Understanding*, had located the self in consciousness, thereby launching fierce literary and philosophical battles about identity in eighteenth-century England.[18] Edwards had already been aware of Locke's comments on identity, extending them—in keeping with his role as theological revivalist—to spiritual as well as physical sensation: "Well might Mr. Locke say that identity of person consisted in identity of consciousness: for he might have said that identity of spirit, too, consisted in the same consciousness."[19]

Ultimately, James was to state: "The individualized self, which I believe to be the only thing properly called self, is a part of the content of the world experienced. The world experienced (otherwise called the 'field of consciousness') comes at all times with our body at its centre, centre of vision, centre of action, centre of interest."[20]

Out of the center of his vision, out of his artistic eye, Copley exhibits a great urge to re-experience his sensations on the canvas, to exercise a kind of power that in some cultures—certainly in this one—is intimately involved in the re-presentation, indeed re-creation, of things. This impulse draws not only on the sensation of sight but also on the sensation of touch, which serves to reinforce and confirm the visual.

In thus making sensation concrete, Copley affirms at least one reality of the "things" he deals with. As James would state: "A bill of fare with one real raisin on it instead of the word 'raisin,' with one real egg, instead of the word 'egg,' might be an inadequate meal, but it would at least be a commencement of reality."[21]

Edwards had insisted in 1750 that the Indian children of Stockbridge should be "taught to understand *things*, as well as *words*."[22] A similar concern with the thing motivated Copley to investigate the nature of *thingness*, pushing him beyond even Locke's *materia prima*. On one level, he is a colo-

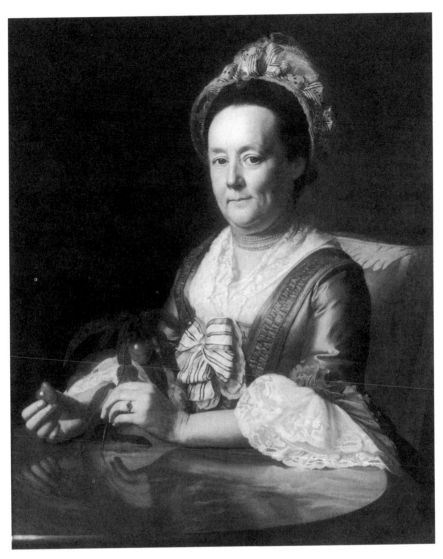

1.4 John Singleton Copley, *Mrs. John Winthrop*, 1773. Oil on canvas, $35^{1}/_{2} \times 28^{3}/_{4}$ in. (90.2 × 73 cm.). New York, The Metropolitan Museum of Art.

nial phenomenologist, dealing with things. Yet in so doing, he immediately presents us with another problem: What is the nature of the things he deals with? And what does his dealing with things signify?

For this concern with thingness, what Etienne Gilson has called the "action-less existentiality"[23] of things, seems to nag at the American artist as periods and eras wax and wane. Is this persistent subtext in American artistic perception derived from a durable amalgam of Locke, Edwards, puritanism,

and primitivism? And, we may ask, why does it so persist even when the force of the original components has been dissipated?

Perry Miller wrote of Edwards that he represented "Puritanism recast in the idiom of empirical psychology."[24] Much the same could be said of Copley. Though he was an Anglican, it would have been difficult for a painter like Copley, in mid-eighteenth-century Boston, to avoid subscribing to some Puritan values—if not theological, then simply social and cultural. We can also read in his images the growing Yankee approval in the 1760s and '70s of the gathering of property. These paintings indicate the value of the New England patrons, many of them merchants, who are having their portraits and those of their families painted, their images preserved, for a portrait is an investment in self, a displacement of one's living image into property and thus value. Do these patrons by now have few metaphysical or puritanical qualms about their pursuit of wealth, including the representation of themselves as capital? These portraits of Copley's implicitly authenticate the value system which they in turn represent. And what of the maker of these portraits?

Copley himself was a property owner. He owned three houses in Boston. Benjamin Franklin might have called that success. Henry May, scholar of the Enlightenment, has written of the strong grip of Arminianism and attendant ideas of personal happiness in Boston after the Awakening.[25] Are we dealing in Copley's portraits with simulacra that signify material success?

Such interpretations have already been presented by Copley scholarship. As Paul Staiti has written, "Copley adroitly choreographed bodies, settings, and objects into visual biographies . . . that had the power to calibrate social position in graphic ways that were legible to a community." "Material goods," Staiti notes, "and the display of those goods became the outward signs of the quest for prestige and power. This practice of equating things and people exemplifies what anthropologists and consumer historians call the power of goods to transform the self."[26]

Though Edwards and Copley can be linked by a mutuality of observational procedure and empirical belief, Edwards—after his successful launch of the Great Awakening—was expelled from Northampton for preaching against the kind of Arminianism that had begun to infect Calvinism, to a large extent justifying wealth achieved through "a self-determining power in the will."[27] Copley's portraits are now taken by contemporary scholars to

give credence and validity to what are essentially Arminian values. Yet it is questionable whether Copley himself fully shared those values.

It is here that some recent scholarship seems to have missed the point of Copley's art, whatever about the values of his patrons. Though his paintings might have pleased his patrons for what they revealed about their status and wealth, Copley himself, like Edwards, seems to have been mainly a good perceptual psychologist—mostly concerned with the problems of solidity and sensation presented by these bodies so voluminously draped in silk and satin.

Edwards had plumbed the solidity of things down to the atoms that constituted matter: "All bodies whatsoever, except atoms themselves, must of absolute necessity be composed of atoms, or of bodies that are indiscerpible, that cannot be made less, or whose parts cannot by any finite power whatsoever be separated one from another."[28] His reference to bodies that cannot be made less again recalls Leonardo, with whose scientific observations Edwards's can on many levels be compared. As Leonardo put it: "The point has no centre, but is itself a centre and nothing can be smaller. . . . The point is indivisible by the mind. The point has no parts."[29]

Yet if both Copley and Edwards were operating as primitive phenomenologists against a theological background open, to a limited degree, to Locke and Newton, that background was also—despite Arminian influences—still checked by the continued hold of Puritan theological issues. Edwards, as a major theologian and prescient physical scientist, still had to balance religion and science against one another, to find in his scientific discoveries ways to equate science with God's will and Creation. The problem at large was to remain for another century, until Darwin changed the equation. But by extending his discoveries about sensation to include the sensations of heart and spirit, referring to "that thing in spiritual and divine things which is perceived by this spiritual sense"[30] and maintaining that a perception carries in the very nature of it the "sense of the heart," Edwards found his own solution.

Nonetheless, he felt obliged to clarify the distinction between spirit and thing: "If we would get a right notion of what is spiritual, we must think of thought or inclination or delight. How large is that thing in the mind which they call thought? Is love square or round? Is the surface of hatred rough or smooth? Is joy an inch, or a foot in diameter? These are spiritual things. And why should we then form such a ridiculous idea of spirits, as to think

them so long, so thick, or so wide, or to think there is a necessity of their being square or round or some other certain figure?"[31]

Copley's necessities in this regard were less stringent. Thus we might pose additional queries to Copley's depictions of people and things. Is there here some retention of his Anglican roots—a reverberation of high church splendor? Edwards had claimed we could not determine whether joy was an inch or a foot in diameter. Can we nonetheless discover Copley's self-reflexive joy in the sumptuousness of the *matière*?

But we are confronted with the objects, the things themselves. The artist is hard to find, because they have displaced him. This is the enigma of Copley. The self as indicated by the artist's hand, the handwriting of stroke, has been erased from the smooth surface. The anonymous paint surface of the primitive has been transformed by Copley into the surface skin of the objects he depicts—the satins, laces, and brocades that adorn his sitters (fig. 1.5).

James was later to declare: "A conscious field *plus* its object as felt or thought of *plus* an attitude towards the object *plus* the sense of a self to whom the attitude belongs—such a concrete bit of personal experience may be a small bit, but it is a solid bit as long as it lasts; not hollow, not a mere abstract element of experience, such as the 'object' is when taken all alone. It is a *full* fact, even though it be an insignificant fact...."[32] In Copley's art, self as *procedure,* that "self to whom the attitude belongs"—located in consciousness—has been utilized, but all trace of it is gone. What is the meaning of this vanished process?

Ultimately, Copley's self was more overtly declared in the ambition that brought him to Europe in 1774, there to indulge, through stroke, in the bodily sumptuousness of paint, not things, an expression of both self and historical style. But in the American works of the 1760s and '70s, self has been erased not only through the stylistic retention of anonymity via the limner tradition from which he springs, but possibly too through the humility of Puritan habit and environment. Are there still, in these American Copleys, some remote echoes of the seventeenth-century English Puritan Richard Baxter's admonitions: "It is self that Scripture principally speaks against. . . . The very names of Self and Own, should sound in the wakeful Christian's ears as very terrible, wakening words, that are next to the names of sin and Satan"?[33]

In America, Jonathan Edwards continued this theme in his role as evangelist and theologian. "Self-denial for the evangelist," Philip Greven has

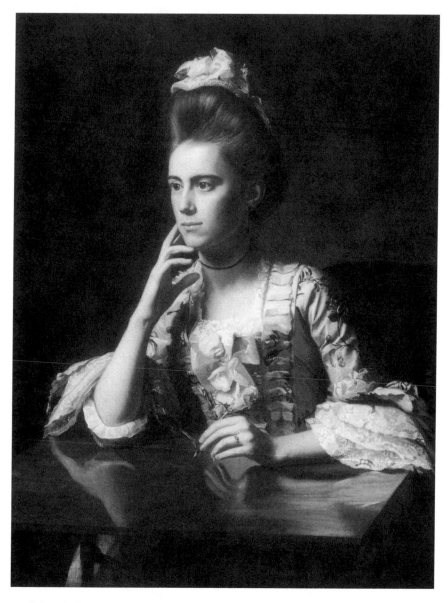

1.5 John Singleton Copley, *Mrs. Richard Skinner* (*Dorothy Wendell*), 1772. Oil on canvas, 39³/₄ × 30 in. (101 × 77.5 cm.). Boston, Museum of Fine Arts.

maintained, "meant nothing less than the denial of the self . . . the self was the agent of sin and the source of discontent."[34] Thus, Edwards, as early as 1723, could renew his baptism "and have given myself, all that I am, and have, to God; so that I am not, in any respect, my own. I can challenge no right in this understanding, this will, these affections, which are in me."

Edwards, as phenomenologist, as scientist of sensation, could still claim as a Puritan evangelist: "Neither have I any right to this body, or any of its members—no right to this tongue, these hands, these feet; no right to these senses, these eyes, these ears, this smell or this taste. I have given myself clear away, and have not retained any thing, as my own."[35] Evangelical humiliation, he was to maintain later, involved a man's "denying his natural self exaltation and renouncing his own dignity and glory, and in being emptied of himself; so that he does freely and from his very heart, as it were renounce himself, and annihilate himself."[36]

Sacvan Bercovitch reminds us of the ambivalence of the Puritan attitude to self when he notes that "the force of I-ness is transparent in the violent vocabulary of self-abhorrence" and suggests that "the very process of self-denial is also a provocation of the self."[37]

In the mix of Anglicanism, Arminianism, and Puritanism that can be disentangled from Copley's American portraits, what is the fate of the self? Copley, surely, never loathed the self as sinful. Yet self-erasure characterizes his artistic approach to the *things* in his paintings and continues as a factor in much American painting for almost a century and even into the present. Where, we may ask, has self in the American portraits gone? Has it been erased, sequestered, immersed, provoked, violently displaced? Can we speak, following Bercovitch, of an anti-self which works against the self's assertiveness and takes on the mask of things? The object's presence here is in inverse relationship to the absence of the artist's self. Are Copley's objects vessels for the transformation, displacement, annihilation of this hidden self? If this is so, to what end?

Do the objects, the things, in Copley's paintings, which anticipate the demands of the nineteenth century for a reconciliation of the real and the ideal, also resolve a conflict between the secular and the metaphysical? If we compare Copley's still-life of fruit in the portrait of Mrs. Goldthwait (see plate 1) with a still life by the seventeenth-century Spaniard Zurbarán, it is evident that Zurbarán's forms have a more clearly articulated and very different spiritual agenda. But does the way in which Copley's objects present themselves also raise questions about their metaphysical status?

Edwards had debated whether matter could possess thought: "It has been a question with some, whether or no it was not possible with God, to the other properties or powers of matter, to add that of thought; whether he could not, if he had pleased, have added thinking and the power of percep-

tion to those other properties of solidity, mobility and gravitation. . . . [E]xcept the property of thought be included in the properties of matter, I think it cannot be properly said that matter has thought; or if it can, I see not a possibility of matter in any other sense having thought. If thought's being so fixed to matter as to be in the same place where matter is, be for thought to be in matter, thought not only can be in matter, but actually is, as much as thought can be in place. It is so connected with the bodies of men, or at least with some parts of their bodies, and will be forever after the resurrection."[38]

Yet even to wonder whether matter had thought, was to raise the possibility of erasing its muteness. How much "thought," albeit connected to the bodies of men, could *things* have for Edwards? He had written of the prophet's inspiration by the Spirit of God: "Such bright ideas are raised, and such a clear view of a perfect agreement with the excellencies of the divine nature, that it's known to be a communication from him. All the Deity appears in the thing, and in everything pertaining to it."[39] How far was he, at this point, from Wordsworth's:

> To every natural form, rock, fruit or flower
> Even the loose stones that cover the highway
> I give a moral life . . .[40]

Or Emerson's: "The laws of moral nature answer to those of matter as face to face in a glass"?[41]

Perry Miller has said of Edwards: "His technique remained that of the Boston lecture, a rigorously unornamented prose, and a stark, logical dissection of some Calvinist platitude, where the deceptive simplicity concealed the fact that certain immense metaphysical assumptions had been smuggled in through the vocabulary."[42]

Miller's point could again apply to Copley's *things*. An overt metaphysics could have been suppressed not only by the growing spread of Enlightenment reason but by certain latent aspects of Puritan dogma itself. Yet it is also true that Copley's *things* are more than things. That there is precisely in them that "actionless existentiality" cited earlier, in which time, checked by the absence of process, stops, delivering them into that suspenseful precinct where the real and the ideal conjugate an illusion of timelessness.

In this arena of stopped time, objects shine, their surfaces so burnished that the sheen seems to become halated with a metaphysical glow, plumbed

from within by the artist's presentation of matter, of polished wood, of silk and satin. Copley's light transforms material things.

Can Copley's transformation be seen in any way as an analogue, albeit a more secular one, to Edwards's characterization of light as an "*emanation* and *remanation*"? "The refulgence," Edwards wrote, "shines upon and into the creature and is reflected back to the luminary. The beams of glory come from God and are something of God, and are refunded back to their original. So that the whole is *of* God, and *in* God, and *to* God, and God is the beginning, middle and end in this affair."[43]

Sidney Ahlstrom, writing about America's religious history, has reminded us that such a statement caused William Ellery Channing to "later classify Edwards as a pantheist."[44] Perry Miller, in his classic essay "From Edwards to Emerson," notes that "Edwards forced into his system every safeguard against identifying the inward experience of the saint with the Deity Himself, or of God with nature. Nevertheless, assuming, as we have some right to assume, that what subsequent generations find to be a hidden or potential implication in a thought is a part of that thought, we may venture to feel that Edwards was particularly careful to hold in check the mystical and pantheistical tendencies of his teaching because he himself was so apt to become a mystic and a pantheist."[45]

With Copley's *things*, endlessly glowing, the fictions of the masked self or anti-self regulate their own displacement into the representations of the natural world. As with Edwards, we might speak here of a link to the nineteenth century. Once the "husks "of Puritan dogma[46] have been discarded, Copley's transcendental heir, the luminist Fitz H. Lane, can invest the things of the natural world with celestial sheen, and not be obliged to deny a Godly immanence. As was the case from Edwards to Emerson, a concealed or repressed metaphysics can become an overt one. The self, however, remains displaced, pressed now into a different service to nature, God, and the universe. It is a situation to which the nineteenth century in America returns again and again in different contexts.

Emerson and Lane: Luminist Time and the Transcendental Aboriginal Self

The mind of America was Emersonian before Emerson.

—Harold Bloom[1]

We cannot consider the self in America without Emerson. He made himself, in so many ways, the American self incarnate. Yet as Perry Miller long ago suggested, "To take Emerson literally is often hazardous."[2] The man who wrote "a foolish consistency is the hobgoblin of little minds "[3] gives each of us the opportunity to see whatever we wish to see in him. Sacvan Bercovitch also rightly noted that the public Emerson does not reveal the struggles with self that we find in the *Journals*: "The Emersonian night of the soul rarely occurs in the open, and never involves the struggle with an external foe. Publicly, the dawn is forever radiant with hope. . . . The struggle takes place in private, in journals, in notebooks, sometimes in letters and *marginalia*."[4]

There was, indeed, a public and a private Emerson (fig. 2.1). The public Emerson envisaged leading the nation to the national self he most desired and dreamed of. He was, in this instance, a kind of Hindu Evangelist. For all his private doubts, for all his despair over the loss of his most loved ones—his first wife, Ellen, his brother Charles, his five-year-old son, Waldo—for all that "Experience," as he noted in his rare public admission in that essay, taught him to be "thankful for small mercies,"[5] he valued most what he found in the Over-Soul. "Our faith comes in moments . . . ," he wrote. If "our vice is habitual . . . there is a depth in those brief moments which constrains us to ascribe more reality to them than to all other experiences."[6]

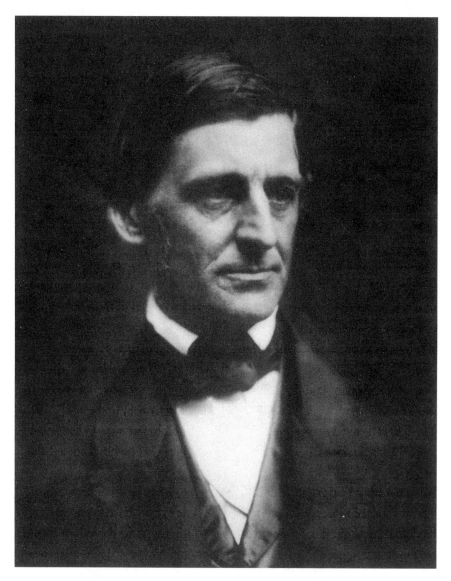

2.1 *Ralph Waldo Emerson*, 1854. Daguerreotype. Cambridge, Mass., The Ralph Waldo Emerson Memorial Association, Houghton Library, Harvard University.

Lane was, perhaps, the one American painter of Emerson's time who most fully embodied the transcendental ideas transmitted by Emerson in such essays as "Nature" and "The Over-Soul." If Emerson was even more than this, if Emersonian Transcendentalism was much closer in some respects, as Harold Bloom has suggested, to the pragmatism of William James and

Nietzsche than to Kant's "metaphysical idealism,"[7] he still retained as well the transcendent spirit so often ascribed to him.

Lane's pragmatism also readily finds connections with James, but little of Emerson's and Nietzsche's and even James's contingent existentialism can be seen in his art. Despite the crippling affliction that must have made his journey through life a trial, Lane's paintings celebrate the brief moments of Emerson's "wise silence," embracing "that great nature in which we rest as the earth lies in the soft arms of the atmosphere: that Unity, that Over-Soul, within which every man's particular being is contained and made one with all other. . . ."[8]

As the visual embodiments of the Emersonian soul, which "circumscribes all things . . . contradicts all experience . . . abolishes time and space," Lane's works allow "no screen or ceiling between our heads and the infinite heavens, so there is no bar or wall in the soul, where man, the effect, ceases, and God, the cause, begins. The walls are taken away. We lie open on one side to the deeps of spiritual nature, to the attributes of God."[9] The erasure of stroke, of the artist's presence, now becomes the fulfillment of Copley's metaphysical promise. Self-erasure is no longer dictated by Puritan dictums against self but by Transcendental erasure of all impediments between the participant and God's soul.

Emersonian self-reliance eradicates the old and gives promise to the new. It is the self-trust that enables the walls to fall, "the sense of being which in calm hours rises, we know not how, in the soul, . . . not diverse from things, from space, from light, from time, from man, but one with them and proceeds obviously from the same source whence their life and being also proceed." Emerson has not lost the connection with thingness that characterizes American art and thought from Copley and Edwards on: "We first share the life by which things exist and afterwards see them as appearances in nature and forget that we have shared their cause."

Like Emerson, Lane never forgets. Every pebble on the beach, every rock, every wave in the sea is instilled with the metaphysics of first cause. If Emerson asks, "What is the aboriginal Self, on which a universal reliance may be grounded?"[10] Lane paints from that aboriginal Self (see plate 2).

If, as with Copley, we cannot call Lane's earliest works aboriginal in Emerson's sense, they are, nonetheless—from an art historical point of view—"primitive." Copley, we recall, found it mortifying to be considered

little better than a shoemaker. Lane's nephew, Edward, informs us that "before he became an artist he worked for a short time making shoes, but after a while, seeing that he could draw pictures better than he could make shoes, he went to Boston and took lessons in drawing and painting and became a marine artist."[11]

Lane went to Boston from his native Gloucester and while there worked as a printmaker. In the late 1840s he returned to Gloucester, and with his brother-in-law, Ignatius Winter, built a stone house, inspired by the historic House of Seven Gables immortalized shortly thereafter by Hawthorne. We don't have the shoes, but the house at Duncan's Point (fig. 2.2) and records of some banners Lane designed survive. All these are solid evidence of a grounding in craft.

It seems worth reminding ourselves that early craft experience, often concomitantly lacking in academic painterly sophistication, occurs frequently in the personal histories of nineteenth-century American artists. We could perhaps say that the notion of self-taught craft with its attendant empiricisms of procedure lies behind the American obsession with the how-to: *How to*

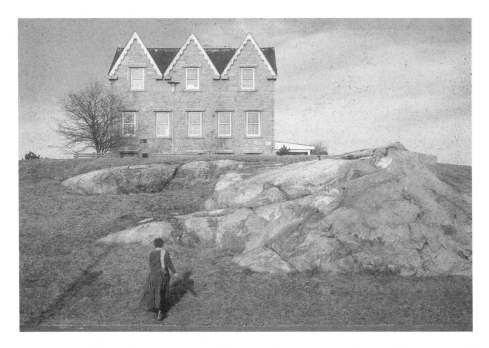

2.2 *Fitz H. Lane's House at Duncan's Point*, Gloucester, Mass. Photograph, collection of the author.

Make Your Own Furniture, How to Lower Your Blood Pressure Naturally. Lane's house, also proceeding from the primitive and the empirically pragmatic, is as spare as Copley's carefully crafted portraits. On the hundredth anniversary of Lane's death in 1865, the poet Charles Olson, also of Gloucester, wrote that Lane was "one of the chief definers of the American 'practice'— the word is Charles Peirce's for pragmatism—which is still the conspicuous difference of American from any other past or any other present, no matter how much we are now almost the true international to which all bow and acknowledge."[12]

The reciprocal relation between object and idea in Lane's mature work— as in Copley's—is painstakingly negotiated. The making of an object is rehearsed by mimicking its substantive creation, by recreating it from its ideational naming to its tangible presence. The same meticulous observation duplicates experience sensation by sensation. The paint is again smoothed into a virtually anonymous surface. With this erasure of stroke, of hand, of overt personality, we must again try to follow the voyage of the missing self.

But now, eighty years after Copley, in a different time and (though still New England), a different place, we may well ask, what self? American critics of the mid-nineteenth century advised artists that "it is not of the least consequence whether you appear in your studies or no."[13] This was a direct contemporary acknowledgment of the issue of the missing self, of the effacement of the self's assistance in making the picture. The metaphysical issues involved are perhaps best phrased by Emerson: "The relations of the soul to the divine spirit are so pure that it is profane to seek to interpose helps."[14]

William James has reminded us that "the oddly-named thing pragmatism . . . can remain religious like the rationalisms, but at the same time, like the empiricisms . . . preserve the richest intimacy with facts."[15] Let us look at the facts in Lane's painting *The Western Shore with Norman's Woe* (fig. 2.3). Each object, each pebble and rock, is perceived, clarified, and represented with a hyperintensity that doubly confirms its presence. (This necessity for doubled sensations in American art possibly connects to a larger distrust of the senses in American culture as a whole. The world would seem to need confirmation over and over again.) The artist has become the transparent medium through which the spectator apprehends the scene. Again, as with Copley,

we can invoke the inverse rule of the object's powerful presence and the painter's absence. But the terms of that absence have changed. Can we perhaps say that Lane achieves in these paintings what Worringer would have called a "human self-consciousness" so small and a "metaphysical submissiveness so great"?[16]

To raise the name of the great German theorist Wilhelm Worringer here is not coincidental. We are well aware that there are powerful parallels between the works of the luminist Lane and his German colleague, Caspar David Friedrich. The American transcendentalists, as we know, were steeped in German philosophy. If, with Copley, we could find an intellectual parallel in the ideas of Locke in England, now we can find powerful intellectual confirmation for American artists and writers in Schelling's *Naturphilosophie*, in Goethe, who was a hero to nineteenth-century American culture (quoted frequently in the art magazine *Crayon*), in familiar ideas that came to the Americans—primarily the literary figures—through their readings in German ideal philosophy and the translations of Coleridge and Carlyle. I say familiar, as some of these ideas had already originated from their own observations of the world around them. The intellectual and philosophical rapport was strong. Many American landscape paintings of the mid-nineteenth

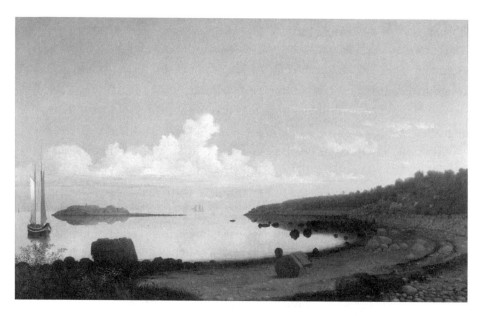

2.3 Fitz H. Lane, *The Western Shore with Norman's Woe*, 1862. Oil on canvas, 21 × 35¼ in. (54.6 × 89.5 cm.). Gloucester, Mass., Cape Ann Historical Association.

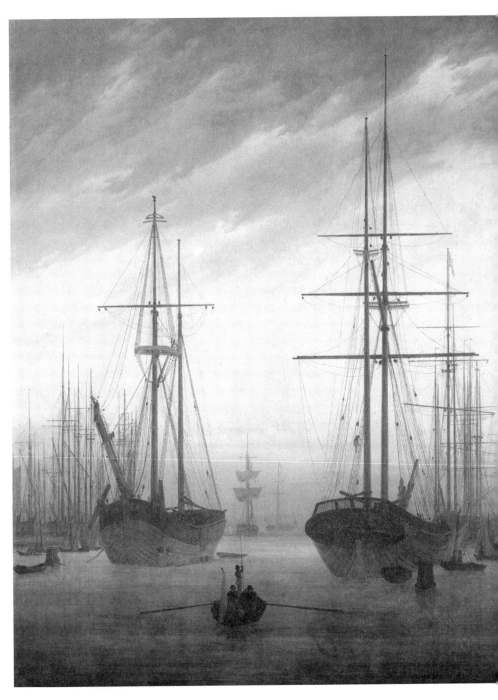

2.4 Caspar David Friedrich, *View of a Harbor* (*Der Hafen*), 1815. Oil on canvas, $35^7/_{16} \times 28$ in. (90 × 71 cm.). Potsdam, Germany, Schloss Charlottenhof.

century, especially those we call luminist, can be seen against such a background.

Elsewhere I have discussed the relation between Lane and Friedrich (see plate 3 and fig. 2.4) and will just summarize it here.[17] Their mutual sophistications grew in each instance out of the primitive and planar folk/craft traditions, advancing finally into transcendental invocations of the numinous. Although there are many cases in art history when similar forms embody differing content, here there are distinct philosophical correlations that tally also with the verbal declarations of Goethe and Carus in Germany and such figures as Emerson in America. In his *Journal*, Emerson not only quotes Goethe's "The works of nature are ever a freshly uttered word of God" but then offers his own "The noblest ministry of nature is to stand as the apparition of God."[18] And Carus's "You are nothing, God is all"[19] could apply to many works by both Friedrich and Lane.

Nonetheless, there are also crucial differences, especially in the area of the self, for Friedrich, in speaking out for "heart" or "feeling" ("The heart is the only true source of art ... a painter should not merely paint what he sees in front of him, he ought to paint what he sees within himself")[20] indicates that his smooth anonymous surfaces are not intended fully to mask the self. Despite Friedrich's vanished process, his belief in the subjective differs from the almost Asian selflessness of American luminist art. (We might also remember that Emerson had seen both Europe and Asia already in Plato's brain,[21] and often called his second wife, Lidian, "My Asia.")

Worringer noted that "mysticism: born of individualism ... immediately preaches against its own origin."[22] With Friedrich, the overt disappearance of self maintains the idea of an original self. Indeed, the individual German self often seems to remain present, despite its striving for mystical annihilation. It is perhaps for this reason that the object in Friedrich's art, far from asserting its own presence, remains mainly a "painted" form. Though not "painterly," it nonetheless carries within it the diachronic "bud" of later German Expressionism.

So for all the similarities between Friedrich and the Americans (see fig. 2.5 and plate 2), the differences enable us to distinguish between the two artistic traditions. Friedrich's self is distilled abstractly into the overall feeling of his matly painted surfaces. Lane's self is immersed in and masked by the hyperrealism of the objects or "facts" in his painted world. The self or

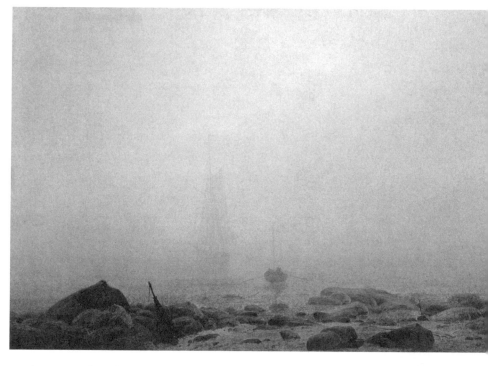

2.5 Caspar David Friedrich, *Mist (Nebel)*, 1807. Oil on canvas, 13¹/₂ × 20⁵/₁₆ in. (34.3 × 51.6 cm.). Vienna, Austria, Österreichische Galerie Belvedere.

ego is somehow displaced into the object of its attention. It is the *thing*, not the self, that remains obdurately present. In the Transcendental moment in America, moreover, the natural fact is more readily equated with Deity without signifying other cultural systems through overt signs. Perry Miller put it succinctly when he referred to the transcendental discard of the husks of Puritan dogma separating God, Man, and Nature.[23] Now, in the Transcendental era, they are inseparable, and Lane's halated forms, his harbored boats and luminous expanses of still water, can be seen in Emerson's words, as facts that are "the end or last issue of spirit."[24]

Thus, as suggested earlier, to go from Copley to the luminist Lane is to go from the metaphysical assumption of the thing to the thing as the embodiment of a metaphysical, that is, transcendental system, in which, to use Emerson's words, "The visible creation is the terminus or the circumference of the invisible world."[25] The objects in Lane's paintings are presented in terms of transcendental hermeneutics. They transport a Providential world-view,

enhanced by correspondences. In Lane's works, as Emerson said in "Spiritual Laws": "the infinite lies stretched in smiling repose."[26]

Is Lane then, just illustrating Emerson? And if he is, which Emerson is he illustrating? Essentially he does not illustrate, but rather *parallels* the public Emerson; however, quite apart from issues of public and private, we remember that Emerson was as contradictory of himself as a weathervane. Literary historians have argued about Emerson's intent in the famous "transparent eyeball passage" that was first connected with luminism years ago by John I. H. Baur.[27] We have seen Emerson as a transparent eyeball in the famous caricature by the poet and painter Christopher Cranch. In Emerson's words: "All mean egotism vanishes. I become a transparent eyeball. I am nothing. I see all."[28] But though Emerson and Lane probably met at the Gloucester Lyceum when Emerson was lecturing there (with Lane serving on the Board),[29] no direct influence is necessary to confirm the extraordinary consonance between many aspects of Emerson's thinking and Lane's implicit aesthetic.

"It is not words only that are emblematic," Emerson wrote in *Nature,* "it is things which are emblematic. Every natural fact is a symbol of some spiritual fact."[30] Though Lane grasps the fact in this metaphysical Emersonian sense, he does so as I have already indicated, pragmatically, as with Copley's fact or thing, in a self-reliance that has by now also become part of the Transcendental credo. Emerson, in an interesting comment that deals with the flow of sensory traffic between the interior and exterior worlds, says: "I am always environed by myself. What I am, all things reflect to me. The state of me makes Massachusetts and the United States out there." He also said: "Here's for the plain old Adam, the simple, genuine Self against the whole world."[31] Insofar as Lane partook of this Emersonian self, he too was Adamic.

But one of the most jealously guarded canons of art-historical theory is that there are no Adams among artists, that art basically derives itself from other art. In America, I feel (and especially with the luminists), this is not so much the case. Heinz Kohut's definition of self as "an independent center of initiative and independent recipient of impression" is useful here.[32] The pragmatic procedure is itself ad hoc, and by definition a rejection of the past. Years ago, R.W.B. Lewis wrote in *The American Adam* about the American case against the past.[33] We have seen Copley invent art. Throughout American art we can point to the American habit of starting from the beginning,

again and again. And in Lane, we witness the same pragmatic reliance on his own eyes, the clinical tang of the ad hoc encounter with nature. I have long maintained that the American artist's consistent pragmatic relation to nature and the object is one of the things that distinguishes American from European painting. As Quentin Anderson commented: "Transcendentalism is a carefully measured madness which admits its aberration when ordering coal."[34] Emerson reveals his own proto-Jamesian pragmatism when he notes, in "Self-Reliance": "Speak rather of that which relies because it works and is."[35] Was he also pinpointing the expedient pragmatism of Americans when he wrote in his *Journal*: "Remarkable trait in the American Character is the union not very infrequent of Yankee cleverness with spiritualism"?[36]

Though my own research has pointed up Dutch prototypes for luminist structure, I have also argued for the Dutch example of simply going directly to nature and observing, certainly an ad hoc encounter characteristic of Lane's procedure. What did Lane observe? In discussing his philosophical implications, one must never lose sight of the way in which his observation was firmly grounded in a specific place with a specific economy. Place, topos, and the recording of place have a crucial role here. Though Lane painted

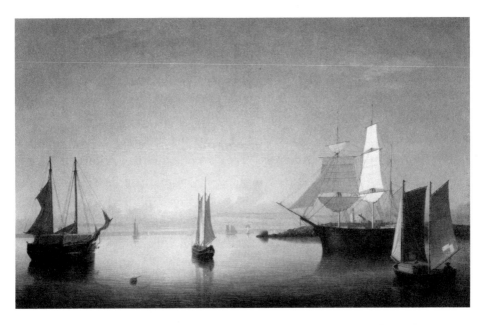

2.6 Fitz H. Lane, *Gloucester Harbor at Sunset*, ca. 1856–59. Oil on canvas, 24¹/₂ × 38¹/₂ in. (62.2 × 97.8 cm.). Private collection.

and traveled in other places, especially Maine, Gloucester was his most com-
pelling model. The places depicted so frequently—Norman's Woe, Eastern
Point, Gloucester Harbor (fig. 2.6), Ten Pound Island—have become as fa-
miliar to us as if we too were their local inhabitants.

The town claimed its identity from the outset from the sea and ships, as
well as from the fish and fisheries that were part of Gloucester's livelihood
and economic and social raison d'être.[37] A plaque set in a huge rock near
Stage Fort memorializes the founding of the Massachusetts Bay Colony and
the fisheries at Cape Ann in 1623. Ships, fish, and rocks define Gloucester as
much as the houses and streets that Lane from the very beginning of his
career had delineated in topographical prints.

Today, the town maintains the same essential character. The town docu-
ments, the archival records of Lane's friends and patrons, the stones at Oak
Cemetery where he is buried bear names that are still a vital part of Gloucester
today. The slowed rate of contemporary change offers within itself an odd
parallel to the suspended time of Lane's paintings. Insofar as Lane's work
sustains this illusion of time stilled, it finds further access to the transcen-
dental idea.

It is both difficult and telling to speak of time in relation to an artwork.
The work itself is of course subject to time. It ages and crackles. But each
work has in it an attitude to time, particularly landscape painting, which
often chooses, especially in America, a specific time of day. How do Lane's
works represent time, and not only what time is it, but what kind of time is
so represented? With the displacement of the self through a perfectly graded,
smooth surface, something also happens to time.

There are moments before nature—particularly at dusk—when the world
seems to hold its breath as it were, and silence adds its auditory coefficient
to the general stillness. There is nothing remarkable here. We've all had those
moments. But what if they are sought and stilled in a painting from which
the author has vanished? And what if they are regularly structured with the
kind of discipline that holds the scene doubly still?

James Jackson Jarves, the most sensitive of mid-century American crit-
ics, had complained that artists like Church and Bierstadt left their labor
trail on the canvas.[38] With Lane, we see no labor trail. Rather, the self as-
sumes the state described by Thoreau when he stated: "He will get to the
Goal first who stands stillest."[39]

The stilled self in Lane's painting is aided in its effects by the measure that clarifies the reading of distance inward from the foreground, as plane parallel to plane the scene steps firmly back, however these planes may be disguised by the accidentals or incidentals of the scene. Along with the erased stroke, this measure is the means by which he manufactures the illusion of stopped time, thereby bringing the scene into the realm of one of mid-nineteenth-century America's obsessions—the Eternal, for behind every change was the immutable presence. Emerson wrote: "The spirit sports with time—Can crowd eternity into an hour, / or stretch an hour to eternity."[40] To make that presence present, to "sport with time" by holding everything still, seems a reasonable strategy, here brilliantly carried through.

Lane's mensurational control also brings to mind Thoreau, the surveyor, at Walden Pond, measuring dimensions with obsessive exactitude to confirm his own physical experience. All through the journals we see that sense of measure, the specificity of number contributing to his mathematics of being.

June 3, 1851: "I examined today a large swamp white oak in Hubbard's meadow, which was blown down by the same storm which destroyed the lighthouse. At five feet from the ground it was nine and three fourths feet in circumference; the first branch at eleven and a half feet from ground; and it held its size up to twenty-three feet from the ground. Its whole height, measured on the ground was eighty feet, and its breadth about sixty-six feet."[41]

Clearly any notion of the transcendental mind as simply up in the clouds misjudges it severely. It is the strong dose of the concrete in American Transcendentalism that enables it to coexist side by side with the pragmatic, in the art as well as the philosophy.

So to the perennial question of how we experience time, we might add the question of time in luminist paintings. Maurice Merleau-Ponty has remarked that "time as the immanent object of a consciousness is time brought down to one uniform level, in other words it is no longer time at all."[42]

Such time is timeless. It has lost its own process. It is, Merleau-Ponty says, "of the essence of time to be in process of self-production and not to be, never, that is, to be completely constituted."[43] The complete constitution of time in Lane's paintings, as in Copley's, converts to timelessness. It is no longer time at all. Timelessness was, for Emerson, the only state in which the soul could reach to divine wisdom. Of the roses under his window, he said: "[T]hey exist with God today. There is no time to them . . . [man]

cannot be happy and strong until he too lives with nature in the present, above time."[44] Time, Space, and Nature, he observed, shrink away before the revelations of the Soul, "time and space are but inverse measures of the force of the soul."[45]

The shrinkage or disappearance of time is an idea that has extended well into our own era, prompting Samuel Beckett to observe "time has turned into space and there will be no more time."[46] Thomas Mann too offers some provocative insights in *The Magic Mountain*: "Time is drowning in the measureless monotony of space; motion from point to point is no motion more, where uniformity rules, and where motion is no more motion, time is no longer time."[47]

In luminist painting, the self has vanished along with time. Thoreau's *Journal* reports on what is left behind: "Drifting in a sultry day on the sluggish waters of the pond, I almost cease to live and begin to be. . . . I am never so prone to lose my identity. I am dissolved in the haze."[48]

When the luminist self is not dissolved in haze, it is dissolved in light. Light, in Emerson's words, is "the first of painters." The universe, for Emerson, "becomes transparent, and the light of higher laws than its own shines through it."[49] In an Emersonian sense, the self as ego vanishes in moments of divine wisdom, to be replaced by the even larger "soul" which is the Oversoul. The soul, too, is not an organ, a function, or a faculty, "but a light. . . . From within or from behind, a light shines through us upon things, and makes us aware that we are nothing, but the light is all."[50]

We usually think of painters of light as Impressionists, plein-air artists capturing actual sunlight by that tiny synaptic crackle between strokes on the white surface. The Impressionist self stands assertively behind those strokes. Each one signs the artist's presence. And the canvases glow when we retreat from them.

In luminist art too, with Lane's paintings, the canvas yields up its glow as we retreat, until from the end of the gallery it often seems as if the painting is holding a pocket of air and light (see plate 3). Close up, however, we can see no stroke—only a rather primitive matness and anonymity of surface. Yet that surface is deceptive, because like the structure, it too is governed by measure. The graduated tonalities of hue are so infinitesimal as to be invisible, mimicking their author's stealthy retreat from view. Precisely because they are so subtly controlled, they emanate that celestial glow. More than

the vanished stroke (of which, however, it is a function) that glow attests to the artist's orderly control of his own transcendent entry into a larger universe, where, as Emerson has reminded us "The laws of moral nature answer to those of matter as face to face in a glass."[51] These surfaces too are glass-like. The luminist painter, like Emerson's poet "turns the world to glass."[52]

And where there is glass, there is reflection. Luminist paintings are filled with reflections, as are Copley's paintings. Within Copley's burnished table tops, stuffs and still-lifes gleam with a doubled existence. This doubling has of course a convenient metaphysical analogue. Edwards had written of the images or shadows of divine things: "The whole outward creation, which is but the shadows of His being, is so made as to represent spiritual things."[53] Now this is brought home most sharply in the art of the mid-nineteenth century. God is reflected in nature, there are reflections of nature in nature's mirrors, the painting reflects nature, within the painting represented nature is reflected, and on all this the mind itself reflects. So between natural reflection and painted reflection is a series of translations as the artist reflects on, and in turn reflects, God's original creation. A complex system of reflections lies open for decoding.

The esthetic, philosophy, and religion of the period rebound in reflections, twins, and doubles. Representations of nature negotiated their way between the real and the ideal, those dialectical twins that are a central theme in nineteenth-century American art and taste. They can be seen as part of Emerson's idea of the universality of "this old double": ". . . there is no other world; here or nowhere is the whole fact; all the Universe over, there is but one thing—this old double, Creator-creature, mind-matter, right-wrong."[54]

Lane's art, and luminist art in general, was arguably the most authentic answer to the American nineteenth century's call for a perfect merger of the real and ideal. Lane's marine paintings are carefully controlled by his knowledge of weather, shipbuilding, designer's plans, nautical science, marine dictionaries, and even an occasional photograph. The painting's *facts* are instructed by ideas about reality that clarify the mess we might call actuality. But beyond this conceptual expertise, an ideal core inhabits the luminist object and ultimately halates it with its platonic perfection. The ideal it represents presses on the thin membrane of the Emersonian fact as "the end or last issue of spirit."

With Lane's reflections then, we are dealing with mirrors within mirrors. The painting itself, by aesthetic criteria going back beyond Leonardo and Alberti to Plato, is of course a mirror of reality. But what happens if the painting, like the mind, is given the possibility of reflection? The conditions for reflection—calm and stillness—are the same for nature and for the mind. These conditions donate their mood to the luminist painting. Reflections have, as we know, the most fragile of surfaces. The fragility, which a pebble can fracture, makes for suspense. This perfection cannot hold. So time, though suspended, is imminent, and we hold our breath lest we disturb it. This perfect double is fugitive and transient and has an apparitional quality. Reflections are visible but vulnerable to the slightest touch, and to the degree that we can destroy them, they empower us. In the mathematics of desire, they inversely reproduce a reality that is knowable, while they themselves cannot be fully known.

In transcendental terms, a reflection is a glimpse of a perfection that puts us in a state of grace and returns us again to Emerson's laws of moral nature answering to those of matter as "face to face in a glass." They also recall Emerson's comment that "When the act of reflection takes place in the mind, when we look at ourselves in the light of thought, we discover that our life is embosomed in beauty."[55] Self-reflection, as thought's light, and actual reflections as other-worldly mirroring, are linked through idea and ideal, and through the submersion of self in the Emersonian universe. Lane's paintings, like that universe, are silent, and Emerson might have written of them: "silence is a solvent that destroys personality and gives leave to be great and universal."[56]

The thinking creature, reflecting, both discovers and loses the self, which is asserted sufficiently for thought, and then willingly surrenders. It was in his own mind, wrote Emerson in "Self-Reliance," that the artist sought his model, the thing to be done, the conditions to be observed. "Insist on yourself," he wrote, "never imitate."[57]

Emerson used his public self to encourage his readers to be their best specific and private selves. The luminist self transmitted in Lane's paintings is at once self-reliant, pragmatic, private, and transcendent, inviting also a private response from the spectator, who often must conceptualize his or her own size, reduce it to thought, before entering the painting. In this instance, the mirroring extends from artist's thought to spectator's thought. Led by

the act of reflection and by reflections into that which is beyond nature, both artist and spectator, reduced to thought, could enter a Godly realm.

That realm, in its ideal form, reflects the desires for perfection of the pre-Darwinian era. It mirrors the perfect planning of the Providential blueprint, the grand design with its carefully plotted rungs of the scala naturae. Like Lane's paintings, with their classic mensuration, we know where we are within this blueprint. We are fortified by the theory of the immutability of species, which has not yet yielded to Darwinian change and chance.

Thoreau and Indian Selfhood: Circles, Silence, and Democratic Land

We begin with the idea of the circle. Jung suggests that what led psychologists to conjecture "an archetype of wholeness, i.e. the self . . . are in the first place, dreams and visions, in the second place, products of active imagination in which symbols of wholeness appear. The most important of these are geometrical structures containing elements of the circle and quaternity. . . ."[1]

The notion of the circle, as an archetype of the self, of a self that is also whole, of wholeness—in fact—*as* self, is of great interest when placed beside Native American building structures, works of art, artifacts, rituals, and ceremonies in which the circular form is invested with sacred meaning.

Jung's self as wholeness would seem to relate to the Indian concept of cosmic interrelatedness, from the ancient medicine wheels, to the stone circles in the Bighorn Mountains, Wyoming, to the circles within circles of ancient pots, the round kivas of the Southwest, the hogans of the Navajo, and the sacred circles on Plains medicine shields, sometimes marked with signs of the four wind directions (Jung's quaternity).[2]

How remarkable, then, to find Emerson writing "Circles"[3] at a moment (1841) when the Native American culture was perceived so much as Other that its extinction was a foregone conclusion. What, we might ask, did the Transcendentalists know of Native American philosophy and religion? Beyond this, with what Indian concepts of nature, God and universe, in relation to self, might at least some nineteenth-century Americans generally have held sympathy, had they known of them?

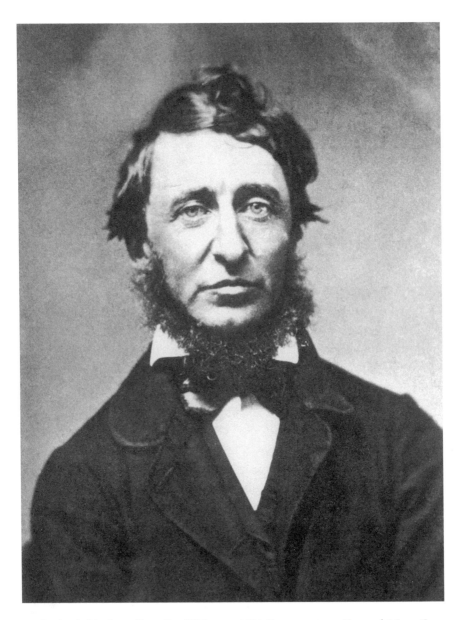

3.1 Benjamin Maxham. *Henry David Thoreau*, 1856. Daguerreotype. Concord, Mass., Concord Free Public Library.

Thoreau has made the problem both easier and more perplexing by add-ing to the puzzle the three thousand manuscript pages of his so-called Indian Books (fig. 3.1). Robert F. Sayre's fine study *Thoreau and the American Indians* attempts to lay to rest the idea—still somewhat arguable—that these "com-monplace" materials indicate Thoreau's intention to write a book about the Indians.[4] The "extract" nature of these manuscripts, called "Extracts" even in the Morgan Library's bibliographical index, suggests that Thoreau re-corded these materials—largely from earlier and contemporary books on the Indians—as a study tool, an *aide-memoire*, to internalize and learn as students and scholars do, in the very act of writing down. Though we are now in the age of the photocopier and computer, older scholars might rec-ognize this method of study.

The learning comes in the actual process of writing down, internalizing knowledge, even as the student is creating his or her personal reference li-brary. Thoreau inserts in the notebooks pertinent newspaper clippings on the Indians, or on recent books about them; he draws moccasins and In-dian shirts and trousers, even tracing an 1852 map by Seth Eastman from Michigan, Illinois, and Arkansas westward, and situating Indian tribes on it.[5] His is an intimate, immediate procedure. It strikingly underscores his intent to learn. That so many of Thoreau's annotations are recorded in quotes indicates some kind of intention for formal use in his own writing in the future. But they remain, as Sayre suggests, largely commonplace materials. There is no "book by Thoreau on the Indians" as such here.

But if it is not useful to speculate too far on Thoreau's intentions, what he chose to record is still instructive. He tries to divine from his readings some sense not only of Indian history, custom, and language, but of reli-gion, copying out rituals and ceremonies. In recording attitudes to death, for example, he reminds us that he was at least somewhat aware of the sa-credness of the circle in Indian cultures, noting from Brebeuf that at the center of Creek (as also of the Cherokee) towns, there "was a 'public' square . . . and placed in a fixed position in respect to it, was an edifice, circular in form, which was more especially dedicated to religious purposes, and within which was kept the eternal fire."[6]

Most important, Sayre has shown how Thoreau's extensive readings of early ethnographic studies of the Indians, of myths and such personal con-tacts as he could contrive (e.g., with the avowed Indian Protestant Joe Polis, who frowned on Anglos who did not go to church on Sunday) informed his

attitudes to wilderness, nature, and universe on a day-to-day basis, instructing even the circular structures of *Walden* (fig. 3.2).[7] As Sayre puts it: "Within recognitions that the year is a circle and 'the day is an epitome of the year' are the tightly folded buds of the whole structure of *Walden*. Without this Indian order and concision, the book would have been a two-year journal, reporting on economic makeshifts and hectoring the Concord villagers."[8]

Though Black Elk was born "in the winter when the Four Crows were killed in 1863,"[9] a year after Thoreau's death in the spring of '62, Black Elk's

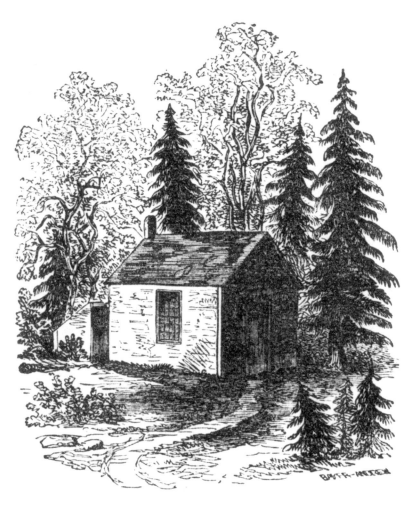

3.2 Sophie Thoreau (sister). Thoreau's Cabin at Walden, detail of title page, *Walden, or, Life in the Woods* (Boston: Ticknor and Fields, 1854). Concord, Mass., Concord Free Public Library.

observation that, "Even the seasons form a great circle in their changing, and always come back again to where they were"[10] is consonant with Thoreau's practice.

The Indian Books, the journals, and Thoreau's literary works at large testify that he was, on the whole, deeply sympathetic to the Indians, knew a great deal about them, and incorporated that knowledge into his lifestyle and work. But to what extent did Thoreau, and Emerson as well, connect their readings in East Indian philosophy and religion, which so influenced them, with the ideas and beliefs of the American Indian?[11]

In his Indian Books, Thoreau recorded the views of Benjamin Smith Barton in *New Views of the Origin of the Tribes and Nations of America* (1798) that Indians were descended from "the Persians and other improved nations of Asia."[12] Barton also suggested a trans-Pacific migration. But Thoreau noted that he still did not clarify "which was the parent stock—old or new world men."[13] The problem of American Indian origin remains with us. But even a brief comparison indicates the extraordinary similarity between a passage in the Hindu scriptures—"The Self is below, the Self is above, the Self is to the west, to the east, to the south, to the north. Truly the Self is this whole universe"[14]—and Jung's idea of the circular self, corresponding with its quaternities, to the universe and its elements. The American Indian circles, as evidenced in their art and rituals,[15] might, as suggested earlier, slide easily enough onto Jung's circular self, though cultural differences could make their circumferences tremble.

Since we are speaking here of some rather mysterious trans-cultural resonances (for want of a better word), can we also cautiously add still another circle from the always obliging Emerson (in "The Over-Soul") when he says "the soul circumscribes all things"?[16] Emerson's essay "Circles" begins: "The eye is the first circle; the horizon which it forms is the second; and throughout nature this primary figure is repeated without end. It is the highest emblem in the cipher of the world. St. Augustine described the nature of God as a circle whose centre was everywhere and its circumference nowhere. We are all our lifetimes reading the copious sense of this first of forms."[17]

Emerson could readily recognize the Hindu source of his ideas; he could also see St. Augustine behind them, and of course Plato, with his celestial geometry, who "stood on a path which has no end, but runs continuously round the universe" and "first drew the sphere," kindling "a fire so truly in the centre that we see the sphere illuminated, and can distinguish poles,

equator and lines of latitude, every arc and node...."[18] Yet it is doubtful that he realized that Native Americans incorporated similar beliefs into their worldview. "You have noticed," wrote Black Elk, in the autobiography dictated to John G. Neihardt (Flaming Rainbow),[19] "that everything an Indian does is in a circle, and that is because the Power of the World always works in circles, and everything tries to be round...."[20]

Compare this with Emerson's reference to "the American scholar": "What is nature to him? There is never a beginning, there is never an end, to the inexplicable continuity of this web of God, but always circular power returning into itself. Therein it resembles his own spirit, whose beginning, whose ending, he can never find—so entire, so boundless."[21]

Even Thoreau, obsessed as he was with the Indians, seems not to have fully grasped the parallels between the rarefied circles of the Hindu and the aboriginal circles of the American Indian, whether from the same ethnological origin or not.

It is indeed a cutting irony that some of the most profound philosophical beliefs of Transcendentalism, culled in part from sources in Asian philosophy, religion, and literature to construct some aspects of the mid-nineteenth-century worldview, would have found welcome resonance in many if not all of the Indian tribes. Did Thoreau have at least some inkling of this when he wrote of "wild men, so much more like ourselves than unlike"?[22]

Emerson, on the other hand, rarely mentions the Indians. Though he refers to the Ohio Circles,[23] believed by some to belong to an earlier, higher society which disintegrated into the nineteenth-century Indian, he is more likely just to include the Indian along with the idiot and child as an aboriginal self, "nearer to the light by which nature is to be read."[24]

Nonetheless, he recognizes an *ascent* to a "primary and aboriginal sentiment" in his idea that "we have come from our remote station on the circumference instantaneously to the centre of the world where, as in the closet of God, we see causes, and anticipate the universe...."[25]

Can we find affinities between Emerson's utterance and the cry of the Kwakiutl neophyte: "I am at the center of the world!"?[26] Or with Algonquin and Sioux beliefs as they built their sacred initiatory lodges?[27] Mircea Eliade tells us: "... the symbolism of the Center of the World is older than known cosmologies elaborated in the Ancient Near East. The very expression 'Center of the World' is literally retrieved and charged with similar symbolism in the ritual of the Kwakiutl and in certain Zuni myths."[28]

Catlin, in the 1830s, depicted ancient Mandan huts,[29] which in their circular structures made of a simple dwelling the "center of the world." Whole villages could be seen in his painted representations repeating in their forms the circles that invoked the link between the Indians and their sacral universe. But the Indians remained Other. For some, dangerous savages, to be exterminated on sight; for others, noble savages, part of a sacred wilderness, which sadly must give way to progress, but always "uncivilized."

The limitations of early ethnographic studies of the Indians, popular nineteenth-century ideas of "savages" and "civilization," the sacred inviolability and secret mysteries of the various Indian rituals and beliefs, even the distinctions between Christians and non-Christians all conspired to keep most European inheritors of the North American continent from arriving at an understanding of the philosophical and religious beliefs of its first inhabitants.

Yet on many levels, the Transcendental quest for a loss of self in relation to a supreme being, a Creator Over-Soul, was as close as Western man—with his resistantly residual and ever relapsing "I"—could get, to ideas intrinsic to Eastern (read Hindu or Buddhist) philosophy, and to certain aspects of Native American spirituality.

Though ultimately Emerson inherited more than twenty of the forty-four Asian books Thoreau acquired from Thomas Cholmondeley in 1855,[30] there is little indication that either Emerson or Thoreau connected what he read in those volumes (and even earlier in books borrowed from the Concord and Harvard Libraries) with the spiritual beliefs of the American Indians. In effect, they seem to have missed what was on their very doorstep.

Does the dearth of a written Indian language become a factor in this narrative of non-recognition? Thoreau wrote: "There is something very choice and select in a written word. No wonder Alexander carries his Homer in a precious casket on his expeditions."[31]

Though Thoreau in *The Maine Woods* made a glossary of American Indian words, these dealt mainly with plants and places[32]—labels and markers rather than philosophical or religious meditations. His Native American studies do not seem to have offered him sufficient evidence of the latter. Such ideas continued to come to him from the higher "civilized" traditions of India and Persia. "If the soul attend for a moment to its own infinity," he

wrote, "then and there is silence."[33] His awareness of the divinity of silence and stillness ("He will get to the goal first who stands stillest"[34]) was rooted not only in his own profound experience of a sacral Nature but in his debts to Asia: "With thoughts all stilled . . . the pure of heart / Behold Him at long last; . . . meditating on Him / (They behold Him) partless and entire."[35]

But Emerson's wise silence, Meister Eckhart's central silence, the Hindu soundlessness ("The higher and the lower God / Whose name is Om, / Soundless and void of contingency"[36]), Thoreau's infinite silence, and even the American luminist painter's silence all find analogues in the Indians' awesome respect for a sacral silence. The Dakota Sioux Ohiyesa (Charles Eastman, grandson of Seth Eastman, whose map Thoreau had traced into his Indian Book) wrote of the First American: "He believes profoundly in silence—the sign of a perfect equilibrium. . . . The man who preserves his selfhood is ever calm and unshaken by the storms of existence—not a leaf, as it were, astir on the tree; not a ripple upon the surface of the shining pool. . . . If you ask him, 'What is silence?' he will answer: 'It is the Great Mystery! The holy silence is His voice!'"[37]

Could Thoreau have sensed this affinity when he wrote: "I rejoice to find that intelligence flows in other channels than I knew. It redeems for me portions of what seemed brutish before"?[38] Yet when he declared, "I find an instinct in me conducting to a mystic spiritual life, and also another to a primitive and savage life,"[39] one feels that he made a genuine schism between them and was perfectly willing to allocate "savage" to the American Indian sources and keep spirit in the Orient. His comment "I am not sure but all that would tempt me to teach the Indian my religion would be his promise to teach me *his*"[40] suggests that lack of access to beliefs as well as lack of the written word kept him from fully understanding the spiritual richness of the American Indian. The churchgoing Joe Polis could hardly admit him into the sacred Native American mysteries. For all his sympathy and study, Thoreau was obliged to write: "He is but dim and misty to me. . . . So he goes about his destiny, the red face of man."[41]

By the early 1850s, according to Sayre, Thoreau had "increased his reading of East Indian and Asian philosophy and had no resistance to unifying ideas which were Indian, Asian, Emersonian, and his own."[42] Yet for him the highest and most civilized world remained the Asian. "I cannot read a sentence in the book of the Hindoos without being elevated as upon the table-

land of the Ghauts."[43] And: "There is nowhere a loftier conception of [man's] destiny . . . no grander conception of creation anywhere."[44]

The written word and "civilization" went hand in hand here. The word was for Thoreau "the simplest and purest channel by which a revelation may be transmitted from age to age."[45] But though Thoreau made pencils, the Indians, without a written language, had little use for them. It is somewhat emblematic of the importance of the written word to the Transcendentalists that Emerson, who rarely spoke out publicly on such issues, wrote eloquently to President Van Buren in 1838 protesting the inhuman treatment of the Cherokee, the first tribe with a written language, what their leader Sequoyah had called his "talking leaves." Even a newspaper, *The Cherokee Phoenix*, was printed, partly in English and partly with the Cherokee characters invented by Sequoyah for his syllabary.[46]

It is also significant that many of the Cherokee were not hunters or wanderers but had by the mid-1830s become farmers. On the white ladder of nineteenth-century Indian hierarchy, the farmer was more "civilized" than the so-called "savage hunter" of the plains. Indeed, in all our ruminations about nineteenth-century attitudes to the Indians the word "civilized" is never far away. Civilization meant not only language, but, of course, garden, as opposed to wilderness. In "civilizing" American nature, in converting wilderness, the Indian too, nature's "natural part," had to be brought within the perimeter of a pastoral ideal. Earlier, Crèvecoeur had made a distinction between "the inhabitants of the woods . . . her undefiled offspring" and "those of the plains . . . her degenerated breed, far, very far removed from [Nature's] primitive laws, from her original design."[47] Henry Nash Smith long ago reminded us that a writer in the *Port Folio* in 1817 referred to the Northern Plains Indians as "the American Tartars," while Timothy Flint spoke of the Southwest Indians as "ruthless red Tartars of the desert."[48]

Thoreau was ambivalent about what he described as the "hunter" Indian. On the one hand he wrote: "There is a period in the history of the individual, as of the race, when the hunters are the 'best men,' as the Algonquins called them. . . . I see that if I were to live in a wilderness I should again be tempted to become a fisher and hunter in earnest."[49] On the other, he maintained: "What a coarse and imperfect use Indians and hunters make of nature! No wonder that their race is so soon exterminated."[50]

The "wild" Indian, even the "savage" Indian, posed a model in relation to nature that he chose to emulate: "The charm of the Indian to me is that he stands free and unconstrained in Nature, is her inhabitant and not her guest, and wears her easily and gracefully."[51] Yet he felt with prophetic certainty that "For the Indian there is no safety but in the plow. If he would not be pushed into the Pacific, he must seize hold of a plow-tail and let go his bow and arrow, his fish-spear and rifle. This is the only Christianity that will serve him. His fate says sternly to him, 'Forsake the hunter's life and enter into the agricultural, the second, state of man. Root yourselves a little deeper in the soil, if you would continue to be the occupants of the country.' But I confess I have no little sympathy with the Indians and hunter men. . . . A race of hunters can never withstand the inroads of a race of husbandmen . . . the plow is a more fatal weapon. . . ."[52] Smith has indicated how important the yeoman's plow and democratic dream of an agrarian utopia was to the transformation of the arid plains after the Civil War.[53]

Yet how much opportunity was afforded the Plains Indians to use the plow? Though even earlier Thoreau saw salvation for the Indian only in the plow, he also noted that the Cherokee farmers' 2,923 plows were not enough. "[I]f they had grasped their handles more firmly," he premises, "they would never have been driven beyond the Mississippi. No sense of justice will ever restrain the farmer from plowing up the land which is only hunted over by his neighbors. No hunting field was ever well fenced and surveyed and its bounds accurately marked, unless it were an English park. It is a property not held by the hunter, so much as by the game which roams it, and was never well secured by warranty deeds."[54]

The issue of course was largely one of property, and the greed that enters into this narrative is one of the great stains on the American psyche. There was a general acceptance of the teleological idea (shared even by Thoreau) that the Indians must go to make way for the white man, who had been God-blessed in his mission to receive the bounties of America. As James Brooks wrote in The Knickerbocker in 1835: "God has promised us a renowned existence, if we will but deserve it. He speaks this promise in the sublimity of Nature. It resounds all along the crags of the Alleghanies. It is uttered in the thunder of Niagara. It is heard in the roar of two oceans, from the great Pacific to the rocky ramparts of the Bay of Fundy. . . . The august TEMPLE in which we dwell was built for lofty purposes. Oh! That we may consecrate it to LIBERTY AND CONCORD, and be found fit worshippers within its holy wall!"[55]

But the Indians also believed they were blessed by the Creator. In Pontiac's speech as early as 1763, the Great Spirit told a Delaware Indian: "I am the Maker of heaven and earth, the trees, lakes, rivers and all things else. I am the Maker of mankind; and because I love you, you must do my will. The land on which you live I have made for you, and not for others. Why do you suffer the white men to dwell among you?"[56]

Many of the great Indian orators sounded this note. In 1832 Black Hawk told his Sauk followers: "The Great Spirit created this country for the use and benefit of his red children, and placed them in full possession of it, and we were happy and contented. Why did he send the palefaces across the great ocean to take it from us?"[57] The Indians felt they had dibs on the land. As the Shawnee chief, Tecumseh, put it in 1810: "The White people have no right to take the land from the Indians, because they had it first, it is theirs . . . the camp is stationary. . . . It belongs to the first who sits down on his blanket or skins, which he had thrown upon the ground, and till he leaves it, no other has a right."[58]

The head-on collision that resulted had more than a little to do with two antagonistic cultures believing the land was theirs by God's mandate, though the terms of that possession were vastly different.

As the Indians put it, the white men came and initially asked for a small seat. Then the demands grew for a larger and larger seat. The white men wanted their land and ultimately convinced them—decimated by ecological change, loss of hunting animals and buffalo, wars and disease—that God was on the white man's side.

As a comment on racial inequities there is heartbreaking pathos in the speech by the Shoshone chief, Washakie, in 1855, on Horse Creek, Idaho, during a visit from Mormon missionaries:

> The time was when our Father, who lives above the clouds, loved our fathers, who lived long ago, and His face was bright, and He talked with our fathers. His face shone upon them, and their skins were white like the white man's. . . . Then He turned His face away from them, and His back to them, and that caused a shade to come over them, and that is why our skin is black and our minds dark . . . after a while the Great Father will quit being mad, and will turn his face towards us. Then our skin will be light.[59]

The appropriation of Indian land by the white man was considered morally justifiable because, as William Cronon has pointed out, "English colonists could use Indian hunting and gathering as a justification for expropriating Indian land. To European eyes, Indians seemed to squander

the resources that were available to them. Indian poverty was the result of Indian waste: underused land, underused natural abundance, underused human labor."[60] Long after the colonists, Tocqueville noticed the same attitude in the nineteenth-century white Americans he encountered: "God, in refusing the first inhabitants the capacity to become civilized, has destined them in advance to inevitable destruction. The true owners of this continent are those who know how to take advantage of its riches."[61]

"Civilized" superiority involved fences, land surveys, and deeds. That the continent would become quickly disposable—its ecosystems altered, the Indian food sources of hunting animals replaced by domestic animals, the land itself and its yield becoming, as Cronon has shown, a capitalist commodity that went "hand in hand"[62] with environmental degradation—is a fact we are still dealing with. Though a Blackfoot chief declared: "Our land is more valuable than your money, it will last forever. . . . We cannot sell the lives of men and animals; therefore we cannot sell this land. It was put here for us by the Great Spirit and we cannot sell it because it does not belong to us . . . ,"[63] that democratic attitude, in which land belonged to no one and thus to everyone, could not prevail. As Thoreau put it: "The white man comes, pale as the dawn . . . building a house that endures, a framed house. He buys the Indian's moccasins and baskets, then buys his hunting grounds, and at length forgets where he is buried and ploughs up his bones."[64]

Black Elk phrased it this way: "The Wasichus have put us in these square boxes. Our power is gone and we are dying, for the power is not in us any more. . . . When we were living by the power of the circle in the way we should, boys were men at twelve or thirteen. But now it takes them very much longer to mature"[65] (fig. 3.3).

In effect, the square had replaced the circle.[66]

What was left to the Indian was that other part of the self as an archetype of wholeness to which Jung had alluded: dreams and visions. Though Sayre has compared Thoreau's two-year sojourn at Walden to certain aspects of the Indian vision quest, he notes: "It is clear from his notes in his 'Indian Books' that as late as 1854, when *Walden* was published, he was unaware of the vision quest as a rite of passage of North American natives. Not until the twentieth century have anthropologists systematically identified and described it."[67]

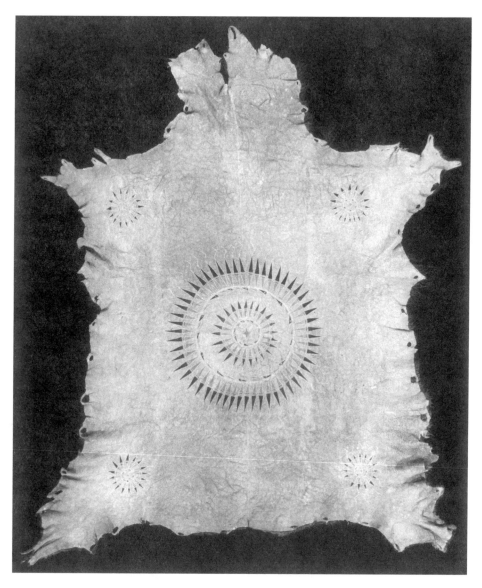

3.3 Buffalo Robe, ca. 1845; Mandan, North Dakota. Buffalo hide, pigments, 103 × 86 in. (261.6 × 218.4 cm.). Cooperstown, N.Y., Fenimore Art Museum.

Nonetheless, the Walden stay—an effort after a holistic self—aspired to the relation to nature he believed the Indians possessed: "We talk of civilizing the Indian, but that is not the name for his improvement. By the wary independence and aloofness of his dim forest life he preserves his intercourse with his native gods, and is admitted from time to time to a rare and peculiar society with Nature. . . ."[68]

While at Walden, Thoreau was engaged in writing *A Week on the Concord* . . . , in which he asked, "If I am not I, who will be?"[69] He was aided in seeking that integrated self, of course, not only through Indian example but also through the intellectual nourishment of his contemplative mind by his Asian sources. The *Brihadāranyaka Upanishad* states: "Should a man [truly] understand the Self / Knowing this that: 'I am He'; / What could he wish for,—what desire / That he should to this body cleave? / Whoso has found the Self and wakened It / Deep buried in this abyss of ambiguity: / All-maker he—for everything he makes and does; / His is the world: the world itself is he!"[70]

For Thoreau: "The New Testament is remarkable for its pure morality; the best of the Hindoo Scripture, for its pure intellectuality. The reader is nowhere raised into and sustained in a higher, purer, or *rarer* region of thought than in the Bhagvat-Geeta."[71] And, "Beside the vast and cosmogonal philosophy of the Bhagvat-Geeta, even our Shakespeare seems sometimes youthfully green and practical merely."[72] The Bhagvat-Geeta told him: "I am the Self established / In the heart of all contingent beings; / I am the beginning, the middle and the end / Of all contingent beings too."[73]

Though Thoreau speaks with wistful respect of the "dreaming" Indian, he is again more apt to refer the dream to the Brahmins: "Their conception of creation is peaceful, as in a dream. 'When that power awakes, then has this world its full expansion; but when he slumbers with a tranquil spirit, the whole system fades away.' In the very indistinctness of their theogony a subtle truth is implied."[74]

Thoreau's "vision," like the Indians' vision quest and his Asian sources, placed an emphasis on contemplation: "If with closed ears and eyes I consult consciousness for a moment, immediately are all walls and barriers dissipated, earth rolls from under me, and I float, by the impetus derived from the earth and the system, a subjective, heavily laden thought in the midst of an unknown and infinite sea, or else heave and swell like a vast ocean of thought, without rock or headland, where are all riddles solved, all straight lines making there their two ends to meet, eternity and space

gambolling familiarly through my depths. I am from the beginning, know-
ing no end, no aim. No sun illumines me, for I dissolve all lesser lights in my
own intenser and steadier light. I am a restful kernel in the magazine of the
universe."[75]

In the vision quest, the frequent apparitional testimony of an animal or
bird signified that a sacral union had transpired. Beyond that was the still
more crucial intention of the "quester" to induce a spiritual or mystical
union with the higher powers of the universe, effecting a recognition of a
larger or transcendent self. That self, as we know, had been connected by
Locke with consciousness as early as 1694. Now Thoreau consulted con-
sciousness as a route to that higher self available through contemplation
and its corollary, silence. He probably would have attributed his awareness
of the contemplative powers of silence to his Asian sources: "Was not Asia
mapped in my brain before it was in any geography?" And, "When I look
eastward over the world it seems to be all in repose. Arabia, Persia, Hindostan
are the land of contemplation."[76]

But the American Indians also esteemed the sacrality of silence and con-
templation. As Joseph Epes Brown has written: "Through the vision quest,
participated in with physical sacrifice and the utmost humility, the indi-
vidual is opened in the most direct manner to contact with the spiritual
essences underlying the forms of the manifested world. In the states achieved
at this level, meditation may be surpassed by contemplation. Thus Black
Elk has said that the greatest power in the retreat is contact with silence 'for
is not silence the very voice of the Great Spirit?'"[77]

Thoreau sought such a silence in the Walden quest, described at the end
of *A Week on the Concord* . . . : "As the truest society approaches always
nearer to solitude, so the most excellent speech finally falls into Silence. Si-
lence is audible to all men, at all times, and in all places. She is when we hear
inwardly, sound when we hear outwardly. Creation has not displaced her,
but is her visible framework and foil. . . . Silence is the universal refuge. . . ."[78]
Even earlier, in his journal, he had written: "Silence is the communing of a
conscious soul with itself."[79]

It is but a step from the silent soul's communion with itself to the spiri-
tualist belief in the continuation of the soul in its union with the universe
after death, a belief that, spurred by Swedenborgianism, attracted a number
of Thoreau's compatriots at mid-century. That Thoreau was aware, in this
instance, of the connections of Indian religious philosophy to spiritualist

belief is affirmed by a newspaper clipping he tucked into Volume 7 of the Indian Books. Dated September 29, 1855, it is a review of a recent publication entitled *The Iroquois . . . Or the Bright Side of Indian Character*, by Minnie Myrtle, and notes that the Indians "were decided Spiritualists," quoting Myrtle's comment, "The author of 'principalities and powers' could not more thoroughly believe in guardian angels and 'princes of the power of the air' than these simple people who never heard of Revelation. . . ."[80] (Modern spiritualists, even today, generally recover the spirits of loved ones with the aid of Indian guides, as if the Indians, ever forgiving and compassionate, have taken eternal charge of America's spiritual soul.) Was Thoreau aware of this even earlier, when he wrote of the tragic demise of the Indians: "He dies. . . . But he is not worsted in the fight, he is not destroyed. He only migrates beyond the Pacific to more spacious and happier hunting-grounds"?[81]

Could Thoreau's recordings of Indian burial practices in the Indian Books have led him toward that awareness? Could they, hypothetically, have led him back, from the light-filled silence of life-after-death into the light of a meditative silence within life for which he had looked to Asia?[82] Could they finally have demonstrated that he could find the spiritual heights he sought on American shores, within the circles of those Native Americans who so concerned him?

What would have been the outcome for the Indians had the Transcendentalists—among the leading intellectuals of their time—championed their cause not only for humanitarian reasons, or for their rare "society" with Nature, but because they recognized in them affinities to those "civilized" spiritual beliefs of the "elevated" Hindoos, to which the noblest sights of Transcendental thought had been raised? We will never know. But it is at least worth noting the irony that the Indian circles, even as the extermination of their makers progressed, signified a quest for a wholeness of self in relation to nature and a sacral universe that has been a latent but persistent strain in American culture from the Transcendental moment until the present.[83]

1. John Singleton Copley, *Mrs. Ezekiel Goldthwait (Elizabeth Lewis)*, 1771. Oil on canvas, 50$\frac{1}{8}$ × 40$\frac{1}{8}$ in. (127.3 × 101.9 cm.). Boston, Museum of Fine Arts.

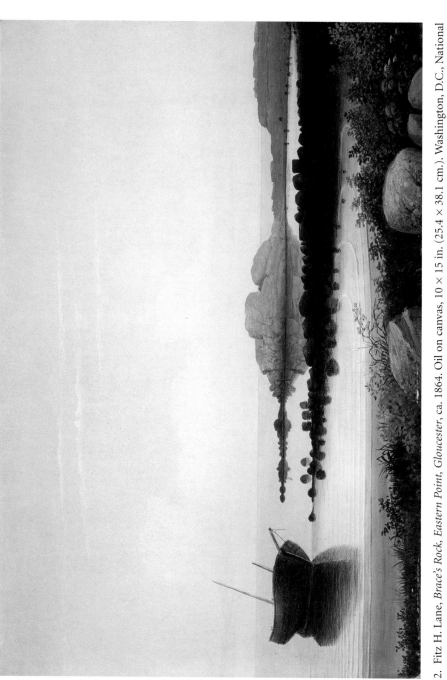

2. Fitz H. Lane, *Brace's Rock, Eastern Point, Gloucester*, ca. 1864. Oil on canvas, 10 × 15 in. (25.4 × 38.1 cm.). Washington, D.C., National Gallery of Art.

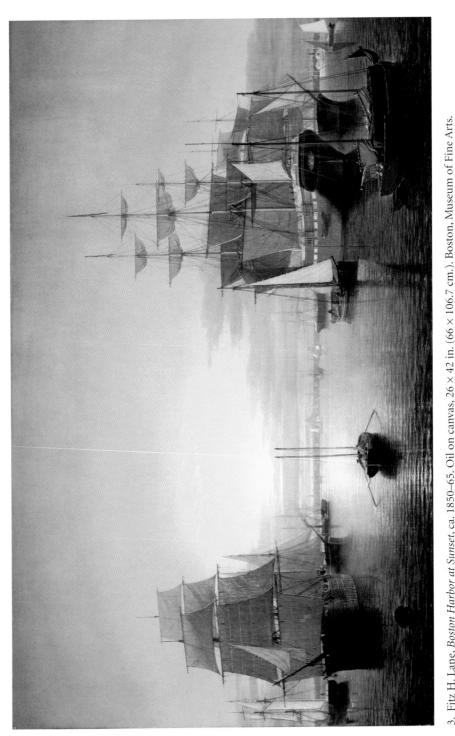

3. Fitz H. Lane, *Boston Harbor at Sunset*, ca. 1850–65. Oil on canvas, 26 × 42 in. (66 × 106.7 cm.). Boston, Museum of Fine Arts.

4. Frederic Edwin Church, *Heart of the Andes*, 1859. Oil on canvas, 66¹/₈ × 119¹/₄ in. (168 × 302.9 cm.). New York, The Metropolitan Museum of Art.

5. Frederic Edwin Church, *Cotopaxi*, 1862. Oil on canvas, 48 × 85 in. (121.9 × 215.9 cm.). Detroit, Detroit Institute of Arts.

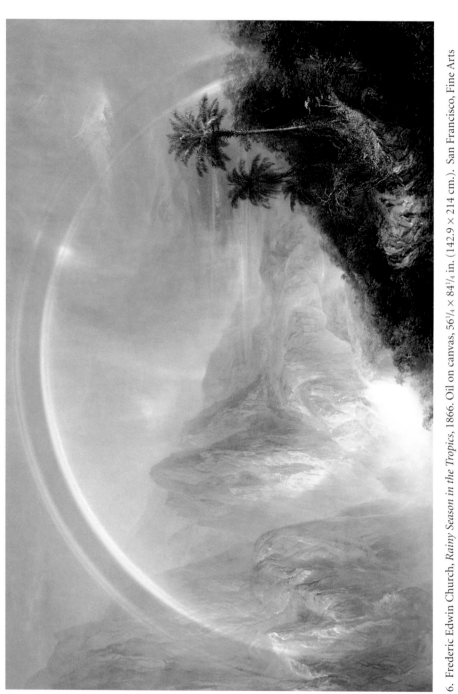

6. Frederic Edwin Church, *Rainy Season in the Tropics*, 1866. Oil on canvas, 56¼ × 84¼ in. (142.9 × 214 cm.). San Francisco, Fine Arts Museums of San Francisco.

7. Winslow Homer, *Croquet Scene*, 1866. Oil on canvas, 15⁷/₈ × 26¹/₁₆ in. (40.3 × 66.2 cm.).
Chicago, The Art Institute of Chicago.

8. Winslow Homer, *Sunset Fires*, 1880. Watercolor on paper, 9³/₄ × 13⁵/₈ in. (24.8 × 34.6 cm.).
Greensburg, Pa., Westmoreland Museum of American Art.

9. Winslow Homer, *The Turtle Pound*, 1898. Watercolor over pencil, 14¹⁵/₁₆ × 21³/₈ in. (38 × 54.2 cm.). Brooklyn, N.Y., Brooklyn Museum.

10. Winslow Homer, *Early Morning after a Storm at Sea*, 1902. Oil on canvas, 30¼ × 50 in. (76.8 × 127 cm.). Cleveland, Ohio, The Cleveland Museum of Art.

11. Winslow Homer, *West Point, Prout's Neck*, 1900. Oil on canvas, 30¼ × 48¼ in. (76.8 × 122.6 cm.). Williamstown, Mass., Sterling and Francine Clark Art Institute.

12. Albert Pinkham Ryder, *Jonah*, ca. 1885–95. Oil on canvas mounted on fiberboard, 27$\frac{1}{4}$ × 34$\frac{3}{8}$ in. (69.2 × 87.3 cm.). Washington, D.C., Smithsonian American Art Museum.

13. Albert Pinkham Ryder, *The Flying Dutchman*, completed by 1887. Oil on canvas, 14¼ × 17¼ in. (36.1 × 43.8 cm.). Washington, D.C., Smithsonian American Art Museum.

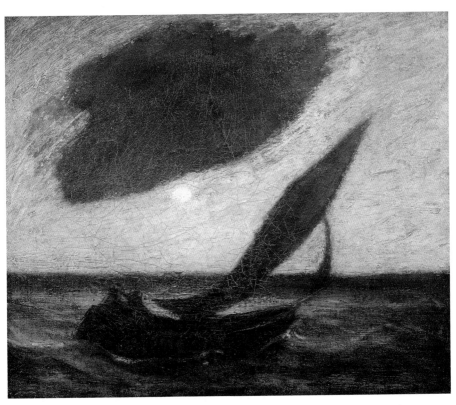

14. Albert Pinkham Ryder, *Under a Cloud*, ca. 1900. Oil on canvas, 20 × 24 in. (50.8 × 61 cm.). New York, The Metropolitan Museum of Art.

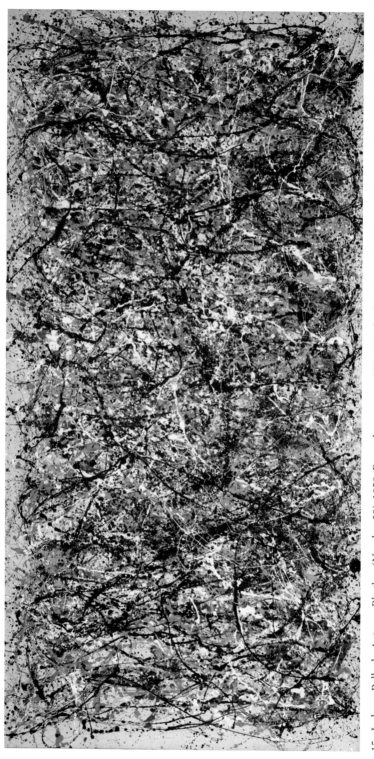

15. Jackson Pollock, *Autumn Rhythm (Number 30)*, 1950. Enamel on canvas, 105 × 207 in. (266.7 × 525.8 cm.). New York, The Metropolitan Museum of Art.

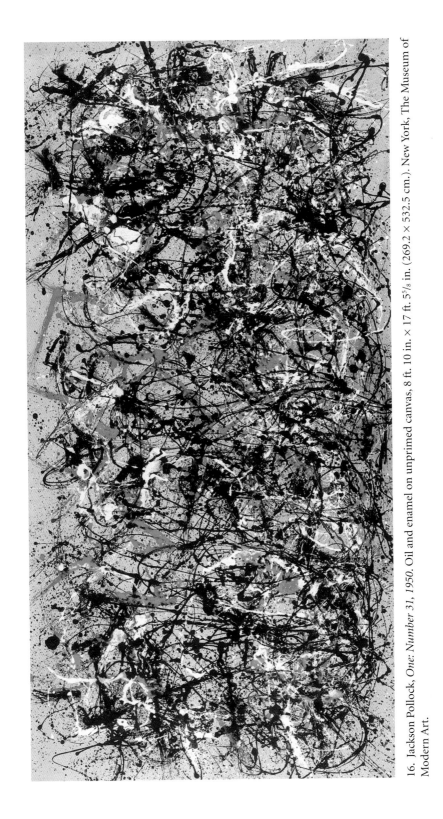

16. Jackson Pollock, *One: Number 31, 1950*. Oil and enamel on unprimed canvas, 8 ft. 10 in. × 17 ft. 5⁵/₈ in. (269.2 × 532.5 cm.). New York, The Museum of Modern Art.

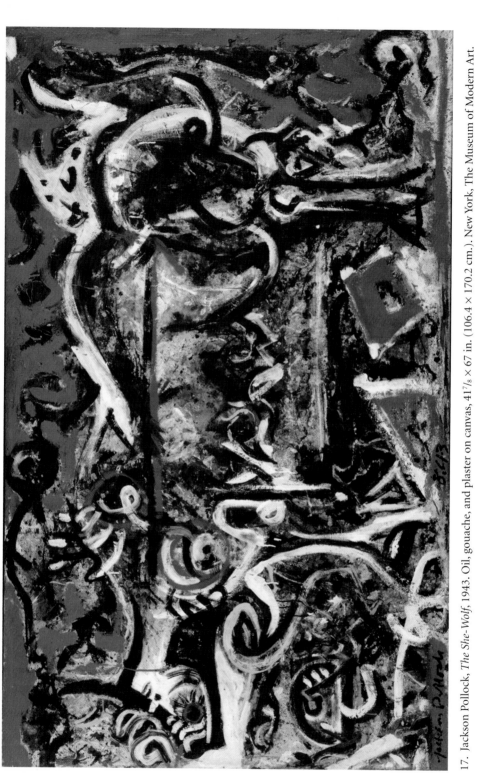

17. Jackson Pollock, *The She-Wolf*, 1943. Oil, gouache, and plaster on canvas, $41^{7}/_{8} \times 67$ in. (106.4×170.2 cm.). New York, The Museum of Modern Art.

Whitman and Church: Transcendent Optimism and the Democratic Self

The chief circumstance which has favored the establishment and the mainte-
nance of a democratic republic in the United States is the nature of the terri-
tory that the Americans inhabit. Their ancestors gave them the love of equality
and of freedom, but God himself gave them the means of remaining equal
and free, by placing them upon a boundless continent. . . . In the United
States not only is legislation democratic, but Nature herself favors the cause
of the people.

—Alexis de Tocqueville, *Democracy in America*[1]

The paradox of democratic idealism has been called insoluble, but that is
only if one tries to open the knot and dissolve the contradiction.[2] It is not so
much a question of solving a paradox as of tolerating it. Or, as Whitman
and Church have proved, of transcending it.

But to speak in this instance of transcendence, and specifically of the
transcendent national optimism—a complex sublimation involving ideal-
ism, denial, inspired obtuseness, a forward impetus, and a selective reading
of the past—is to enter dangerous territory.

It is of course a cliché that American optimism—its furious, transform-
ing, and regnant powers—had a dark underbelly. The source of that opti-
mism has been frequently examined, composed as it is of the idea of progress,
of Enlightenment reason, of social justice, of messianic urges and open ho-
rizons. If the ideal of "America" has been challenged in many ways by
postmodern thinking, a post-9/11 America further clarifies the schism be-
tween utopian and dystopian views of the future. The notion of transcen-
dental benefits is either encouraged or compromised by these views, and

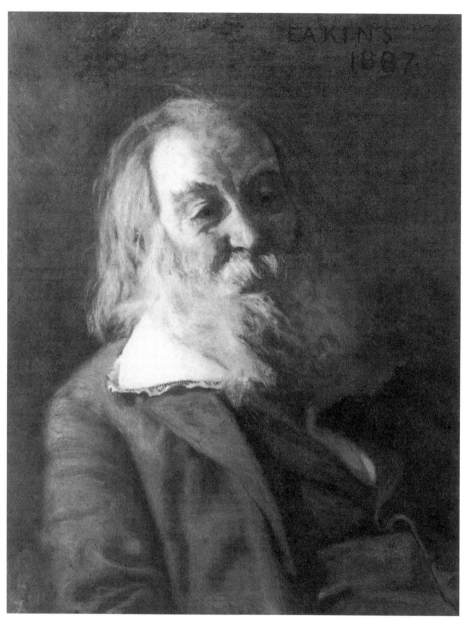

4.1 Thomas Eakins, *Walt Whitman* (*1819–1892*), 1888. Oil on canvas, 30¹/₈ × 24¹/₄ in. (76.5 × 61.6 cm.). Philadelphia, Pennsylvania Academy of the Fine Arts.

with many, the idea of transcendental blessings draws a swift hostility certain of its target. And perhaps in some ways it should. How does one weigh—and on what moral scales—the benefits of the transcendent American optimism against the sufferings embedded inseparably in its matrix? We now know more sharply than we ever did that in history, as in life, everything must be paid for. How do we estimate the cost of one of the most extraordinary social constructs in history—the unique transforming dynamic of American optimism? How much has American culture paid for its obtuseness and opacity, both at home and abroad?

We know better than we did the cost of transcendentally inspired optimism. It can be perceived as made up of unquestioned conventions, economic greed, moral hypocrisy, religious arrogance, spiritual yearnings, and noble impulses. There is always, I suppose, a degree of self-absorption in the transcendental impulse. The rocket goes up. Few watch the smoking debris below. The forces that raise it up are now clearer to us. So is the rhetoric in which that transcendent optimism was expressed—a rhetoric which is a persistent strain in our culture. Which brings me back to Whitman and Church, two figures of rhetorical genius but very different in their projection of the national ideals their work sustained.

Why consider these two figures together? Because both generate nationalist constructs that circulate powerfully into the communal rhetoric of how the United States perceived itself at mid-century. Both combine intense microscopic vision with illimitable vistas. Both witnessed the national blight of the Civil War. The ambitions were vast—Whitman subsumed his country through tactics that border on effrontery; Church decided to annex South America as a virgin territory of wonders in which the United States could see its own imperial face. Both of them, world-swallowers, were—miraculously—successful. For any investigation of the optimistic democratic self, they offer a highly productive pairing.

Whitman, who of course proclaimed, "I am large, I contain multitudes,"[3] is famous for his multiple personae: democratic poet and essayist, critic, printer, editor, carpenter, nurse and healer, hustler, dandy, homosexual, possible bisexual, lusty man among men, howling his barbaric yawp (fig. 4.1).

To counterbalance the idea of the affirmative "celebratory" Whitman, some recent critics have drawn attention to his tragic side, in much the same way that some have pointed to the public and private Emerson. The personal tragedy was surely there, especially in the disappointments, as

Whicher has pointed out, of the love and death crises around the time of the Calamus poems.[4] Yet if Whitman acknowledged a "me and not-me," he chose for his national democratic self—as Emerson did—the transcendent optimistic "me." This was the "me" that coincided most with the national vision embraced by his culture, supported by a rhetoric that often went so far as to deny any evil, even death.

It was the "me" embraced also by Church, whose egoistic "me" covered—like Whitman's—a continent (fig. 4.2). Church's persona is less varied, yet he was, like Whitman, as much adventurer and entrepreneur as artist, a creator of theatrical spectacles, offering high art in a populist mode, through a vehicle derived as much from popular panorama as from the elevated tradition of history painting. Whitman, at a level of sophistication unavailable to Church, was the more outrageous, the more overtly Dionysian. Yet both drew their energies from the deepest of generative and creative wells—in Whitman's case overtly sexual: "Urge and urge and urge; / Always the procreant urge of the world."[5]

The vistas opened by Church and Whitman project us onto a stage far grander in scope and ambition than the empirical nominalism of Copley and Edwards, and far again from the pellucid transcendentalism of Lane or Emerson at his most ideal, though there are connections between this aspect of Emerson and the transcendental "hysteria" of Whitman.

Whitman characterized the paradoxes of democratic selfhood in *Leaves of Grass* when he wrote: "One's-Self I sing, a simple, separate Person; / Yet utter the word Democratic, the word *En-masse*."[6] This duality between the individual and the group is the paradoxical essence of democracy as practiced in the United States. The individual, the irreducible self, is exalted, supreme, yet an equal unit of the community. Each role's demands are not easily compatible, especially in a culture that celebrates individual excess—when successful.

How to balance or sustain the one in the other in a way that violates neither? Complex forces are at work here: The exceptional is resented, yet desired; the powers of conformity suppress, yet welcome, acceptable transgressions. But irrespective of their talents, in terms of their rights, all men are created equal. Democratic politics promises that each has an equal vote and thus possesses an equal share in the democratic state. Each is, in that sense, an indissoluble part of the state. The individual's vested interest in

4.2 Matthew Brady, *Frederic Church*, ca. 1860. Carte-de-visite. Olana, N.Y., Olana State Historic Site, New York State Office of Parks, Recreation and Historic Preservation.

the state is thus of the highest order—an investment of self. As Tocqueville put it, "[A]s the American participates in all that is done in his country, he thinks himself obliged to defend whatever may be censured in it, for it is not only his country that is then attacked, it is himself."[7] This is true of any democracy. But exceptional energies are devoted to this self-consciousness in the United States. The idea of the democratic self in America, as manifested in the works of Church and Whitman, thus involves the uneasy and obvious paradoxes of the individual ego and the multitude.

How is the idea of nationalism perceived and worked out by and through these two artists? How did they intend it to be received by their democratic fellow-citizens?[8] Beyond nationalist politics, some matters of spirit or religion implicate their work in the problematic realm of the cosmic and transcendental. As Whitman writes in *Democratic Vistas*, "[A]t the core of democracy, finally, is the religious element."[9]

That element is not so much parochially religious as spiritually transcendent. Both Whitman's and Church's work aspires, ultimately, to that transcendent "heaven" with an easy and supple reach, a reach that seems to be implicit in the American concept of democracy. There, deceptively masked, may still reside the paradoxes, suppressions, and contradictions they have, through strategies of brilliant denial and sublimation, attempted to escape. How is this elevation accomplished? The answer must include the ways in which the personae of the two artists—how they see themselves as avatars of a democratic ideal—interact with their works. An unimpeded circulation would seem to flow from persona to creative process to work to public audience, and back to persona again.

This circulation involves not only a spiritual coefficient but the two bodies as represented by their owners—the two-hundred-pound body of Walt Whitman, nakedly proclaiming its glory, its breath, the beating of its heart, the movement of blood and air through its lungs, and Church's more modest corpus, borne on a mule through South American extremes of territory and climate, the artist-explorer at risk on his magnificent mission of retrieval. Specific, palpable, and tangible, these bodies are subsumed—aggressively and consciously in Whitman's case—as rhetorical fictions. Whitman's body stretches across the firmament, the synchrony of its processes and organs an image of the ideal social body. Church's tiny figure, laboring in a vast, alien landscape, which he consumes leaf by leaf and mile by mile, is also

delivering a continent. Both artists, then, use their secular bodies to create a persona capable of stretching across a cosmos, cosmos being a word particularly relevant to both men's work.

We are presented here with a curiously anthropomorphic transcendentalism. Church's slow physical crawl through the South American landscape has an analogue in what the mid-century critic James Jackson Jarves called his "labor trail," the way his brush registers his passage through the work. This physical presence, this assertion of himself as witness and executor, is *identified* (to use Whitman's term) with the affirming ego, an ego that Freud reminds us is "first and foremost a bodily ego, not merely a surface entity but itself the projection of a surface."[10]

Art-historically what we speak of as *touch*, a quality isolated by Delacroix in his *Dictionary*, is often seen as expressive of the individual self, though we must allow for the school and period circumstances of style as well. With Church, the presence of this touch, subdued as it may be, counterposes another esthetic to the smooth effacements of his luminist colleagues.

Whitman's sense of touch was, predictably, more direct. "What is less or more," he asks us in *Song of Myself*, "than a touch? . . . I merely stir, press, feel with my fingers, and am happy / To touch my person to some one else's is about as much as I can stand."[11] Whitman's body being, of course, the "canvas" on which he exercises this touch in his typical, inclusive, shrewd, and quasi-narcissistic ecstasy. Perhaps we can identify this touch as well with Freud's bodily or skin ego—that unique separate self, equal among equals, which is subsumed, in one of Whitman's supple leaps, from any particular to any available generality. From blades of grass, or leaves of trees, he quickly extends his reach to the celestial: "I believe a leaf of grass is no less than the journey work of the stars, / . . . And the tree-toad is a chef-d'oeuvre for the highest / And the running blackberry would adorn the parlors of heaven. . . ."[12]

Whitman however, always returns to the specifics of place and nation. Before the eternal *last stop*, *all out* is sounded by the conductor of the celestial train, Whitman will call out the inventories of place for which he is so famous, including Mannahatta, linking it in the same line with the cosmos: "Walt Whitman, a kosmos, of Manhattan the son."[13] In these bewildering shifts of perspective, Whitman creates his rhetorical space through abrupt juxtapositions, microscopic details, airy distances, and continental vistas—strategies, in fact, shared by Church in his paintings.

Church's Manhattan was centered in his studio at 15 West 10th Street, but he was, unlike Whitman, in no way an urban artist.[14] Church's "Cosmos" was, in part, Alexander von Humboldt's book of the same title, which in its combination of botanical and geological detail with vast panoramic vistas appealed to Church's vision and confirmed his view of a world in which God was immanent. Even without Humboldt—given his other readings—I believe he would have conceived his canvases as great consuming spaces.

The physical journeys of both men—where they transported their bodies—are in part functions of their different arts. Church, well before the avant-garde era, identified the new with the new subject, the new and virgin landscape, where he worked beyond the margins of the known, as did Bierstadt, Moran, and the Western photographers shortly thereafter. The artist-adventurer, whatever the hardships, *went there.*

Church's two journeys to South America exposed him to punishing extremes of hot and cold climate, from the tropical Magdalene (fig. 4.3) to the snowy heights of the Andes. Noble reports on his dizziness and nausea in the Andes, his seasickness in the Arctic, where he managed to collect those compelling sketches that resulted in *The Icebergs* of 1861 (fig. 4.4), as popular in chromolithograph reproductions as the original was when first exhibited in the United States and England. Physical sacrifice on the part of a tough and seasoned adventurer certified the authenticity of the witness and of the work.

Whitman, for all his *adhesiveness* to his male comrades, was a softer, lazier fellow, with more androgyne than macho in his persona. Was he, in fact, like Ryder, largely androgynous? Some who knew him personally saw womanly characteristics: "his pinkish white skin, his soft eyes, his pristine flowing beard, his generally gentle manner."[15] David Reynolds observes that Edward Bertz commented: "[A]lthough many ignorant persons took Whitman for the most complete example of manliness, the poet was a woman in all respects except anatomy."[16] Yet he postured in a manly way about his modest travels and may have colluded with early critics of *Leaves of Grass* in the deception that he had ranged far afield—equally at home on "Kanadian" snow-shoes, with the ice-boat fleet, on a Texas ranch.[17] He was a "comrade" of Californians years before he actually traveled West. When he did, he recorded his comfortable train trip in *Specimen Days*. He liked, as he often said, to loaf. Yet to fault him for this is also to misunderstand the needs and demands of poetry, which flourishes in a kind of potent idleness that to the unsympathetic seems lazy or self-indulgent.

4.3 Frederic Edwin Church, *Scene on the Magdalene*, 1854. Oil on canvas, 28¼ × 42 in. (71.1 × 106.7 cm.). New York, National Academy Museum.

4.4 Frederic Edwin Church, *The Icebergs*, 1861. Oil on canvas, 64½ × 112½ in. (163.8 × 285.8 cm.). Dallas, Texas, Dallas Museum of Art.

Just as Church's canvases could be seen as a great maw into which vast landscapes were sucked by a powerful creative attraction, Whitman's self-image possessed a similar assimilative energy—an energy with a relentless, obsessive, indeed sometimes violent character. His sense of the unity of all things within the persona he had manufactured was a transcendent fiction. By identifying the landscape with his continental body he could incorporate within himself "gneiss, coal, long-threaded moss, fruits, grains, esculent roots."[18] The bard's spirit, Whitman continues, "responds to his country's

4.5 Frederic Edwin Church, *Wild Sugar Cane, Jamaica*, 1865. Graphite, brush and oil paint on thin paperboard with orange backing paper, 11⁵/₁₆ × 11¹⁵/₁₆ in. (28.7 × 30.3 cm.). New York, Cooper-Hewitt, National Design Museum, Smithsonian Institution.

spirit.... [H]e incarnates its geography and natural life and rivers and lakes."[19] But before taking that final transcendent step into eternal nature (a nature he saw as the older brother of democracy),[20] he traverses the various states of the nation in a typical litany in which naming is an act of possession: Mississippi, Missouri, Ohio, Virginia, Maryland, Massachusetts, Maine, Texas, Florida, California, Oregon, extending even to Mexican and Cuban seas. "When the long Atlantic coast stretches longer and the Pacific coast stretches longer [the bard] easily stretches with them north or south. He spans between them also from east to west and reflects what is between them."[21]

But the figure projected in this extraordinary figure of speech is accompanied by another, involving, as usual, paradoxical changes of scale. For Whitman also says, "I am he who walks the States with a barb'd tongue, questioning everyone I meet."[22] We have the doubled perspective of the poet walking across his own spread-eagled continental body. And what kind of person is walking? In the Preface to *Leaves of Grass* his answer preserves this doubled perspective: "Here is action untied from strings necessarily blind to particulars and details magnificently moving in vast masses. Here is the hospitality which forever indicates heroes.... Here are the roughs and beards and space and ruggedness and nonchalance that the soul loves."[23] He paints a swaggering image of *himself* as hero, nonchalantly rough and bearded, ruggedly traversing a limitless space—an image that spoke to and across subsequent generations with an irresistible power. The nation was a projection of his own democratic self, or he a projection of its. As Rob Wilson has suggested, he was "the singular yet interpellated embodiment of the American whole."[24] As Whitman said, "The United States themselves are essentially the greatest poem."[25] All, in the end, is language.

As perhaps we could say of Church—all in the end is painting. Despite the different imperatives of the two media, the ambitions—and the strategies designed to implement them—are not dissimilar, particularly in the conception and construction of space. The swiftness and range of images available to language are not immediately available to depiction. But painting, like poetry, can address the spectator by orchestrating a variety of modes in a single painting, from the intimate detail or incident to the mood of the painting's final synthesis. Within that mood or effect a variety of details call for attention and, in the case of Church, emancipation. This balance between the detail and the general effect was perhaps the major esthetic issue discussed in mid-century landscape painting in America. Church's major

works cannot be discussed without a discussion of this matter, which in-volves, as does Whitman's poetry, a kind of double occupancy by the reader/spectator.

The panoramic extensions of Church's major paintings encourage the viewer to embrace the length and width of the painting by a gesture that resembles that of Vitruvian man searching for the limits of his body (fig. 4.6). It also recalls Whitman's "Within me latitude widens, longitude lengthens,"[26] and his claim that "If I worship one thing more than another, it shall be the spread of my own body, or any part of it."[27] At the same time, the spectator is drawn into an eager inventory of the painting's details and seduced into its atmospheric depths. Several forces are in operation, which subsequently engage in an intriguing dialogue (see plate 4).

This experience could be both confusing and exhilarating, and so it was for at least one of Church's contemporaries. Two years after *Heart of the Andes* was painted, Mark Twain wrote to his brother of "the most wonder-fully beautiful painting which this city [St. Louis] has ever seen." After de-scribing the "birds and flowers of all colors and shades of color, and sunny

4.6 Frederic Edwin Church, *The Andes of Ecuador*, 1855. Oil on canvas, 48 × 75 in. (121.9 × 190.5 cm.). Winston-Salem, N.C., Reynolda House, Museum of American Art.

slopes, and shady corners, and twilight groves and cool cascades" he went on: "I have seen it several times, but it is always a new picture—*totally* new— you seem to see nothing the second time which you saw the first. We took the opera glass, and examined its beauties minutely, for the naked eye cannot discern the little wayside flowers, and soft shadows and patches of sunshine, and half-hidden bunches of grass and jets of water which form some of its most enchanting features."

His first visit had been disappointing, but after he had returned several times: ". . . your third visit will find your brain *gasping* and straining with futile efforts to take all the wonder in—and appreciate it in its fulness [*sic*]. . . ." Then, attempting to synthesize his impressions, he compares the effect of the picture when he is before it and then absents himself: "You will never get tired of looking at the picture, but your reflections—your efforts to grasp an intelligible Something—you hardly know what—will grow so painful that you will have to go away from the thing, in order to obtain relief. You may find relief, but you cannot banish the picture—it remains with you still. It is in my mind now—and the smallest feature could not be removed without my detecting it. So much for the 'Heart of the Andes.'"[28]

It is always difficult to retrieve the visual habits of previous generations before their artworks, which we, of necessity, see differently. Twain, however, records exactly the agility demanded by Church in creating a situation where detail and effect create a distraction between two modes of perception, between the "smallest feature" and the "intelligible Something."

What do the figures in Church's paintings do? They pause to contemplate; they make their way to one or another of the few crosses to appear in American landscape painting; they labor up and down trails, confined in their immediate environs. There they serve as surrogates for the spectator, bringing him or her into intimate relation with the meticulous profusion of natural details. From a distance, engulfed in the vast masses of sublime space, they are simply anthropomorphic points in an equation that adds up to infinity. Like Twain, the spectator can isolate and follow them through an opera glass or rolled telescope of paper, plotting his or her own course through the landscape, spying, like some remote God, on his creations. Then return to apprehend the entire panorama through which he or she has journeyed by proxy, in one assimilative stare. This doubled occupancy of the work is sometimes tripled because the artist's ambiguous presence, as both impresario and guide, is coaching responses through the esthetics of the sublime

and the exotic. These are identified, in a complex series of transactions—a vast regressive leap through the virgin landscape—with Creation. And through that ultimate destination, which haunted Americans in several disciplines, with the national Self.

We thus see here the powerful expression and inflection by Church of a nationalist rhetoric, a rhetoric that confirms the providential privileges of the United States. And all this is accomplished through a *foreign* landscape.

The identification with the specifics of place—even *South* American landscape in Church's case—was thus extended by Church and Whitman to a nationalism that rewarded the citizen's investment in the democratic state signaled by Toqueville only a few years earlier. "Come," says Whitman, "I will make the continent indissoluble; / I will make the most splendid race the sun ever yet shone upon; / . . . I will plant companionship thick as trees along all the rivers of America, and along the shores of the great lakes, and all over the prairies; / . . . For you these from me, O Democracy, to serve you, *ma femme* / For you, for you I am trilling these songs."[29]

This song to America was a paean to democracy, his *femme*, often his mother: "And thou America, / Thy offspring towering e'er so high / . . . Thou Union, holding all, fusing, absorbing, tolerating all . . . / With all thy wide geographies, manifold, different, distant, / Rounded by thee in one— one common orbic language / One common indivisible destiny for All."[30] As Irving Howe has suggested: "Only perhaps in Whitman do the publicly democratic and personally sublime achieve a fusion."[31] America, an extension of his own democratic self, flowing out from him and back into him, would fuse, absorb, tolerate all.

In *Democratic Vistas* in 1871, Whitman made it clear that mere political means, superficial suffrage, legislation were not enough to realize the democratic promise. Though some critics have seen this as a savage criticism of the country at that particular time,[32] he projected a future democracy that would fulfill his assimilative dreams. He did so with an extraordinary burst of rhetoric that generated enough heat and light to absorb all contradictions. "The true nationality of the States," he wrote, "the genuine union, when we come to a mortal crisis, is, and is to be, neither the written law, nor . . . either self-interest or common pecuniary or material objects—but the fervid and tremendous IDEA, melting everything else with resistless heat, and solving all lesser and definite distinctions in vast, indefinite, spiritual, emotional power."[33]

He then went to work resolving possible contradictions between this powerful guiding Idea and individual freedom, between once again the particular and the general. In doing so he elaborated the quintessential notion of the democratic self, potently framing its irresolvable paradox in an image of "completeness in separatism, of individual personal dignity," an idea, as he put it, of "perfect individualism . . . that deepest tinges and gives character to the idea of the aggregate. For it is mainly or altogether to serve independent separatism that we favor a strong generalization, consolidation."[34] Does this language betray the stresses put upon it to fuse irreconcilables? It is in the nature of rhetoric to persuade, which presumes an audience, and Whitman's audience was clear to him—every democratic citizen residing within the nation's—and Whitman's—body. The rhetoric flattered every citizen. Insofar as it did, Whitman was a political poet, running in some celestial election and soliciting voters far into the future and as yet unborn.

His insistence that democracy was the best, perhaps only, fit and full means to be "the formulator, general caller-forth, trainer, for the million,"[35] and especially for immortal souls, adds a proselytizing, missionary fervor to his democratic call. He was on one level voicing a nationalistic doctrine of manifest destiny that was familiar especially in antebellum America. But that attitude had defined American thought from the very beginning—the Puritan founding of the New Jerusalem. It has continued, with better and worse results, into our own time and frequently beyond national borders.

If democracy was the best system, the argument has often been, then America, with patriarchal transnationalism, owed it to the rest of the world to share that privilege. This was firmly stated by James Batchelder in an 1848 publication, *The United States as a Missionary Field.* Utilizing the matriarchal form of the nation's gender, Batchelder paints a picture of Church-like amplitude: "Its sublime mountain ranges—its capacious valleys—its majestic rivers—its inland seas—its productiveness of soil, immense mineral resources, and salubrity of climate, render it a most desirable habitation for man, and all are worthy of the sublime destiny which awaits it, as the foster mother of future billions, who will be the governing race of man."[36] The voicing of this curious nationalist concept of global responsibility may explain much American foreign policy up to the present.

Whitman's and Church's overt (and in the case of Whitman, swaggering) nationalism privileges that part of the self invested in the state. Their postures

can thus be seen as emblematic of the national will. Their works not only embody but codify the imperial potential of this democratic self. It is perhaps this nationalist aspect (matriarchal or patriarchal depending on one's gender politics), with its expansionist potential, that explains Church's annexation of the South American terrain—a kind of artistic Manifest Destiny. We could perhaps speak of it also, more charitably, as a form of hemispheric solidarity, an extension of the implications of the Monroe Doctrine, a New World fraternity that allows for such annexation because it is, so to speak, all in the family. Yet the fact remains that Church painted a South American landscape, *Heart of the Andes*, and delivered it to the North American public much in the manner of a *national* landscape, and that it was perceived in much this way. What else could explain its mode of presentation in New York City in 1864, at the Metropolitan Art Fair held by the Sanitary Commission, where it was crowned by the portraits of the first three presidents of the United States: Washington, Adams, and Jefferson?

Nationalism, a dynamic synthesis composed of mythic, economic, racial, and political determinants, is, however, subject to repeated stresses and, occasionally, to radical fractures. The national agony of the Civil War, to which both Church and Whitman responded in different degrees, has in recent years been summoned to cast a retrospective shadow on art produced during its course. Some scholars have found references to this national trauma in the landscape painting of the era. Wilmerding, for example, has tied Heade's great storm paintings to the war for the entire decade spanning it, and Sarah Cash after him has also invoked the war.[37]

The habit of reading landscape paintings produced during, and in the vicinity of, the Civil War, as texts that register its effects has now become so widespread as to be somewhat problematic. What is striking about some revisionist scholarship is its eagerness to donate to works of art contents that might, to say the least, surprise their makers.

While this mode of inquiry has its advantages in sophisticated hands, its excesses (often Freudian in nature) have tended to compromise its practice. Social and political inquiries have brought us many insights we might not otherwise have had. But ideological readings imposed from without, from predetermined points of view, can abuse the past while charging that it is impossible to reconstruct it—thereby licensing often strikingly imaginative excursions into the restless vistas that compose the unedited past. What is

ignored here is the nature of the artistic enterprise, no matter how brilliant the attempt to situate it in its political, economic, and social context.

Such practice often leaves little room for the ambiguities, contradictions, and strategies implicit in the creative act, which remain more or less legible in the artwork, an artwork, however, that is now rarely read for such. I believe that what we *first* read in the work of art—a reading which must of necessity be as much formal as contentual—must be *confirmed* by its context, not the reverse. To harness the work of art into service as a convenient illustration of historical events—the dates of which sometimes have little to do with the gestation of the work itself—or to impose upon it personally or politically expedient ideas of interpretation is to do it a disservice. Just like the artist or artwork under scrutiny in the past, we are confined in our historical moment, in the accidents and myths of our own era into which we may have imperfect insight.

It is remarkable and, I feel, significant, that *direct* evidence of Civil War concerns in American landscapes at large is scanty. The American landscapists tried to keep the painful and less beautiful aspects of existence at bay. One has to go to Brady and photography to confront the brutality of the War between the States. The different responses in painting, photography, and literature are in part a function of each medium's nature. But most of the interpretations regarding painting's involvement, some quite astute, are only circumstantial. The question is: How does a landscape represented as synonymous with national ideals, in which God is immanent and a privileged future assured, register the impact of a national tragedy? A tragedy that, unless it could be assimilated into this optimistic and idealized program, would destroy the sense of privilege and cast a darkness over the American destiny?

The issue has generated interesting arguments. Angela Miller, following up on suggestions by Franklin Kelly, sees in Church's major works—especially in the *Cotopaxi* of 1862—a consistent redemptive program that reflects the impact of the war on Church's thinking[38] (see plate 5). While I agree that the war threatened the complex convergence of God, nature, and destiny that produced the rhetoric of the nationalist self as embodied in Church's work, I find the evidence with regard to the volcano paintings too indirect. Miller further contends that Church's *Rainy Season in the Tropics* of 1866 "celebrates the miraculous healing of the nation's war wounds in the language of nature" as seen in the rainbow and offers a "postwar ritual of

renewing the covenant" through "a symbol of national rebirth"[39] (see plate 6). The existence of several sketches for this composition on the back of a letter from his mother dated January 15, 1863, several years *before* the end of the war, makes this reading problematic.[40] Church's endless vistas, reformulated sublimity, exotic journeys, and volcanic obsession, which absorbed him as early as 1853, refer as much, and in my view, more, to the myths of Creation and the search for the undefiled landscape.[41]

Undoubtedly, Church's vision was threatened by several factors of which the Civil War was one. His work can be seen as resisting the crisis of faith by turning back the Darwinian clock that announced that the time for his vision was passing by. He and his audience continued to aspire to Easter Sunday and Paradise even after Darwin's *On the Origin of Species* was published in 1859.[42] His reluctance to abandon his faith as Darwinian theories took gradual hold is evidenced by those revealing shelves of his library stacked with books attempting to reconcile religion and contemporary science.[43]

There is no doubt that the decades of the sixties and seventies rudely ushered in a crisis of confidence in the culture at large, which was met with the usual responses of denial, assimilation, negotiation, and reaction. Every field—science, philosophy, religion, politics, economics, and sociology—registered changes that were forcing choices that the more homeostatic preceding decades did not demand. Assigning each of these changes its degree of influence in composing the zeitgeist is hazardous. All of them deeply tested the rhetoric of nature that Church had identified with the national purpose, tested, in fact, the Christian nation's Protestant beliefs and ethics. The war, I feel, was not as important an influence on landscape painting as Darwin's ideas, which slowly advanced in the last quarter of the nineteenth century. If the Providential blueprint had been demolished, if God was no longer in the landscape, where was He? And since most American landscapes prior to *Origin* were produced and informed by the sense of God in nature, why continue to paint them?

When Church did choose to address the national crisis, he did so directly, as in his famous clearly identifiable Civil War painting, *Our Banner in the Sky* (1861). It is one of the rare excursions in Church's work into overt metaphor and synecdoche for specific and patriotic purposes. The flayed and tattered flag is identified with a stormy night sky, its stripes doing double duty as clouds. A grouping of stars shows through a gap in the clouds, one brighter than the others as if pointing to a new rebirth, a new Jerusalem. A

4.7 Frederic Edwin Church, *Our Banner in the Sky*, 1861. Oil paint, over photomechanically produced lithograph, on paper, laid down on cardboard, 7½ × 11⅜ in. (19 × 28.9 cm.). Chicago, Terra Foundation for American Art.

convenient tree trunk does duty as a flag-pole. Over it, a bird (eagle? dove?) spreads its wings. A gesture of aggression? reconciliation? A scarecrow-like bush on the left mimics a figure pointing to the fiery distance. This is a remarkably potent image, which is not compromised by the banality of the idea. Anticipating Perry Miller's felicitous phrase "Nature's nation," nature is indivisibly identified with the country's flag, and vice versa. A relay shunts rapidly from sky/flag to war, to nation, to Christian purpose, to God, to nature, to destiny (the bright star), to return again to initiate what is basically a cyclical sign system. Set in a desolate landscape, it posits a soldier raising his eyes to a vision that would confirm the future victory as well as the survival of the rhetoric of Church's much larger public paintings. As its sales in chromolithograph testify, it gave those safely behind the lines an opportunity to identify with that fictive soldier (fig. 4.7). A far more interesting painting than it at first appears, it conflates Church's patriotic beliefs into what would have been, if a bit more subtle, a brilliant epigram, but its situation in Church's oeuvre remains largely exceptional. Church was after

even bigger game than that offered by the tragic human circumstances of the War between the States. One cannot overemphasize the cosmic and transcendent ambitions to which his paintings testify, nor the enormity of the self to which those ambitions refer.

In contrast to the painters, who had a vested interest in maintaining the Deity in the landscape, Whitman seems to have accepted readily enough Darwin's revelations, accommodating them for his own purposes to an idea of evolution that would aid America's development toward a better world. Traubel quotes him on "Passage to India": "There's more of me, the essential me, in that than in any of the poems. There is no philosophy, consistent or inconsistent in that poem . . . but the burden of it is evolution—the one thing escaping the other—the unfolding of cosmic purposes."[44] Whatever his frequently expressed doubts, Whitman would not allow them to detain him from expressing the grand nationalist vision. Whitman of course had an element of irony that was entirely foreign to the painters. God and irony do not go well together in a painting. But in Whitman, the changing perspectives of ironic distance do not for long deflect the rhetorical vision.

Whitman experienced the agonies of the Civil War directly while nursing the wounded at the Patent Office in Washington, observing the endless amputations that characterized Civil War surgery. But only a few years later, in an extraordinarily telling formulation, he professed to see "sin, disease, deformity, ignorance, death, etc." as "local considerations."[45] Thus, in a transcendental mode, he denies to these plagues any universal status. Nowhere in his thinking is the frequent distraction between experience and the ideal so sharply contrasted. Ultimately, like the painters, his assimilative vision accommodated all to a universal spiritual wholeness that was, in essence, good. So he could write: "For I do not see one imperfection in the universe, and I do not see one cause or result lamentable at last in the universe." And "I will show that whatever happens to anybody it may be turn'd to beautiful results—and I will show that nothing can happen more beautiful than death."[46] Thus he gave himself license to offer healing analogues to Church's Unionist rallying cry in the *Banner* with such lines as "Over the carnage rose prophetic a voice, / Be not dishearten'd, affection shall solve the problems of freedom yet, / Those who love each other shall become invincible. . . ."[47]

The profundity of the great death poems—"When Lilacs Last in the Door-Yard Bloomed" and "O Captain! My Captain!," mourning his fallen commander in chief—goes far beyond Church's vision in the *Banner*. A

lesser-known poem, "Reconciliation," extends to all victims a transcenden-
tal democracy: "For my enemy is dead, a man divine as myself is dead, / I
look where he lies, white-faced and still in the coffin—I draw near, / Bend
down and touch lightly with my lips the white face in the coffin."[48]

Writing of "The Sleepers," David Reynolds has noted Whitman's "dialec-
tical process of engagement with the negative . . . followed by incessant re-
iteration of the hopeful or the richly human. . . ." And also, his "affirmation
of renewal in the face of annihilation" and "vision of universal rebirth
[which] shows that the poem itself has had a restorative function."[49]

Reynolds, observing Whitman's engagement with the ideas of Mesmer-
ism, Spiritualism, Swedenborgianism, and Harmonialism, has been one of
the few critics to acknowledge the way in which *Leaves of Grass* embodies
the spiritual attitudes of its contemporary American culture. He notes very
compellingly: "If the piety of Whitman's poetry was so clear to many of his
contemporaries, why was it lost from view in much later commentary on
him? Part of the explanation lies in the prevailing interest in the erotic and
the psychological in our post-Freudian age. Many have preferred to con-
template Whitman as Oedipal father-hater and mother-lover or Whitman
as homosexual rather than Whitman as religious seer."[50]

The affirmative spirituality of that earlier culture helped Whitman to
transform his personal "I" or "me" into the all-subsuming national self with
which he hoped to heal his democratic nation. If Emerson was America's
Hindu Evangelist, Whitman strove to be its trance-led medium for national
health and well-being. His transcendent optimism was, at times, like that of
the landscape painters, a denial of evil, at times an acceptance of its exist-
ence, but a refusal to allow it to win the game, that game he claimed to be
"in and out of." The ambition, like Church's, was gigantic, cosmic, an affir-
mation of the self that pushed so far out into time and space that it tran-
scended even those limits.

Thus Whitman's restorative affirmations, reconciling all differences, could
now be carried to the next way-station for the transcendentally impelled
democratic self—the national mandate derived from the God-given boun-
ties of American nature, that nature being of course the citizens' certificate
of inheritance that they were God's chosen people. If the democratic self
was both cumulative in its particulars and assimilative and expansive in the
aggregate, then Transcendentalism, as both philosophy and religion, allowed

it to penetrate the smallest and subsume the largest. For those who came in contact with it, the rhetoric developed by Church and Whitman could be of practical use.

This telescopic vision—reversing perspectives—was intrinsic to the nationalist rhetoric of both men. Whitman enumerates each leaf of grass. Church exhausts himself, we are told, painting each separate leaf in *Heart of the Andes*. Both inventory details with an obsessive passion, each naming and depiction an act of possession. God, to use Ruskin's phrase, is in the details. Whitman's endless litanies become incantatory and bardic, so that the trivial is given a kind of ecstatic halo: the growing sugar, the yellow-flower'd cotton plant, the rice in the low moist field, the long-leave'd corn, the delicate blue-flower flax, the dusky green of the rye as it ripples and shades in the breeze. Church paints endless sketches of similar details that exhibit the Creator's profusion: a corn plant, tropical vines, wild sugar cane (see fig. 4.5).

Church's details are reconstituted within the large synthetic compositions that parallel Whitman's all-consuming expansiveness. There they are recombined; space, time, and geography rearranged to transcend the literal and act as emblems for the most comprehensive idea of place. *Heart of the Andes*, the critics said, stood for all of South America.

Tuckerman had of course insisted that the artist, as suggested above, must offer both detail and general effect[51] and praised Church for achieving this in *Cotopaxi*, an idea related to—but not quite synonymous with—the mid-century categories of the Real and the Ideal. What is remarkable is the amount of energy devoted in esthetic discourse to the reconciliation of these apparently exclusive concerns. There is an easy—perhaps too facile—path to democratic dilemmas here. The detail must not, no more than the individual, usurp the overall effect or good; yet each detail—or individual—must be allowed to maintain its integrity. In the voids and spaces of great distances all contradictions are resolved, and distance, like time, projects its perspectives into the unknown. There resides the ideal with which the real is carefully brought into an alignment that preserves both.

An equally important esthetic issue was, as we know, the presence—or absence—of the artist in the work. Allowing God to remain in the details, Church discreetly maintains his own presence by incorporating his "labor-trail" into the space, synthesizing, generalizing, controlling, taking on God-like powers. No such polite prescriptions of modesty inhibit Whitman: "I

inhale great draughts of space; / The east and the west are mine, and the north and the south are mine."[52] And also: "I know I have the best of time and space, and was never measured, and never will be measured."[53] Whitman's theology, doubling back as usual, returns to augment the self: "Nothing, not God, is greater to one than one's self is."[54]

God-like, Church and Whitman share a mutual concern with primal energies. Church taps the volcanic energies of Cotopaxi, Sangay, Chimborazo. Whitman shamelessly invokes the sexual energies that give life. "Sex contains all," he writes, "bodies, souls, / Meanings, proofs, purities, delicacies, results, promulgations, / Songs, commands, health, pride, the maternal mystery, the seminal milk. . . . / These are contain'd in sex as parts of itself and justifications of itself." The sexual energies subsume a nationalistic mission as well. "I pour the stuff," he says, "to start sons and daughters fit for these States. . . ."[55]

Some might also see a sexual burst in Church's volcanoes, if only as a commonplace of the romantic era, despite the fact that from all available evidence, the mid-century American painters were phenomenally chaste, as befits those involved in the task of depicting the national, God-given mission.

The making of the world and the making of man are again the large and small of it. Both artists, in their concern with beginnings, are exercising the Adamic properties of the democratic self. Whitman claims: "I speak the pass-word primeval, I give the sign of democracy."[56] "I, chanter of Adamic songs."[57] Church's critics note that he shows in *Heart of the Andes* "a knowledge of the roughening and smoothing of the earth by the powers which haunt its sunless caverns and contend upon its face . . . an apprehension of the process of landscape *making* by the instrumentalities of the Creator."[58] Church so penetrated the generative energy of the volcanoes that his critics spoke of his recognition of the "manner and method of nature" in her volcanic aspects.[59] Whitman proclaims, "Thus we presume to write, as it were, upon things that exist not, and travel by maps yet unmade, and a blank. But the throes of birth are upon us. . . ."[60]

Formally, of course, Whitman's Adamic inclinations are more actively utilized. He writes on blank, he says, as he originates his own form of blank verse. Church, with pictorial references to Turner and Claude, incorporates within his works an art historical past. But in their subjects, and in their implicit meaning, both Whitman and Church seem urged toward beginnings and, even more, toward that eternity that lies beyond beginnings and

waits ahead, diffuse and amorphous in the future, allowing the lists and litanies of details to unravel expansively into it, a future perhaps described by Maurice Merleau-Ponty as "not prepared behind the observer" but "a brooding presence moving to meet him."[61]

We come then to the last way-station of the transcendental democratic traveler, who, like Whitman and Church, allows the bodily ego to accompany him on his journey. Time is the medium of travel, but it is a time strikingly unconcerned with the past, despite Church's pictorial nods to art history and some brief lip service by Whitman. The disheveled past is forgotten in the urgent rush to the future. Time unravels, is propelled toward the future by a cumulative expansive, motion best defined as process. "The fruition of democracy . . . ," says Whitman, "resides altogether in the future."[62] That future has its roots in the Transcendental All, in an eternal absolute that existed prior to beginning. In Whitman's words: "Afar down I see the huge first Nothing, I know I was even there."[63] There the future, at once alpha and omega, resides, having collapsed all its presents and pasts. That future awaits the democratic self, as Whitman has it, an isolated self, which through its noiseless operation, enters "the pure ether of veneration," reaches the "divine levels," and communes with "the unutterable."[64] It is there that Whitman's rare cosmical artist-mind can be lit with the Infinite, an infinite made brilliantly clear by Church's celestial light. There too, we can contemplate the quiet meaning of Whitman's words: "The clock indicates the moment—but what does eternity indicate?"[65] The exhilaration of the rhetoric, like American optimism itself, consumes in its heat what is antagonistic to it.

Leslie Fiedler has insightfully seen in Whitman a duplicity that he found "peculiarly American," a "double-ness of our self-consciousness, which our enemies too easily call hypocrisy, but which arises from our belief that what we dream rather than what we are is our essential truth."[66] Both Church and Whitman believed their dream and included in it their idea of eternity.

Thus did the idea of eternity that Whitman, Church, and the democratic community they created and embodied most readily find a way to subsume the frictions, ironies, and ambiguities of their daily existence. As a route toward transcending even the essential democratic paradox of "I" and *en masse*, eternity offered the most attractive prospect.[67] Cleaving to the idea of eternity, they could assimilate the growing encroachments and pollutions of technology, celebrate the dead martyrs of the Civil War, even attempt to

rationalize the unsettling prospects of a Darwinian world of chance and, perhaps even more, deal with existence on a still new continent where the footing was for both cultural and natural reasons, precarious. Eternity offered not only a future, but a home, perhaps even a refuge, an ideal resting above and beyond the world's cares.

Any definition of that eternity would also include the definition of the democratic self described in *Leaves of Grass* to whom "the converging objects of the universe perpetually flow."[68] Whitman counseled: "See ever so far, there is limitless space outside of that / Count ever so much, there is limitless time around that."[69] That limitless space and time also reside in the atmospheric distances of Frederic Church.

Yet, perhaps fittingly, Whitman might have the final word. "Even for the treatment of the universal, in politics, metaphysics, or anything," he wrote, "sooner or later we come down to one single solitary soul."[70] Thus he returns, it would seem, to the paradoxical core of the democratic self, and having leaped over the paradox, delivers that self intact.

CHAPTER 5

Homer and James:
The Pragmatic Self
Made Concrete

Like Boston it is primarily a state of mind.
　　　　　—John Elof Boodin, "What Pragmatism Is and Is Not"[1]

Winslow Homer and William James were practitioners of the pragmatic self, which, as James formulated it, stressed the immediate experience and looked for concrete results. Both New Englanders came to adulthood in a post-Darwinian moment that had fundamentally changed the world they encountered. Though vastly different in temperament, their interests coincided briefly when James was starting out. James had an early urge to become a painter (fig. 5.1), studying with William Morris Hunt in Newport around 1860.[2] Five years later he was on a biological expedition with Louis Agassiz,[3] Darwin's main American antagonist. He must have known several members of Agassiz's wide circle, which included the painter Albert Bierstadt and Agassiz's friend and colleague in The Saturday Club, the ubiquitous Emerson—a friend also of William's father, Henry James Senior. William, as we know, went on to formulate Pragmatism into a leading American philosophy, though his *Varieties of Religious Experience* and his later interest in spiritual and psychic phenomena left room for a sense of spirit sadly diminished by Darwin's advent.

It has always fascinated me that American artists practiced pragmatism long before James codified it. To rehearse Harold Bloom's comment about Emerson: "His relation to both Nietzsche and William James suggests that Emersonian Transcendentalism was already much closer to pragmatism than

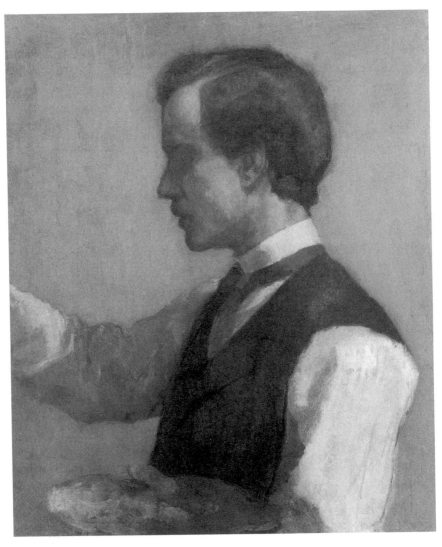

5.1 John La Farge, *William James*, ca. 1859. Oil on cardboard, $25^7/_8 \times 21^3/_4$ in. (65.7×55.2 cm.). Washington, D.C., National Portrait Gallery, Smithsonian Institution.

to Kant's metaphysical idealism."[4] This applies as well to the landscape artists of Emerson's era. Homer, following upon them, also tempered idea with the pragmatic encounter. His practice tellingly corresponds in time to the development of the pragmatic systems of James and Charles Sanders Peirce. Homer's laconic observation of the "facts" yielded work that, in contrast to his Hudson River predecessors, was primarily secular, just as William's pragmatist turned "towards concreteness and adequacy, towards fact, towards

action and towards power"[5] and "away from abstraction. From verbal solutions . . . fixed principles, closed systems and pretended absolutes and origins."[6] But James also cited—part of a recurring sense of nature in his thinking and experience—"the open air and possibilities of nature, as against dogma, artificiality, and the pretense of finality in truth."[7] This was in concordance not only with Homer's art but with the out-of-door pragmatic studies of the American landscapists who preceded him. Indeed, the enduring strain of pragmatism in American culture may serve to validate both James and his painter predecessors. The painter-pragmatists, employing a method I have described elsewhere as "the pragmatic step,"[8] also turned toward the open air, toward facts. Their "action" was a function of their ad hoc responses to "concrete" (James's word) experience.

It might seem paradoxical that that concreteness was maintained by a conceptual bias, an idea of what was perceived. Yet Giles Gunn has reminded us that even James's pragmatism "holds that ideas are not only abstractions from experience and generalizations about it but also aspects or components of it."[9] In contrast to the developing optical tradition of the European mainstream, which passed through Impressionism and ended in modernist formalism, the Americans used the pragmatic step as a form of observation that was as much knowing as seeing. The reciprocal feedback between concept and percept cued American landscapists prior to Homer, fortifying a regnant idea with the flexible plenitude of experience. In their works, light hitting on leaf, stone, and rippled water—aspects of plein-air observation that in France would lead to what Lionello Venturi called art's "autonomy"— were pragmatically observed without compromising the sacredness of nature and, implicitly, of Creation.

Darwin changed all this. From the beginning, Winslow Homer was more indebted to Darwin than has been generally recognized—not necessarily from reading him, but from embodying his ideas, as Lane did Emerson's. Post-Darwinian ideas are more overt in the late sea pictures from the mid-1880s on. But even in the '60s, Homer's art is no longer irradiated with Providential certainties. A conceptual bias still permeates his art, but it is no longer the divine mind so unquestioningly proffered by Louis Agassiz—the Mind that created species *with a thought*. It seems reasonable to speculate that a man who had reported from the front lines of the Civil War relinquished

5.2 Napoleon Sarony, *Winslow Homer taken in N.Y. 1880*. Albumen print. Brunswick, Me., Bowdoin College Museum of Art.

whatever remnants of idealism he might have possessed in the face of bru-
tal realities (fig. 5.2).

When Homer makes his first paintings in the mid-1860s, Darwinian
mutability is just beginning to be accepted by American science. In 1859,
Boston and Cambridge witness the fierce Agassiz-Gray debate over Darwin's
ideas.[10] Agassiz, Emerson's darling, with whom James, as noted above, trav-
eled in 1865, has lost. A vast tectonic change has begun. The idealisms of the
previous generation are fatally compromised. In 1865, Fitz H. Lane, whose
paintings composed the ideal visual text for Emerson's meditations, dies.
The key landscapists who survive him—Heade, Church, Kensett, Gifford,
Cropsey, Durand, and Bierstadt—continue to paint a nature solicitously
monitored by the Divine. Church, especially, spends the latter part of his
life trying to reconcile religion with post-Darwinian ideas. He is not alone
in this enterprise, which has some aspects of a threatened cottage industry.

Though the moment for Transcendental painting has passed, the ema-
nations and outpourings of light which are the very signature of earlier
nineteenth-century American landscape art do not fully disappear in
Homer's works. Rather, the metaphysical glow of luminism converts into
the more mundane glow of sunlight on objects, a light that describes and
defines as if it were a material substance. And the *thing* so described, the
solidity apprehended by Edwards and Copley, survives. Elsewhere I have
defined this property as contributing to an "American look." Antipictorial,
even antipicturesque, puritanical in its sparseness, the "look" recalls Perry
Miller's comments about the rigorously unornamented prose of the Boston
lecture. But Miller, in that same comment, had alluded to "metaphysical
assumptions."[11] We may question whether traces of these also remain.

Though advanced contemporary thinking now embodies an evolution-
ary flux (signaled by Impressionism in Europe), the time component in
Homer remains curiously stilled. This, despite the active skin of paint, which
Homer often shares with the international tradition. That paint *suggests*
process but does not carry its temporal implications. The temporal para-
doxes are compounded by Homer's relation to the European developments.

He was in France in 1867, the year of the Universal Exposition in Paris
(where he showed two Civil War paintings), as Impressionism was develop-
ing. Did he encounter any of the Impressionists? We do not know. Some
years ago, one of my graduate students placed Homer—while visiting an
American colleague—on the same street as Edouard Manet and his friends

at the Café Guerbois. Did Homer ever walk through that door? From what little we do know about his reticent character, he seems to have been more publicly gregarious in this early period of his career. He had studied at the National Academy of Design in the late 1850s and early '60s (becoming a full academician and a member of New York's Century Club in 1865) and had done his service as artist-correspondent for *Harper's Weekly* during the Civil War—situations surely involving interchanges with large numbers of people. When he left for Europe late in 1866, he traveled with a friend, the artist Eugene Benson, and shared a studio in Paris with another friend, Albert Warren Kelsey. They lived in Montmartre.[12] Which cafés did they frequent? Which artists did they meet?

Homer had the opportunity to visit the special exhibition of Manet and Courbet. He saw some of the works of the Barbizon men. But what else he saw, and what he could have known of Impressionism, remains elusive. There are occasional similarities between some of his Paris paintings and those of Degas, later—along with Homer—a favorite of Edward Hopper's. He visited the Louvre and could have known the splendid gallery of Poussins. To my mind they—along with the antecedent luminist geometries—partly account for the rigorous classic mode that defines his works from 1872 to 1874. Ever the pragmatic observer, he must have, like Americans before and after him, paid as much attention to the landscape and the people he saw in Europe as he did to the art. And some of that art, particularly that of the early Monet, probably unknown to him, shares a brief transatlantic cousinship to his early work.

Even before his trip to France, comparisons with some of Monet's early works indicate that Homer was developing his own distinctive attitude to out-of-door painting, resulting in what Baur has characterized as an indigenous American Impressionism. In coupling the pragmatic procedures of plein air empiricism with concept—translating Copley's sense of *thing*, of *ding an sich*—into weight and volume, he allowed the object's specific surface "skin," its palpable envelope, to be perceived through a painterly surface that registered the artist's "labor trail" so unhappily decried by the critic James Jackson Jarves as late as 1864.[13]

Homer would seem here to be abandoning the earlier native injunctions against stroke or touch that signals the artist's self, declares his physical presence. Nature, nonetheless, is still important to him—God's objects in nature, locally colored, are still respected. Yet in contradistinction to the

5.3 Winslow Homer, *The Old Mill (The Morning Bell)*, 1871. Oil on canvas, 24 × 38¹/₈ in. (61 × 96.8 cm.). New Haven, Conn., Yale University Art Gallery.

pre-Darwinian landscapists, in Homer's art God now recedes, relinquishing His metaphysical radiance. Where God and Nature had dominated the picture, now Art and Nature rule. Natural light, no longer iconic, still activates the ad hoc spontaneity with which Homer speckles his early figures and landscapes. Perceived through the lens of his native plein-airisme, nature accommodates pragmatic adjustments of structure that link actuality and geometry. Geometry will also help to explain the extraordinary power of the late pictures in which the sea (Melville's sea: "No mercy, no power but its own controls it"[14]) is the major protagonist. In these works, the changes in the nature of the geometry itself are as much psychological and philosophical as formal. The later geometry—heavier and weightier—carries a different message.

We are, then, dealing with two Homers. Before and after the 1866–67 trip to Paris, Homer is a plein-airiste with fascinating parallels to developments in France and also to the Macchiaioli in Italy (see plate 7). His classic figures of the early 1870s are still somewhat delicate in type (fig. 5.3). By the mid-1870s, however, they begin to grow and amplify. After his stay in the fishing village of Cullercoats, England, in 1881–82 and in the years that follow, both form and subject become monumental emblems of Darwinian struggle. With

only interludes of interruption for trips mainly to the Caribbean, Florida, and the Adirondacks, Homer spends the rest of his life, from 1883 on, at Prout's Neck, Maine, observing a sea that like Cézanne's Mt. Sainte-Victoire stimulates an obsessive rehearsal of pictorial problems. Cézanne indeed is his natural European counterpart, though it could be argued that Cézanne's work is inherently more art-like, and more revelatory of self through stroke. Nevertheless, his later art, like Cézanne's, is as enduring and solid as that of the museums, approaching the conceptual synthesis of early modernism. In this way, Homer's late work could be seen as a perfect bridge from an American tradition to mainstream European art at the close of the century. Yet the unsolved mysteries of his Parisian visit and influences continue to problematize virtually all of our knowledge about his relation to European art—as the mysteries surrounding his emotional life inflect our judgments about his transformations of self.

The myth of Homer's later reclusiveness has colored the way he has been perceived. Cicovsky rightly calls attention to Homer's early sociability: He had studios at such artistic centers as the University Building and the Tenth Street Studio Building in New York. He belonged to many clubs—not only the Century, but the Palette Club and the Tile Club. He had a large number of women friends, including Helena de Kay (sister of the critic Charles de Kay, who wrote importantly on Ryder), of whom he did a rare portrait study in 1870–71.[15] What caused the alleged psychological shift that prompted a critic, after his return from England in 1882, to speak of "a very different Homer from the one we knew in days gone by"?[16] Scholars from Goodrich on have premised a romantic disappointment, but without more concrete evidence we can only say that we now are dealing with a different self.

Ultimately, as with Copley, and to some extent Lane, Homer's self, or selves, remain an enigma. Copley was a family man, well connected, with a wide circle of friends on both sides during the Revolution. But we have not yet deciphered his mystery. The myth of Lane's reclusiveness can be challenged by scholarship that stresses his community activity in his hometown of Gloucester. Yet his self remains closed to us. Ironically, it was the occasion of Homer's second summer visit to Gloucester—Lane's back yard—in 1880 that produced, atypically, a group of proto-expressionist watercolors, signaling a change in his interior life, an emotional attitude perhaps confirmed by his decision to board in the home of the lighthouse keeper on Ten Pound Island[17] (see plate 8). This isolation, it has been speculated, was the

response not only to a possible romantic disappointment but to negative criticism of his work. Certainly, in the early 1880s, his observations of the mortal dangers of the sea for the fishermen at Cullercoats reinforced the psychological change (see fig. 5.10, p. 97). After his return from England the myth of his isolation at Prout's Neck grew. It is not an easy myth to dispel, because on some levels it remains accurate, despite our knowledge of an active family and entrepreneurial life. Copley, we remember, was a property owner. Homer became a land developer, helping his family, to which he was deeply devoted, sell lots and houses in Prout's Neck to summer visitors, even doing some of the handiwork himself.[18]

Recent scholarship has emphasized that Homer was more socialized and amiable—at least in the context of close family and friends—than has been generally believed. The family circle that surrounded him was warm and loving. His mother, Henrietta Benson Homer, a fine watercolor painter in her own right, contributed to his youthful artistic inclinations through heredity and example. Philip Beam has called his father, Charles Savage Homer—from all accounts less tortured and philosophically intellectual than James's father—"a martinet."[19] Self-absorbed, demanding, optimistic despite innumerable business setbacks, he was, after his wife died, often a companion to Homer, who cared for him in his old age until his death in 1898. Homer welcomed his company but found it at times overwhelming. For all his devotion to his family, which included his two brothers, nephews, and their wives, and especially Mattie, his brother Charles's wife, the myth of his isolation is supported by his sustained bachelorhood and joy in his chosen solitude and freedom, often with only the winter sea as companion. His pragmatic self took special pleasure in the harsh rocks, sea, and weather at Prout's Neck.[20]

If present accounts stress Homer's general wit, good humor, friendships, and family ties,[21] it is perhaps worth returning to Beam's seminal *Winslow Homer at Prout's Neck* for some testimony from his nephew Charles, referring to the summer resort months when the family was at Prout's. Beam notes: "As he [Charles] told me, Winslow had two personalities, one when he was working, another when he was off duty. When he put down his brush in the late afternoon, picked up his walking stick, whistled for Sam and went out, he was a polished, courteous, even genial gentleman. Relaxed and easy in his manner, he always greeted friends and acquaintances, often stopped to chat affably with them. . . . At his easel, on the other hand, he was

intent on his business, keyed up, and when disturbed even testy . . . his studio was his sanctuary where he could paint, think, or putter. For his family, he devised a system of identifying knocks. . . . [He] was unusually sensitive, devoted to his work during painting hours to the exclusion of everybody else, independent to the point of eccentricity. He did not like everybody and felt no particular need to pretend that he did. Through long habit . . . he came to make a fetish of privacy, even beyond his requirements for undisturbed working time"[22] (fig. 5.4).

As a serious artist, indeed, a great one, Homer placed highest priority on his art, tending to his "business" and, judging from his letters to his galleries, treating it like one. Like Lane, Homer has left scant comments about his artistic procedures and intimate feelings. Scholarship has with some justice resented this anonymity. Freud has been enlisted to elucidate Homer's attitudes toward women as read in his paintings, and this psychological path has gone so far as to translate his last obsession with the sea in sexual terms.

5.4 Anonymous American photographer, *The "Ark" & W.H.'s Studio ca. 1884*. Brunswick, Me., Bowdoin College Museum of Art.

Some accounts present a self suffering the modernist angst so familiar to us in Van Gogh and Munch.

But Homer's impersonal dignity only rarely acknowledges psychological frailties. With Homer, as with Eakins, who has received similar attention, the pressures of the inner vision, if such they be, do not distort the integument of the external world. Unlike Eakins, despite the stroke that signals his presence, the terms of that presence are unusually distant. In the sea paintings, Homer's stroke shows the *force* of the personality but does not express it. Homer's self remains impersonal. As with Copley and Lane, the idea of self is deferred, or perhaps referred to that equivocal location—*elsewhere.* In the late sea paintings, Homer's forceful style and painterly impastos emphasize the convention of painting, qualifying the thing represented with the process of representation. To the definition of Nature is added an implicit definition of the nature of Art. Though Nature by now has begun to lose some of its privileged position in American art, the concrete object survives the growing tide of painterly process.

It is but a short step from Homer's pragmatism, so evident in his attitude to the concrete, to William James's pragmatist cited earlier in this chapter, "who turns towards concreteness and adequacy, towards action and towards power." This can be applied not only to the concrete thing but to the process by which it is apprehended and recorded. James goes on to say: "At the same time it does not stand for any special results. It is a method only."[23]

Homer's method pragmatically builds the picture out of blocks of experience, monitored, as I have suggested, in a reciprocal process by concept. Again, James states it well: "Theories thus become instruments, not answers to enigmas, in which we can rest. We don't lie back upon them, we move forward, and on occasion, make nature over again by their aid."[24] Remaking, reformulating, reshaping nature through the instrumentation of his empirical responses, Homer paints the later pictures as though he were using large geometric sections—hunks—of sea, which have what Edward Hopper called "Homer's weight."[25] They are pieced together almost as a workman might, with some of the practical how-to efficiency of such predecessors as Copley and Lane. Like them, Homer would seem to be asking that familiar Jamesian query: Does it work? This is essentially the question he asks when he places a painting on the upper balcony of his Prout's Neck studio, where he can then study it from a distance of seventy-five feet and see "the least thing that is out."[26]

5.5 William James, *Portrait of John La Farge*, ca. 1859. Cambridge, Mass., The Houghton Library, Harvard University.

Early on (1860) when James was studying with Hunt, the artistic circles they both moved in (James in Newport, Homer at the National Academy of Design in New York) might have touched upon one another.[27] James's sensitive portrait, ca. 1859, of John La Farge,[28] also a friend of Homer's, indicates that he could have been a fine artist (fig. 5.5).

But James's theologian father, Henry James Sr., raised as a Calvinist and later a Swedenborgian, always railing against the conventions of religion and society, disapproved of art as a profession for his eldest son. With little

gift for intimate friendship, he counted Emerson, Alcott, Thoreau, and even Carlyle (through Emerson) as acquaintances but suffered from attacks of self-doubt that caused him to withdraw from society. He wrote his theological essays in a comparative intellectual vacuum. Subject to nervous attacks and depression (as William was after him) Henry Senior's discovery of Fourier and Swedenborg gave him a sustained reason for being, encouraging a selflessness that alleviated the pain he felt as a striving, little-recognized writer. "With no attempt there can be no failure, with no failure no humiliation," he wrote later to William, "so our self-feeling in this world depends entirely on what we back ourselves to be and do. . . . To give up pretensions is as blessed a relief as to get them gratified. . . . The history of evangelical theology, with its conviction of sin, its self-despair, and its abandonment of salvation by works, is the deepest of possible examples, but we meet others in every walk of life. There is the strangest lightness about the heart when one's nothingness in a particular line is accepted in good faith."[29]

Henry James Senior, struggling with his own disappointments and lack of self-worth, tried to control William's education and goals, to monitor his development of self. He continually interrupted his son's early education to change schools and tutors, seeing to it that he remained his son's chief role model. When William developed "a little too much attraction to painting— as I supposed from the contiguity to Mr. Hunt: let us break that up we said, at all events." He wanted William to be a scientist; "to give up this hope without a struggle, and allow him to tumble down into a mere painter, was impossible."[30]

The younger Henry James also took classes with Hunt for a while but ultimately began writing art criticism. One can still marvel at some insightful aspects of his famous criticism of Homer in 1875: "Mr. Homer goes in . . . for perfect realism, and cares not a jot for such fantastic hairsplitting as the distinction between beauty and ugliness. He is a genuine painter: that is, to see, and to reproduce what he sees, is his only care; to think, to imagine, to select, to refine, to compose, to drop into any of the intellectual tricks with which other people try to eke out the dull pictorial vision—all this Mr. Homer triumphantly avoids. He not only has no imagination, but he contrives to elevate this rather blighting negative into a blooming and honorable positive. He is almost barbarously simple, and to our eye, he is horribly ugly, but there is nevertheless something one likes about him. What is it? For ourselves, it is not his subjects. . . ."

One need not quibble with Henry James here. That he does not recognize, among other things, Homer's selective conceptualism is obvious. If he also did not like Homer's "flat breasted maidens, suggestive of a dish of rural doughnuts and pie," he did admire Homer's "great merit . . . he naturally sees everything at one with its envelope of light and air. He sees not in lines, but in masses, in gross, broad masses. Things come already modelled in his eye."[31] James was admiring (though he did not articulate it) what I have called Homer's "American look," lacking the subtleties that Henry had already discovered in Europe. Those qualities, of directness, of working in "gross, broad masses," of constructing or "sculpting" a painting out of large, simple units, would ultimately parallel methodologically the way William James conceived of using the mind: "The mind . . . works on the data it receives very much as a sculptor works on his block of stone."[32]

The directness that characterizes Homer's works would surely have appealed to William, who criticized his brother Henry late in his career for his "gleams and innuendoes and felicitous verbal insinuations." "Give us *one* thing in your older, directer manner," he wrote. "You know how opposed your whole 'third manner' of execution is to the literary ideals which animate my crude and Orson-like breast, mine being to say a thing in one sentence as straight and explicit as it can be made, and then to drop it forever." The "core" of literature, for William, was "solid." He beseeched his brother to "Give it to us once again."[33] Homer was by then already offering that solidity in his late paintings.

James the scientist would also grapple with the problem of selfhood that so eluded his father and moved the elder James finally to cultivate the idea of selflessness. Just as there were two Homers, there were, in a sense, two William Jameses. The younger James suffered from nervous depression in the late 1860s, partly a result of his father's efforts at dominance.[34] When he recovered, he committed himself to the active self described by R.W.B. Lewis: "His course lay before him: to acquire the habit of strong mental activity, for in habitual 'acts of thought' lay his salvation. . . . All 'mere speculation,' all passive pronouncements . . . are set aside in favor of thoughts conceived as actions. . . ."[35]

William's later self incorporated an awareness of the flux and change he saw in the physical world around him, and in the psychic world as well. "What we conceptually identify ourselves with and say we are thinking of at

5.6 William James, *Self-Portrait*, ca. 1866. Cambridge, Mass., The Houghton Library, Harvard University.

any time is the centre; but our *full* self is the whole field, with all those indefinitely radiating subconscious possibilities of increase that we can only feel without conceiving, and can hardly begin to analyze. . . . Every bit of us at every moment is part and parcel of a wider self, it quivers along various radii like the wind-rose on a compass, and the actual in it is continuously one with the possibilities not yet in our present sight."[36]

The conscious self of the moment, the central self, was for James "the present *acting* self."[37] James had by now (*Radical Empiricism*, 1909) read Bergson's *Evolution*, whose ideas of time and flux paralleled, influenced, or

reinforced some similar ideas in his late work, depending on which inter-
pretation one accepts.[38] Could James's image of a central self with radia-
tions quivering around it find a kind of metaphorical parallel in the image
of Homer's obdurate rocks surrounded by the brush strokes that define the
palpable waves of his powerful sea?

The William James who ultimately became a major philosopher, psycholo-
gist, and teacher, following his father's instruction by negating theory and
convention, has offered us so many words in his books, essays, and pub-
lished lectures and letters that we feel we know him better than we know
many close friends (fig. 5.6). James himself had many close friends, espe-
cially in his later years. He was genial, outgoing, gregarious, open to people
and ideas. The pragmatic self he offered was as expansive as the quivering
universe he came to believe in, in contrast to the more reserved façade that
Homer ostensibly presented to the world. If Homer in his later years was
less reclusive than his myth implies, he was still much more restricted in his
circle of intimates than was James, the scholar and teacher who, in his ma-
ture years, embraced the world.

Homer's longtime love of the Adirondack region, the source of some of
his most provocative paintings on the theme of man and nature, was one he
shared with James (both men spent time in Keene Valley), whose letters
reveal a love of the nature experience not so readily found in his more sci-
entific papers.

Homer first visited the Adirondacks in 1870 and stayed at the Baker fam-
ily farm near Minerva, New York, later the site of the North Woods Club.
Although he visited the Adirondacks sporadically over the years, his most
productive visits coincide with his election in 1888 to the North Woods Club.
He visited there in the fall of 1889 and again in 1891 and 1892 to execute the
paintings that have stimulated recent scholarly speculation. An avid fisher-
man, his watercolors of leaping trout in the Adirondacks aroused the en-
thusiasm of some contemporary critics for their truthfulness of iridescent
tone.[39] These are relatively straightforward in content, but the Adirondack
deer hunting paintings, both watercolors and oils, are less so.[40]

Contemporary observers were thoroughly aware of the cruelty and lack
of sportsmanship whereby deer were literally "hounded" by dogs into lakes
and then drowned or killed by hunters with paddles or guns. Homer did
some of his most interesting "land" paintings on the theme of hounding.

5.7 Winslow Homer, *Huntsman and Dogs*, 1891. Oil on canvas, 28⅛ × 48 in. (71.4 × 121.9 cm.). Philadelphia, Philadelphia Museum of Art.

5.8 Winslow Homer, *The Fallen Deer*, 1892. Watercolor over graphite pencil on paper, 13⅞ × 19¹³/₁₆ in. (35.2 × 50.3 cm.). Boston, Museum of Fine Arts.

Though recent critics have interpreted them as criticism of this practice, a cryptic note on the back of a watercolor of a fallen deer—"just shot . . . A miserable . . . Pot hunter"—is one of the few indications we have of his feelings, which I suspect were mixed (fig. 5.8). He probably did not deplore hunting so much as the debasement of "sport" to a form of brutal killing. The monumentality with which he depicts the young huntsman carrying a deer in his major oil, *Huntsman and Dogs*, 1891 (fig. 5.7), makes its meaning problematic. Of *Hound and Hunter*, painted at the same time and clearly dealing with deer hounding, Homer wrote in typical laconic fashion to his dealer, Thomas B. Clarke, "It is a figure piece pure & simple—& a figure piece well carried out is not a common affair." He later told Bryson Burroughs that "it's a good picture . . . I spent more than a week painting those hands."[41]

While Homer did paint some fine views of the mountain heights in such paintings as *The Woodcutter* or *Sunrise, Fishing in the Adirondacks*, there is a curious airlessness in many of the Adirondack watercolors, a hemmed-in quality that might be taken (though not too far) to be a metaphor for the trapped feeling of the doomed deer. Such paintings contrast sharply with the brilliant light and space of the Caribbean and Florida watercolors of the late 1880s and '90s (see fig. 5.9 and plate 9). Does this contrast in itself convey some sense of the harsh Darwinian nature he depicts even more explicitly and powerfully in the later sea paintings?

William James, on the other hand, experienced the Adirondacks with a blissful sense of nature's balm that harks back to the pre–Civil War days. His visits, like Homer's, date from the 1870s, and prompted frequent letters around the time in the 1890s that Homer visited the area. Of his experiences in the Keene Valley, James wrote: "There are some nooks and summits in that Adirondack region where one can really 'recline on one's divine composure' and, as long as one stays up there, seem for a while to enjoy one's birth-right of freedom and relief from every fever and falsity."[42]

James felt a need for the woods as a balance to the cerebral academic life he led, contrasting the open air life of the Adirondacks not only to academe but to the more civilized spaces of Europe. Like Worthington Whittredge earlier,[43] he was acutely aware of the differences between American and European landscape. Writing from Nauheim in 1901, he observed: "What I crave most is some wild American country. It is a curious organic-feeling need. One's social relations with European landscape are entirely different, everything being so fenced or planted that you can't lie down and sprawl. . . .Thank

5.9 Winslow Homer, *A Garden in Nassau*, 1885. Watercolor and selective scraping with touches of gouache over graphite on textured cream wove paper, 14½ × 21 in. (36.8 × 53.3 cm.). Chicago, Terra Foundation for American Art.

heaven that our nature is so much less 'redeemed'!"[44] In another letter, he referred to "what a predominant part in my own spiritual experience [scenery] has played."[45]

At Panther Gorge he spent a night in the woods, "where the streaming moonlight lit up things in a magical checkered play, and it seemed as if the Gods of all the nature-mythologies were holding an indescribable meeting in my breast, with the moral Gods of the inner life. . . ."[46] On that trip, while mountain-climbing on the "Range" trail, he lost his Norfolk jacket, a sartorial taste he seems to have shared with Homer and, later, with Edward Hopper.

Like Homer, he appreciated storms and snow, writing in 1904 from the Boston, New York and Chicago Special to Pauline Goldmark, a young friend for whom he had developed a platonic attachment: "We are rocking and stumbling along through a wild northeasterly storm. The snow is over, but the horizons disappear in the blackish gray of a frozen atmospheric jelly, while the white fields receive the trees against them as if drawn in pencil. . . . I saw

some exquisite days, the perfection of weather, in Florida, but when I came back to Boston cold, I said, 'This is my native air, and I claim it.' It is only a question of the number of weeks one shall claim it."[47]

James writes here like an artist, but Homer, the artist, writes with typical brevity, though in his winter sea paintings, like James he "claimed the cold." One short comment in an 1890 letter to his brother Charles amplifies this: "Am just home from a walk—very cold—vapor in high stringers all over the sea. I am getting in my ice, seven inches thick & clear as glass—The most beautiful day of the winter." Writing earlier (1886) to his father complaining that his stove was not large enough he noted: "I wear rubber boots & two pair of drawers—Water is scarce—I break four inches of ice to get my water. . . . P.S. Great storm last night."[48]

As Homer has left us so few words about his artistic process and theory,[49] it is at least helpful to find his account of his procedure in painting *Early Morning after a Storm at Sea*, 1902 (see plate 10), basing it on a watercolor of 1883 (*Prout's Neck, Breakers*). Homer began the painting in 1900 but could not finish it until he had had several additional encounters with what he felt to be the same moment in nature. "It will please you to know," he wrote to his Chicago dealer, M. O'Brien & Son, "that after waiting a full year, looking out every day for it (when I have been here), on the 24 of Feb'y, my birthday, I got the light and the sea that I wanted, but as it was very cold, I had to paint out of my window, and I was a little too far away . . . it is not good enough yet, and I must have another painting from nature on it."[50] Later, he wrote, "This is the only picture that I have been interested in for the past year. . . . I will now say that the long-looked-for-day arrived, and from 6 to 8 o'clock A.M. I painted from nature on this 'O'B', finishing it— making the fourth painting on this canvas of two hours each."[51]

Of *West Point, Prout's Neck* (1900) (see plate 11) Homer wrote: "The picture is painted fifteen minutes after sunset—not one minute before—as up to that minute the clouds over the sun would have their edges lighted with a brilliant glow of color—but now (in this picture) the sun has got beyond their immediate range & *they are in shadow*. The light is from the sky in this picture. You can see that it took many days of careful observation to get this, (with a high sea and tide just right)."[52]

To produce these late sea paintings, Homer worked spontaneously and pragmatically from nature within a narrow temporal window, when the

effects of light, sea, and color were precisely "right" for his purposes. There is here an attempt to "fix" a moment in time through a carefully controlled repetition of experience. With *Early Morning after a Storm at Sea* we see the fourth painting on a single canvas, each recording a process of "two hours each."

Like James's pragmatist, Homer makes experience concrete. For James, as for Homer, "The truth of an idea is not a stagnant property inherent in it. Truth *happens* to an idea. It becomes true, is *made* true by events. Its verity *is* in fact an event, a process ... the process namely of its verifying itself, its veri*fication*. Its validity is the process of its valid*ation*."[53]

Homer attempted to verify and validate his image of the sea by an elusive and difficult process of returning to a moment in time. No moment, of course, can ever be recaptured. These words as they are written have already retreated into past time. But the return to a *similar* moment, with its concomitant effects of light and air, might, through repetition of process (a process both of experience and procedure), result in sufficient reinforcement to validate the "truth" of Homer's visual statement. "Never suffer an exception to occur," James wrote, "till the new habit is securely rooted in your life."[54]

Repetition of experience, specific to the event and without exception, "not one minute before," would reinforce the "habit" of seeing that Homer

5.10 Winslow Homer, *Inside the Bar*, 1883. Watercolor and graphite on off-white wove paper, 16 × 29 in. (40.6 × 73.7 cm.). New York, The Metropolitan Museum of Art.

drew upon to produce many of the later sea paintings. But as James also noted, "There is no proof that the same bodily sensation is ever got by us twice. What is got twice is the same OBJECT. . . . "[55] He observed too that "the entire history of Sensation is a commentary on our inability to tell whether two sensations received apart are exactly alike. . . . Experience is remoulding us every moment, and our mental reaction on every given thing is really a resultant of our experience of the whole world up to that date. . . ."[56]

In trying to return to the same experience, Homer's attempts to capture the sea as object, as thing, would have been—in James's terms—a virtual impossibility, since the sea itself flowed like time. And consciousness too, James maintained, was best described as "the stream of thought . . . or of subjective life."[57]

But by repeating as far as was possible the experience of the sea in an isolated moment of light and time, by "repeating the habit," collaging time, incorporating it in levels or layers on four separate occasions onto the surface of a single canvas over the space of about a year, perhaps we might say that (at least in artistically viable terms) Homer did reverse time, hold it fast, turn moment into thing. In fixing also on the sea as object—as thing—he stilled it, transforming fluid into concrete, making palpable the impalpable. James had also written: "The sameness of the *things* is what we are concerned to ascertain, and any sensations that assure us of that will probably be considered in a rough way to be the same with each other."[58]

James's observation serves to remind us of the longstanding thing/thought awareness in American art and culture. At its most quotidian level the preoccupation with things could be seen as materialist. For Thomas Cole, the landscape idealist, Americans too much preferred "things not thoughts." Emerson too worried that things were in the saddle and rode mankind. But Emerson also made it clear, in "Nature" and elsewhere, that things and facts could be emblematic, could embody symbol and meaning.[59] James, on the other hand, sought to end the dualism of thing and thought by noting, with echoes of Berkeley, that "thoughts in the concrete are made of the same stuff as things are."[60] Thing and thought are here virtually interchangeable. All are concrete.

James observed: "The rationalization of any mass of perceptual fact consists in assimilating its concrete terms, one by one, to so many terms of the

conceptual series, and then in assuming that the relations intuitively found among the latter are what connect the former too."[61] This is eerily similar to much American artistic practice, from Copley on.

James would also seem to be almost arguing this sequence in reverse, declaring that in contrast to purely mental objects, "With 'real' objects . . . consequences always acrue; and thus the real experiences get sifted from the mental ones, the things from our thoughts of them, fanciful or true, and precipitated together as the stable part of the whole experience—chaos, under the name of the physical world. Of this our perceptual experiences are the nucleus, they being the originally *strong* experiences. We add a lot of conceptual experiences to them, making these strong also in imagination, and building out the remoter parts of the physical world by their means."[62]

Homer's late sea paintings stem mainly from this latter process, adding to his awareness of perceptual flux the concreteness of *things,* established through the strong tempering of concept. Homer's *things,* as we know, lack the specific identity of differentiated surface texture found earlier in Copley and Lane. Copley's fabrics are shiny and satiny. His tables are made of wood. Lane's sails are sewn for his ships. His water is crystalline clear and reflective. Homer's objects all have the same texture. But it is not simply that he has replaced object texture with paint. In the work of America's greatest sea painter, *water* is not *wet.* It solidifies, returning us to a kind of Lockean primary matter.

Why this extended concern with solidity, this need to transform the transient state of water into the mineral-like density of rock or concrete? In Freudian terms, there might seem to be a cathexis here, a holding or *Besetzung,* in which the psychic energy of the artist is invested in the solid state of thingness. When we identified this property in Copley, it was easy enough to attach it, through convenient historical congruity, to John Locke. Now we find it in a post-Darwinian moment—a moment brimming with pre-relativistic flux, a flux, as we have just seen, also signaled by some aspects of Jamesian philosophy, as well as by the stylistic maquillage of strokes in the painting itself.

We might query whether the object here functions to some extent, in Heinz Kohut's terms, as a "self-object,"[63] mirroring the self in a partial narcissistic fusion. But if we put psychoanalysis aside, we can perhaps ask it more simply: Is the necessity for this object, with its solid connections to a

primary tactile function—as something that can be touched and grasped—a basic and fundamental statement about existence within American culture? Was Charles Olson perhaps suggesting something like this when years later he said: "I just wish at this moment to fiercely see if truth can be said to be itself, and if possible, against I think all history except our own as a people, to be so articulate, or to have failed in being so, as to say that matter is the fourth scalar—the world which prevents, but once felt, enables your being to have its heaven. I daresay . . . for some of you it sounds like what I—it sounds to me as pragmatism"?[64]

Homer's "matter" enables his being to "have its heaven." Homer's self is reified here into a sea that is presented to us as a calcified tundra. In offering us the sea in this way, he has, of course, also halted time—freezing it like James's "sculptor," *mind*, into those solid sections mentioned earlier, removing it to that place so eloquently described by Thomas Mann, where motion was no more motion, and time no longer time.

Homer was not a frequent churchgoer. Yet he did write to his brother Charles: "I am so very thankful for all '*His Mercies*'—that I now write to you. There is certainly some strange power that has some overlook on me & directing my life. That I am in the right place at present there is no doubt about—as I have found something interesting to work at—in my own field & time & place & material to do it."[65]

James, though reluctant to deal with immortality, indicated through his interest in psychic and spiritual phenomena that he was open to the idea, as well as to the religious experience on a personal, or as he phrased it, an egoistic level. "Religion," he wrote, "occupying herself with personal destinies and keeping thus in contact with the only absolute realities which we know, must necessarily play an eternal part in human history."[66] For James, religion had to be pragmatically grounded: "I believe the pragmatic way of taking religion to be the deeper way. It gives it body as well as soul, it makes it claim, as everything real must claim, some characteristic realm of fact as its very own."[67] "Pragmatism," James wrote, "is willing to take anything, to follow either logic or the senses and to count the humblest and most personal experiences. She will count mystical experiences if they have practical consequences. She will take a God who lives in the very dirt of private fact—if that should seem a likely place to find him."[68] In his address at the Emerson Centenary in 1903, James lauded Emersonian optimism, which had "noth-

ing in common with that indiscriminate hurrahing for the universe with which Walt Whitman has made us familiar. Emerson's revelation, he found, was that "the point of any pen can be an epitome of reality; the commonest person's act, if genuinely actuated, can lay hold on eternity."[69]

Eternity, for James, lay somewhere within the concrete. It was what we might call a pragmatic eternity.

Mircea Eliade has written of stones as hierophanies, which manifest the sacred: ". . . they reveal power, hardness, permanence . . . above all, the stone *is*, it always remains itself, it does not change—and it strikes man by what it possesses of irreducibility and absoluteness, and, in so doing, reveals to him by analogy the irreducibility and absoluteness of being. Perceived by virtue of a religious experience, the specific mode of existence of the stone reveals to man the nature of an *absolute existence*, beyond time, invulnerable to becoming."[70]

Homer's seas, with their stonelike concreteness, point to a sacrality that lies, like Eliade's stone, "beyond time, invulnerable to becoming." In their resistance to time, they possess what Eliade has also described in sacred rocks as "reality coupled with perenniality."[71] In reaching toward that absolute, Homer's pragmatic procedures, recording solid experience moment by moment, achieved a unified possession of self and object. It was an "act" that both Emerson and James could applaud, leading him toward W. B. Yeats quoting Villiers de l'Isle-Adam quoting St. Augustine: "Eternity is the possession of one's self as in a single moment."[72]

CHAPTER 6

Dickinson and Ryder: Immortality, Eternity, and the Reclusive Self

1.

When I think of Emily Dickinson and Albert Ryder I visualize them in the uniforms of their eccentricity: she in the white gown that named her the White Moth of Amherst, he in his top hat strolling along the Bowery, admiring the silvery moonlight. She (according to her own statement) is very small. He—to judge from Marsden Hartley's memory portrait of him in his daily uniform of knitted sailor's cap and sweater—is quite large (fig. 6.1).

Small and large, they shared a remarkable number of contingent situations: both shy and called reclusive, both considered eccentric, both perceived as childlike, both with eye troubles, both born New Englanders. Both created works that were small in size and large in ambition. Both worked in the latter part of the nineteenth century (Dickinson more than a decade and a half earlier) at a time when Darwinism had placed God in doubt.

God. Or, in His place, Immortality. Eternity. These were perhaps their largest shared themes, often with sea imagery suggesting these immensities (in Dickinson's terms, *capacious*) fortified by the Bible and Shakespeare.

To consider them together enlightens us further as to the complex role of the creative self in America, a self that in this dual instance remains a New England self, but a self that also announces its presence in ways that tie it to modernist existentialism and to an earlier Gothick romanticism (both European and American) as well as to the mystic silences that inhabit luminist paintings and Emersonian transcendentalism.

6.1 Marsden Hartley, *Albert Pinkham Ryder*, 1938. Oil on masonite, 28 × 22 in. (71.1 × 55.9 cm.). New York, The Metropolitan Museum of Art.

What can their clothes, their exterior trappings of dress, tell us about them (fig. 6.2)? As coconspirators in the fabrication of a personal or public myth, clothes transmit messages not only to the outside world but to the self that they reveal, conceal, or confirm. Ryder's fancifulness, only sometimes communicated by the frock coat and top hat he reserved for gallery viewing and formal occasions, was more frequently embodied in his romantic subjects. But the simplicity of his lifestyle was of a piece with his simple daytime dress. "He dressed," said a friend, "like a workman, with old shabby clothes and a sweater."[1]

His material needs, clothes included, were minimal. The exterior world was never as important to him as the inner world of his mind. But sartorial eccentricity seems to have gone hand in hand with social eccentricity. For the last twenty years of his life his increasing withdrawal nourished a reclusive myth that still clings despite all scholarly efforts (recently intensified) to assure us that he had a devoted circle of patrons, collectors, and friends.

For Ryder, nonetheless, there was somehow a functional logic to the workman's clothes, often also a pair of slippers and overalls, in which his body ruminated. William Merritt Chase elegantly held forth in his elaborately decorated studio-salon. Ryder was an artist who worked small, close to his pictures, in a narrow space defined by masses of debris and garbage. Only the painting was sacrosanct, and even this was treated high-handedly, swiped with varnish, wiped with wet rags to bring up its luster. The artist as workman hardly needed, by his standards, to look like a dandy (contemporary paradigms such as Whistler to the contrary). And elegant clothing might presuppose viewers, of both painting and dress, who could not in any case be comfortably accommodated amidst the detritus that stamped his daily living habits on his rooms in a calendrical measure of waste. Yet why did Mrs. Fitzpatrick's housecleaning, on the rare occasion when he was too ill to resist, yield fifteen white dress shirts?[2] All, of course, dirty.

The pristine whiteness of Dickinson's legend is in sharp contract to this. Where Ryder is blind to the physical accretions of dirt and dust, Dickinson "cultivates" the myth of "snow." Purity, virginity, martyrdom. Especially the last:

> Of Tribulation, these are They,
> Denoted by the White –
> The Spangled Gowns, a lesser Rank
> Of Victors – designate –

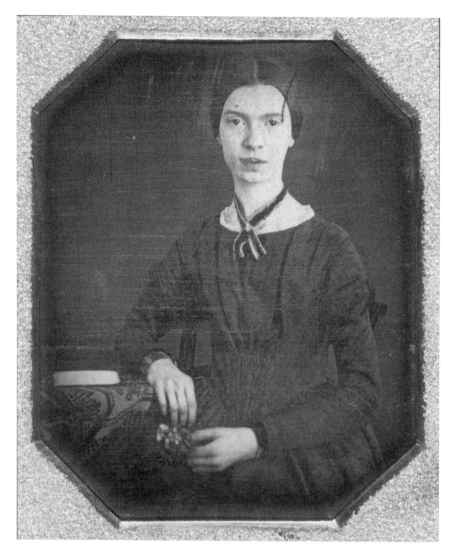

6.2 *Emily Dickinson*. Daguerreotype. Amherst, Mass., Amherst College Archives and Special Collections.

> All these – did conquer –
> But the ones who overcame most times –
> Wear nothing commoner than Snow –
> No Ornament, but Palms –[3]

Dickinson's legend indeed seems more "cultivated," even perhaps contrived. Ryder's myth grew to some extent out of his inattention, Dickinson's out of a more sophisticated awareness of others' perceptions. She had a more deliberate sense of the development of a personal myth. One feels, in many

ways, that she built her own myth not only for her public, her audience, but for herself.

Whether she really wore white all through those interviews in which she remained unseen we will never know. But her visitors, blocked by the half-closed door, had been conditioned to expect white and saw it whether it was there or not. Like Ryder, she was perceived as reclusive in the last fifteen or twenty years of her life, though she sent out letters and poems far and wide, communicating through prose and poetry, reading the *Springfield Republican* daily, part of a community in Amherst that was ever conscious of her, so that the public awareness of her withdrawal offered her the best possibility of being palpably present while absent.

The issue of their so-called reclusiveness reveals some similarities—and vast differences, partly gender related. Ryder seems to have retired almost without realizing it to that inner world that saw only the two windows and the self-romanticized "whispering leafage" of the garden outside,[4] neglecting the clothesline that strung across it and the cereal boxes and buttermilk cans that stuffed the space of his small rooms at 308 West 15th and 308 West 16th Streets in New York City much as he constricted the space in which he produced those miniature forms that contained "the storm within."[5] On some levels, he could be perceived as a victim of time, the accretions and aggregations of daily existence cramping him into ever tighter quarters.

Perhaps, however, that physical constriction was welcome, since it served further to focus him inward, to a world of thought and dream. In a few lines of a poem about Joan of Arc he speaks with Dickinsonian economy:

> Who knows what God knows
> His hand he never shows
> Yet miracles with less are wrought
> Even with a thought.[6]

To this acknowledgment of the primacy of thought Dickinson herself might have answered:

> Heaven is so far of the Mind
> That were the Mind dissolved –
> The Site of it – by Architect
> Could not again be proved –[7]

Ryder, though sophisticated intellectually, seems to have been genuinely childlike. He was never agoraphobic, a charge leveled against Dickinson.

(She has also been diagnosed as a bit anorexic—no cereal and buttermilk there.[8]) Ryder was simply, I think, single-minded. Art was all, and he never doubted his own greatness, no matter how neglected he was early on. He could deal with romantic subjects of courtly love (Chaucer's *Constance*) (fig. 6.3) and float his imagery onto a sea of imagination and eternity. He could even, like his later kindred spirit Joseph Cornell, fall into a fantasy of infatuated love with someone he hardly knew—an opera singer in one account[9] (with Cornell it was a movie teller)—and have to be spirited away by his friends,[10] of whom he had more than his myth allows.

Dickinson, on the other hand, was childlike without being truly childlike, wearing the mask of the child to keep from being burdened with the woman's role. Unlike Ryder's garbage-filled rooms, her room in her father's house (hung with paintings of George Eliot, Barrett Browning, and Carlyle)[11]

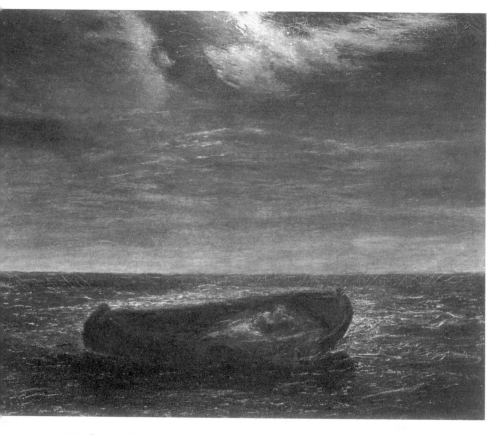

6.3 Albert Pinkham Ryder, *Constance*, 1896. Oil on canvas, 28¼ × 36 in. (71.7 × 91.7 cm.). Boston, Museum of Fine Arts.

was pristine, offering the same contrast as did her white dress to his workman's clothes. Both Ryder and Dickinson hid behind their eccentricities as a way of husbanding their energies for their art. But husbanding here is perhaps a nicely operative word, for Dickinson had to proclaim "I'm 'wife'"[12] without being wife, had to *strategize* (her word) with multiple personae to achieve her freedom. Dickinson has been accused of being something of a poseur in her white dress. But Gilbert and Gubar in *The Madwoman in the Attic* have brilliantly shown the rich multiple significations of white: virgin, bride, nun, ghost, madwoman, angel.[13]

> A solemn thing – it was – I said –
> A woman – white – to be –
> And wear – if God should count me fit –
> Her blameless mystery –[14]

The white dress was as potent a shield as the mail worn by the courtly medieval lovers who fought for their ladies. Aware—like Ryder with Chaucer—of courtly love, she became the embodiment of the Tristan legend, playing Isolde to her unknown Master, whose very existence freed her to fly as a white moth into the heavens. Her actual sources were perhaps closer in time. She used the romantic gothick literature of the women she admired—Barrett Browning's white-gowned Aurora Leigh, Brontë's Jane Eyre—as paradigms for her own sense of self and/or swoon into love.[15] That love, as sensitively defined by Denis De Rougemont in *Love in the Western World*, drew its nourishment from obstruction.

In De Rougemont's argument, the lovers' "need of one another is in order to be aflame, and they do not need another as they are. What they need is not one another's presence, but one another's absence."[16] De Rougemont finds in the Tristan legend the evidence that "the love of love itself has concealed a far more awful passion. . . . Unawares and in spite of themselves, the lovers have never had but one desire—the desire for death!"[17] They behave, he tells us, "as if aware that whatever obstructs love must ensure and consolidate it in the heart of each and intensify it infinitely in the moment they reach the absolute obstacle, which is death."[18]

If the mysterious Master to whom Emily Dickinson addressed the three letters and poems that tell us of her heart's affliction in the early 1860s was a real person, he was unattainable:

Master:

> If you saw a bullet hit a Bird – and he told you he wasn't shot – you might weep at his courtesy, but you would certainly doubt his word.
>
> One drop more from the gash that stains your Daisy's bosom – then would you *believe*? Thomas' faith in Anatomy, was stronger than his faith in faith. God made me – [Sir] Master – I didn't be – myself. I don't know how it was done. He built the heart in me – Bye and bye it outgrew me – and like the little mother – with the big child – I got tired holding him. . . . I am older – tonight, Master – but the love is the same – so are the moon and the crescent. If it had been God's will that I might breathe where you breathed – and find the place – myself – at night – if I (can) never forget that I am not with you – and that sorrow and frost are nearer than I – if I wish with a might I cannot repress – that mine were the Queen's place –. . . .[19]

Scholarship has wavered between three main possibilities for Master's identity: the Philadelphia preacher Charles Wadsworth,[20] the *Springfield Republican* editor Samuel Bowles,[21] and the more openly recognized love of her later life, Judge Otis P. Lord.[22] My own vote leans toward Wadsworth.

But it really doesn't matter. Any of the three would do. All married. Blocked. Offering her *the obstruction*. In this world at least. But not in eternity. So Emily earned her freedom through the myth of romantic love. She could hide behind it (". . . We must meet apart – / You there – I – here – / With just the Door ajar . . ."). She could leave "the Door ajar."[23] And since, as De Rougemont says, the ultimate obstruction is death, she could embrace death.

But death for Emily is hardly death. Despite the fact that she calls to mind the mourning pictures, both sewn and painted, of the earlier century, sewing her own small elegies together in tiny secretive fascicles, despite the fact that she visits graves in her mind surely every day, despite her concern with that long sleep, it is not sleep but resurrection that she is after. To Master, in the same letter quoted above: "I used to think when I died – I could see you – so I died as fast as I could – but the 'Corporation' are going to Heaven too so [Eternity] won't be sequestered – now [at all] –. . . ."[24]

Emily in her white dress reaches for the light of eternity and peoples it with her loved ones, now reunited and reassorted in Paradise, so that she is, if not the worldly wife, surely the heavenly one. A task more agreeable, somehow, since Swedenborg, who is as we know (along with American Spiritualism) partly responsible for all this, never said she had to bake cakes and clean the house up there. It is in this quiet light, this heavenly silence, that she touches upon America's spiritual soul. Finally freed of angst, disembodied.

2.

Emily Elizabeth Dickinson was born on December 10, 1830, in the college town of Amherst, Massachusetts, while her mother's bedroom was being papered.[25] Albert Pinkham Ryder was born on March 19, 1847, in New Bedford, Massachusetts, a whaling port. Ryder's residence in a house at 16 Mill Street placed him serendipitously in the vicinity of an earlier Albert, Albert Bierstadt, whose family occupied a house opposite for a while. Bierstadt, like Dickinson, was seventeen years old when Ryder was born.[26] But the two Alberts were very different. Albert Bierstadt had been born in Solingen, Germany, and returned to train in nearby Düsseldorf before finding a stimulus for his baroque giganticism in the American West.

Dickinson and Ryder, by contrast, saw—in Dickinson's words—New Englandly.[27] There is a frugal modesty in the pared-down simplicity of their respective voices that finds its equivalences in New England speech and syntax. The modesty extends as well to size, to Dickinson's almost haiku-like verses, and to Ryder's paintings, often no larger than 4 by 8 inches. Yet modesty and understatement are not necessarily incompatible with vastness. As Gaston Bachelard has suggested: "The cleverer I am at miniaturizing the world, the better I possess it."[28]

Emily could go even beyond possession. As late as September 1871 she wrote to Sue Gilbert: "To miss you, Sue is power. The stimulus of Loss makes most Possession mean."[29] Yet both Ryder and Dickinson may have been better players at possession than has been acknowledged. Reclusiveness is itself a kind of empowerment, a restriction of the outer world's access, a territorial enthronement. Dickinson's comment: "They say that God is everywhere, and yet we always think of Him as somewhat of a recluse" seems apt here.[30] And physical self-restriction, Emily's refusal to leave her father's house from the late 1860s on, could have the added value of enhancing inner freedom, artistic freedom, freedom of thought and mind. That need for a respite from outside problems deterred Thoreau from reading the daily paper (though Emily did, evidently with great interest). But once the body was stilled, held back, she could not only engage in world affairs, or read, as she did voluminously, in the Bible, Shakespeare, and the romantic gothick literature so often written by other women. Her mind could also fly into eternity, to check out heaven so that she knew the exact spot.

All this was better accomplished behind the partly closed door, with visitors carefully controlled. There seems to have been a perception of danger, somehow, in the gaze of the Other. What did sight, and being seen, mean to her?

Her seeing "New Englandly" had something to do with it. Throughout her work, in the letters and in the poems, there is a shyness, an embarrassment at revelation of the fleshly self, the organic part. In De Quincey's *Autobiographical Sketches*, she marked the phrase "For I was the shyest of children. . . ."[31] She emphasizes her own smallness, she becomes a phoebe, she worries that her lover would prefer ivory to her freckled skin.[32] The young Emily wrote to her friend Abiah Root that she expected to develop into a beauty,[33] but whether her ultimate self-image confirmed this prognosis is problematic. Yet self-effacement and shyness are often also masks for extreme self-concern, even for a narcissistic preoccupation that assumes the whole world is watching. Part of Emily's withdrawal is, in this sense, simply tied to the physicality of *being seen*. To be seen, in this way, is to become an object, and we can reasonably believe that she wanted always to remain the subject. "Perception of an object costs / Precise the Object's loss —"[34] suggests her fear of obliteration through the gaze of the Other. Lacan has referred to Sartre on this: "The gaze, as conceived by Sartre, is the gaze by which I am surprised—surprised in so far as it changes all the perspectives, the lines of force, of my world, orders it, from the point of nothingness where I am, in a sort of radiated reticulation of the organisms. As the locus of the relation between me, the annihilating subject, and that which surrounds me, the gaze seems to possess such a privilege that it goes so far as to have me scotomized, I who look, the eye of him who sees me as object."[35]

There have been suggestions that Emily's eye problems had some psychological or hysterical root.[36] Perhaps putting her own gaze at risk not only had the effect of enabling her to look inward instead of outward but included also a wish-fulfillment about the unwelcome gaze of the Other.

Ryder's affliction may have had a more genuinely organic base, deriving from a childhood vaccination.[37] Physical or psychological, however, in both instances the organic eye, afflicted, could have its outer pressures relieved by closure, and the inner eye could not only compensate but dominate. It could allow Dickinson to annex some aspects of Brontë's trances, and it could surely give the inner spirit of the imagination greater power, could allow it to

speak with a voice unobstructed by the physical world of actuality. Gilbert and Gubar tell us that eye troubles abound in the lives and works of literary women.[38] How much were these troubles flights toward the inner eye?

The inner eye unobstructed. The outer eye of the Other, the one that would direct the gaze, limited in its access to both Emily and Albert. "I could not bear to live – aloud –," she wrote, "The Racket shamed me so –."[39] "How dreary – to be – Somebody! / How public – like a Frog –."[40] Even her doctors, it is claimed, had to examine her at a distance.[41] The desire to dwindle, almost to disappear, was not so much the rather trite self-deprecating *I'm Nobody!* it might seem to be. It was perhaps an urge toward empowerment through dematerialization, part of the tropism toward spirit that drove her poetry. There is a strong dose of an older Puritanism here. As Sacvan Bercovitch has reminded us: "The Puritans felt that the less one saw of oneself in that mirror [of election], the better; and best of all was to cast no reflection at all, to disappear."[42]

Fleshly shame had as its corollary that invisibility that ensures spiritual grace. Yet her will toward spirit never allowed her completely to let go of the flesh, nor of the sensuality that lies behind her ecstasy in living: ("How good – to be alive! / How infinite – to be . . ."). Was she an American St. Teresa? Given her natural obliqueness of expression, it is hard to decipher this aspect of her constant riddle.

> Wild Nights – Wild Nights!
> Where I with thee
> Wild Nights should be
> Our luxury!
>
> . . .
>
> Rowing in Eden –
> Ah, the Sea!
> Might I but moor – Tonight –
> In Thee![43]

What are those wild nights? Are they dreams of her Master/Lover, or is it God Himself who absorbs her passion? How often, indeed, in some of the poems is she addressing the Deity in terms of a lover, or a lover in terms of the Deity? She was not pure spirit. She was more of the flesh than her myth allows for. One is reminded of Bercovitch's comment: "We cannot help but feel that the Puritan's urge for self-denial stems from the very subjectivism of their outlook, that their humility is coextensive with personal assertion."[44]

3.

Dickinson's background was thoroughly Puritan. As Whicher has noted, "in her passion for veracity, Emily Dickinson was a Puritan of Puritans. If she was unable to accept the traditional Puritan belief in the verbal inspiration of the Bible, it was for the most Puritan of reasons."[45] Yet despite her irreverence for organized religion ("Some keep the Sabbath going to Church / I keep it, staying at Home . . ."[46]), the King James version of the Bible was her close companion, and her bond with Jonathan Edwards, sharing with him even a fascination for spiders, seems a natural one: "A Spider sewed at Night / Without a Light / Upon an Arc of White. . . ."[47]

Ryder, on the other hand, was a Methodist, though we don't know how religious a one. New Bedford, however, has been characterized by Ryder's biographers as a "haven for religious dissenters, intensely pious Protestants who had left religious orthodoxy behind."[48] Many of the settlers, we are told, were "Quakers and Primitive Methodists, [who] had come down from the Massachusetts Bay Colony."[49] As with Dickinson, the Bible was an important source for Ryder, and with an almost primitive naiveté God the Father could sometimes anthropormorphize in his paintings, orb in hand, like some distant heir to a medieval manuscript. Both Dickinson and Ryder could perhaps be described as profoundly spiritual religious mavericks, sharing an interest in Biblical themes and using them in idiosyncratic and personal ways, for example, Ryder's *Story of the Cross, Resurrection,* and *Death on a Pale Horse.* (The latter, also known as *The Race Track* and referring to a waiter friend who killed himself after losing his savings at the track, brings Benjamin West's influential Apocalyptic theme closer to the modernism Ryder welcomed [fig. 6.4].)

The matter of their shared themes is a peculiar one. Why should these two artists *in small* concern themselves with the heroic history painting subjects (both Biblical and Shakespearean) of their forebears West and Allston earlier in the century? Allston had chosen gargantuan canvases to elucidate these themes. His *Belshazzar* became the bête noire of his life, rolled and unrolled like an old carpet in his studio for over a quarter century.[50] Emily's "Belshazzar" is eight lines of succinct wit:

> Belshazzar had a Letter –
> He never had but one –
> Belshazzar's Correspondent
> Concluded and begun

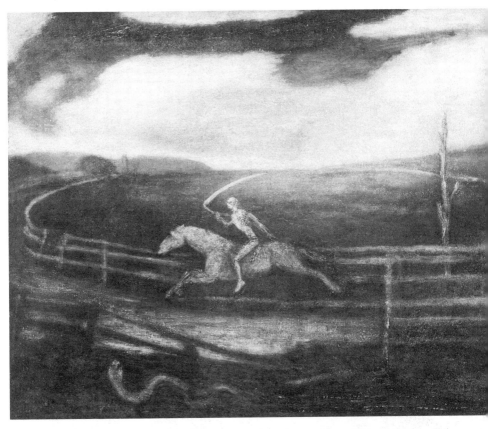

6.4 Albert Pinkham Ryder, *The Race Track* (*Death on a Pale Horse*), ca. 1886–1908. Oil on canvas, 27³/₄ × 35⁷/₁₆ in. (70.5 × 90 cm.). Cleveland, Ohio, The Cleveland Museum of Art.

> In that immortal Copy
> The Conscience of us all
> Can read without its Glasses
> On Revelation's Wall —[51]

Capps, dealing with Dickinson's reading, has suggested that Dickinson could be "impudent with the Deity" but displayed "remarkable reverence for mortal Shakespeare."[52] Like Emerson, she might have felt that Shakespeare was "like some saint whose history is to be rendered in all languages, into verse and prose, into songs and pictures, and cut up into proverbs; so that the occasion which gave the saint's meaning the form of a conversation, or of a prayer, or of a code of laws, is immaterial, compared with the universality of its application."[53]

Shakespeare comprised some of her favorite reading—*Macbeth, Hamlet, Othello* . . . In *Othello* she could find a concept of love after death similar in

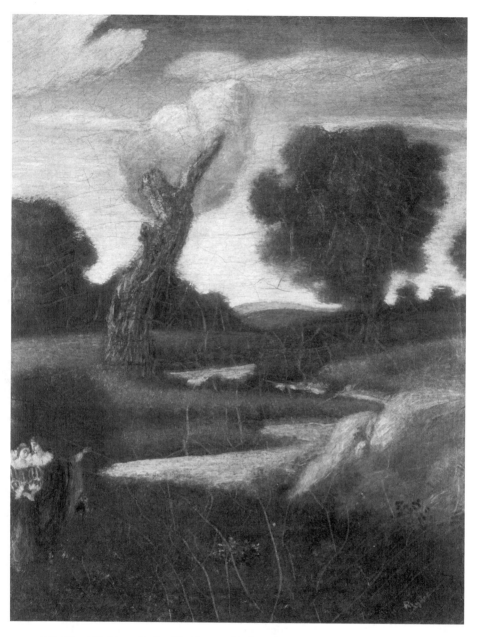

6.5 Albert Pinkham Ryder, *The Forest of Arden*, 1888–97?; reworked 1908? Oil on canvas, 19 × 15 in. (48.3 × 38.1 cm.). New York, The Metropolitan Museum of Art.

some ways to the one she so steadfastly sought, as when he tells Desdemona: "Be this when thou art dead, and I will kill thee, and love thee after."[54] Murder notwithstanding ("There's nothing wicked in Shakespeare," she is reported to have said, "and if there is I don't want to know it"[55]), Othello's comment is not so far from Emily's "What if I say I shall not wait! / What if I burst the fleshly Gate – / And pass escaped – to thee!"[56] But though there are some Shakespearean references in the poems ("'Hamlet' to Himself were Hamlet— / Had not Shakespeare wrote—"[57]), she did not allude to Shakespeare as frequently as she did a Biblical Eden or Heaven. Mostly, he was a revered muse, not only for her poetic thought, but for her life.

In accordance perhaps with the visuality of their medium, the painters used Shakespeare more graphically and specifically. Earlier, Benjamin West, participating in the Shakespeare worship of the late eighteenth century, had painted a powerful *King Lear*,[58] and Allston not too long after depicted *Macbeth and Banquo Meeting the Witches on the Heath* (1823). Ryder's own *Macbeth and the Witches*, even in its deteriorated state, suggests that like Dickinson he might have said, "he has had his Future who has found Shakespeare."[59] Ryder also painted a Desdemona, *The Tempest*, and Florizel and Perdita from *The Winter's Tale*, and drew one of his most enchanting paintings, *The Forest of Arden*, from a combination of Shakespeare's *As You Like It* and the Bronx Park (fig. 6.5).

Yet the main theme that united Dickinson and Ryder goes beyond the literary and religious tastes and subject matter of the European and American romantics, to touch upon the central signifier that contained their most profound thoughts. Keats, writing to Jane Reynolds in 1817, voiced it most succinctly: "Which is the best of Shakespeare's plays? I mean in what mood and with what accompaniment do you like the sea best?"[60]

Emily and Albert shared the sea, though she had never seen it, and he, for all his childhood memories of New Bedford, and his several sea voyages across the Atlantic, never treated it with the factual concreteness of that other New Englander Winslow Homer. What did the sea mean to them?

4.

"The beginning of man was salt sea," wrote Charles Olson, "and the perpetual reverberation of that great ancient fact, constantly renewed in the unfolding of life in every human individual, is the important single fact

about Melville."[61] The most striking word in Olson's comment is *salt*. Melville had salt in his blood, as did Homer. The sea in Ryder and Dickinson is not so much salt as space, not so much water as air, something easily reversed with sky, or curiously merged with it, despite Ryder's strong horizons. Yet Olson's comment also reminds us that the sea is renewed in each of us, part of our physical and psychological makeup, part of our most interior being. As Rilke said: "The world is large, but in us it is deep as the sea."[62] This interior depth is the kind of immensity that Bachelard has described as "a philosophical category of daydream."[63]

With this daydream, reinforced by the inner eye of solitude, both Dickinson and Ryder could use the sea as a metaphor for their most profound thoughts. For Dickinson, whose references to the sea are more numerous than most scholarship has indicated, the sea was a multiple trope that could add to the riddle she made of her life:

> My River runs to thee –
> Blue Sea! Wilt welcome me?
> My River waits reply
> On Sea – look graciously –
> I'll fetch thee Brooks
> From spotted nooks –
> Say – Sea – Take *Me*![64]

As with Ryder, who offers us more mystery than riddle, the sea for Dickinson could have figured in a general way as a universal signifier of the unconscious and, as a corollary, the imagination. In Jungian terms, we know the sea as "an image of the collective unconscious, the infinite mother nature out of which all life comes."[65] From that collective unconscious, both Ryder and Dickinson might be said to have salvaged a particular and singular concept of the sea as a vehicle for the imagination that draws heavily on the individual unconscious.

It was that imagination that turned her into a "Inebriate of Air" and "Debauchee of Dew"[66] and made of Ryder an artist so involved with his own dreams (including those of technical experimentation) that he built into his works the chemistry of their own destruction.[67] Both were insistent on the imaginative originality that caused him to claim, "The least of a man's original emanation is better than the best of a borrowed thought"[68] and Dickinson to comment, "I marked a line in one verse – because I met it after I made it, and never consciously touch a paint mixed by another person – I

do not let go it, because it is mine."[69] In each instance the artistic self is set apart by a unique expression in turn extruded from a unique imagination.

Yet for both Dickinson and Ryder, the chief signification of the sea was surely as a figure of—or route to—eternity or immortality. Claudel has written of the sea as "the eye of the earth, its apparatus for looking at time."[70] For Dickinson, and perhaps for Ryder as well, that time was infinite. In one of Dickinson's earliest known poems, written circa 1853, "On this wondrous sea / Sailing silently" she seeks the shore "Where no breakers roar – / Where the storm is o'er," and pilots the craft to "Land Ho! Eternity! / Ashore at last!"[71] By 1859: "Exultation is the going / Of an island soul to sea, / Past the houses – past the headlands / Into deep Eternity –."[72] Much later, in 1882, after her mother's death: "Eternity sweeps around me like a sea."[73] And within her own self, so multiple and fractured ("That person that I was – / And this One – do not feel the same")[74] that she herself must have had difficulty keeping track: ". . . It is a Suffering to have a sea – no care how Blue – between your Soul, and you."[75] Yet, despite the immensity of the sea, despite its vast eternity: "The Brain is deeper than the sea – / For – hold them – Blue to Blue / The one the other will absorb – / As Sponges – Buckets do –."[76] Consciousness could encompass even eternity. And with that consciousness came the possibility of an immortality of the soul, or spirit, which selected always, even in heaven, "her own society." Though consciousness could also enlist doubt.[77]

But though there was earthly pain, doubt was not voiced as often as belief, faith. A large portion of Dickinson's 1,775 poems are about the leap into immortality, an immortality she craved after the death through love that would prolong life's ecstasy, an immortality she could enter through an ecstatic spirit: "This world is not Conclusion. / A Species stands beyond – / Invisible, as Music – / But positive, as Sound –."[78] If one can make a distinction between immortality and eternity, I would call Ryder's quest in the sea pictures a quest for eternity, while Dickinson reaches more for immortality—that is, for the continued existence of her individual "I."

5.

Novalis has written: "The supreme task of education is to take possession of one's transcendental self, to be at once the 'I' of one's 'I.'"[79] Dickinson's language holds tenaciously to the "I" while dematerializing it, converting it to spirit:

The Drop, that wrestles in the Sea –
Forgets her own locality –
As I – toward Thee –

She knows herself an incense small –
Yet *small* – she sighs – if *All* – is *All* –
How *larger* – be?

The Ocean – smiles – at her Conceit –
But *she*, forgetting Amphitrite –
Pleads – "Me"?[80]

Ryder, conversely, gently strokes the painted surface in an assertion of the "I" that results in an aggregation of nurtured physicality, emphasizing not only his continued presence but the objectness of the work itself and offering to it an evolutionary and biological identity in accord with his reference to his works as his "children."

There is a rather neat Jungian (anima/animus) compensation going on here. Ryder, with his concept of the work growing from the seed—"The canvas I began ten years ago I shall perhaps complete to-day or tomorrow. It has been ripening under the sunlight of the years that come and go"[81]— has a mothering attitude to his creations, while Dickinson eschews the female role of Wife, though reaching often to Mother Sea, mother also of the unconscious and the imagination. One can identify strong androgynous elements in both artist and poet.

A later poet, Rainer Maria Rilke (christened René Maria by his French-speaking mother, who was mourning the loss of a daughter), could have been describing Ryder's process and experience when he wrote in 1903: "In the man there is motherhood, it seems to me, physical and spiritual; his procreating is also a kind of giving birth, and giving birth it is when he creates out of inmost fulness. And perhaps the sexes are more related than we think. . . ."[82]

Rilke, also reclusive, and insistent on a life of "poetic inwardness," also conceived of the work itself as a "vital fruitfulness of soul. The birth process which in a purely spiritual way the man artist enjoys, suffers and survives" (June 12, 1909).[83]

Dickinson's early "love" attachment to Sue Gilbert ("One Sister have I in our House / And one, a hedge away"),[84] who was to marry her brother Austin and live with him ultimately unhappily next door in the Evergreens beyond a hedge that Dickinson didn't cross in the last years of her life, is an

indication of androgynous instincts in her own nature. Yet even more crucial to the concept of Dickinson's androgyny was the need for the freedom enjoyed by the male artist or poet that caused her to eschew, escape, or reject the role of wife and housekeeper that might interfere with the work. Dickinson fulfilled her urge to creation through her art rather than through fleshly progeny.

Carolyn Heilbrun, writing of androgyny in Shakespeare, suggests that he "was as devoted to the androgynous ideal as anyone who has ever written,"[85] a point that might underscore Dickinson and Ryder's mutual devotion to him. In a reading differing considerably from De Rougemont's, Heilbrun sees in the Tristan and Isolde legend "an overpowering love, a metaphor for the androgynous condition, the need of a merging of the masculine and feminine with equal passion ... an equal love to which each brings an equal thrust of energy."[86]

We have few indications of the "equality" of Dickinson's mysterious love relationships. Indeed, for all we know, except in the instance of Otis Lord, they were in a sense like Ryder's, conceivably quite one-sided fantasies if indeed they focused on a real person or persons at all. But Emily as Isolde, using love as a route to death and immortality, might indeed have incorporated into this role a few kernels of the androgynous instinct toward an "equal thrust of energy."

Beyond androgyny, Ryder and Dickinson shared a situation that was at least in part existential:

> I saw no Way – The Heavens were stitched –
> I felt the Columns close –
> The Earth reversed her Hemispheres –
> I touched the Universe –
>
> And back it slid – and I alone –
> A speck upon a Ball –
> Went out upon Circumference –
> Beyond the Dip of Bell.[87]

Emily out upon circumference beyond the dip of bell was not unlike Albert and his inch worm: "Have you ever seen an inch worm crawl up a leaf or a twig, and then clinging to the very end, revolve in the air, feeling for something to reach something? That's like me. I am trying to find something out there beyond the place on which I have a footing."[88] The precariousness was exacerbated, indeed caused, by the enormity of their ambition.

Dickinson stated it quite baldly and with no apologies: "My business is Circumference," she wrote to Thomas W. Higginson.[89]

In Dickinson's lexicon (Webster's *American Dictionary of the English Language*, 1847 ed.), which she called her "only companion," circumference was defined, with citations from Milton and Dryden, as "the space included in a circle."[90] As Sherwood has pointed out, her poetic imagination alone might have sufficed for the discovery of "the figure of the circle with the mortal consciousness as the center, the extent of perception as the radius, and the area of comprehension the circumference." It was, as Sherwood claims, a felicitous discovery for "illustrating and organizing some of the themes her poetry was concerned with from the beginning."[91] Sherwood and Charles Anderson have also suggested that she might have drawn on Sir Thomas Browne, one of her (and Melville's) favorites, for the figure of the circle "whose center is everywhere, whose circumference nowhere" when she needed a definition and an image of the infinite.[92]

Yet if we turn again to Emerson's essay "Circles," which indeed she could have known through the recommendation of her early tutor Ben Newton,[93] we find him looking to St. Augustine for precisely the same figure, here specifically described as "the nature of God."[94] For Emerson, the circle was "the highest emblem in the cipher of the world." "Whilst the eternal generation of circles proceeds," he wrote, "the eternal generator abides. That central life is somewhat superior to creation, superior to knowledge and thought, and contains all its circles."[95] In "The Over-Soul," as we know, Emerson speaks of the soul that "circumscribes all things . . . contradicts all experience . . . abolishes time and space."[96] Emerson writes here of "the heart which abandons itself to the Supreme Mind," ascending "from our remote station on the *circumference* [italics mine] instantaneously to the centre of the world, where, as in the closet of God, we see causes, and anticipate the universe, which is but a slow effect."[97]

Sherwood argues withal that "Dickinson never made Emerson's leap in logic from the premise that God operates in nature to the conclusion that God and nature were identical."[98] He finds her not part of the transcendental world but of the Puritan tradition behind Emerson. To Dickinson, he claims, the "tripartite equation of God, man and nature at the heart of transcendental thought would have been inane, blasphemous and naive."[99] But Dickinson herself was hardly of a single piece, masking her multiple personae, troping her tropes, elaborating her riddles, doubting organized reli-

gion but affirming spirit, craving her place in immortality and charting her very location in the future heavens as if with a compass. She was, it seems to me, quite often precisely that blend of Puritan and Transcendental so frequently found in the American self. When she writes "There is no first, or last, in Forever, – It is Centre, there, all the time –"[100] she is very close to Emerson's soul that "circumscribes all things" and to his idea of the mind which "with each divine impulse . . . rends the thin rinds of the visible and infinite, and comes out into eternity. . . ."[101]

We speak idiomatically today of being *centered*. That centering is an ordering mechanism that can usher us into a psychological and spiritual arena of calm. As we know, Jung has seen the circle as one of several symbols, signifying psychic wholeness, which also express "the universal 'Ground,' the Deity itself."[102] "In the products of the unconscious," he writes, "the self appears as it were *a priori*, that is, in well-known circle and quaternity symbols which may already have occurred in the earliest dreams of childhood, long before there was any possibility of consciousness or understanding."[103] The circle as it relates to self, God, and the unconscious has archetypal bearing on Dickinson's "business" of the circumference.

Ryder slices his horizons out of Dickinson's circumference and fixes them onto his eternal seas. In his marine paintings he yearns toward center, for the mind to come out, as Emerson might have suggested, into eternity. Though not wholly transcendental here—his consciousness affirming its existence through the pure physicality of his paint—he nonetheless shares Dickinson's concern with the Center "in Forever . . . all the time."

With Dickinson too, had her "business" been thoroughly successful, she might not have written: "Of Consciousness, her awful Mate / The Soul cannot be rid – / As easy the secreting her / Behind the Eyes of God."[104]

6.

It is this omnipotent awe-ful God that Ryder invokes in the heavens of his *Jonah* (see plate 12), reinforcing a Gothic-Baroque rhythm (*Siegfried, Jonah, The Flying Dutchman* [see plate 13]) that links him more closely to modernist angst than to the distilled Taoist serenity of his marine pictures. For Dickinson, this may indeed have been the Puritan patriarchal God ("Himself – a Telescope"),[105] and her own St. Teresa-like ecstasies have an organic sensuality that link her also to this tragic anthropomorphic strain:

For each ecstatic instant
We must an anguish pay
In keen and quivering ratio
To the ecstasy.[106]

This organicism has been identified by Worringer in his analysis of North-ern Gothic man as a "sensuous-super sensuousness" achieved through the introduction of pathos."[107] It was only this pathos, Worringer premised, "which lifted him above his earthly limitations and his inner wretchedness; it was only in that intensification of ecstasy which culminated in the anni-hilation of self that he could experience the awe of eternity . . . his wish was to lose himself, to attain to the super-sensuous by self-renunciation."[108] Both Ryder and Dickinson share in the context of their work a unique split that relates them to the dualism Worringer found in Gothic man, interpolated from his work into modern expressionism. We could speak of it as a split within a split or, more precisely, within one half of a dualism. With each, there are some works that attain the serene spirit of the soul in its safe cen-tral harbor. But others are beset precisely by that dualism ascribed to Gothic man that "consists partly of a vague presentiment, partly of a bitter experi-ence of facts. His dualistic sufferings have not yet been transformed into reverence. He still strives against dualistic inevitableness and endeavors to overcome it by an unnatural enhancement of feeling. . . . [H]e stands as a product of earthly unrest and metaphysical anxiety."[109]

Dickinson and Ryder, fluctuating between mystic serenity and "meta-physical anxiety," rehearse in part the journey of Worringer's Gothic man. Dickinson suggests both poles in a single poem that in its last line almost literally calls up Ryder's *Jonah*.

Two swimmers wrestled on the spar –
Until the morning sun –
When One – turned smiling to the land –
Oh God! the Other One!

The stray ships – passing –
Spied a face –
Upon the waters borne –
With eyes in death – still begging raised –
And hands – beseeching – thrown![110]

But the journey also tracks back to American Puritanism, then branches to course through certain aspects of transcendentalism, or, alternatively, exits in modernist existentialism. Ryder thought of himself as a modern artist:

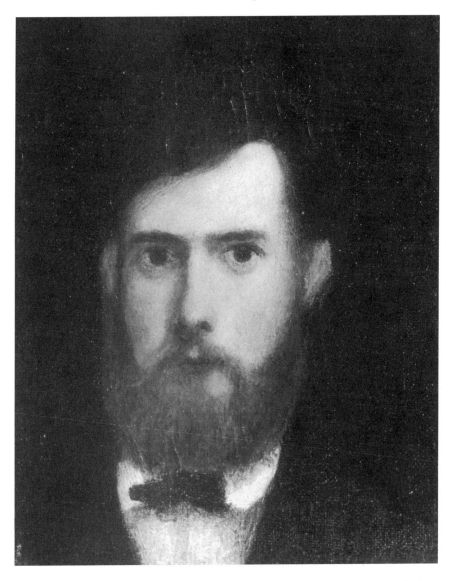

6.6 Albert Pinkham Ryder, *Self-Portrait*, ca. 1878. Oil on canvas mounted on wood, $6^1/_2 \times$ 5 in. (16.5 × 12.7 cm.). Collection of Daniel W. Dietrich II.

"Modern art must strike out from the old and assert its individual right to live through Twentieth Century impressionism and interpretation. The new is not revealed to those whose eyes are fastened in worship upon the old"[111] (fig. 6.6). The message he carried to Jackson Pollock maintained the "I" of consciousness in an Expressionist posture in which paint, stroke, and gesture implanted the artistic self into the fabric of the work. Yet one can also

read in his small boats, so silently moored in eternity, that transcendent calm Pollock achieved in the all-over paintings of the late 1940s and early 1950s. Pollock's famous "I am nature" was at once both a transcendental merger with the elements and an affirmation of the hegemony of self."[112]

Geoffrey Hartman, writing of the European romantic poets, suggests that they "do not exalt consciousness per se. They have recognized it as a kind of death-in-life, as the product of a division in the self."[113] Hartman suggests that "solitaries are separated from life in the midst of life, yet cannot die. . . . It is consciousness, ultimately, which alienates them from life and imposes the burden of a self which religion or death or a return to the state of nature might dissolve."[114] Wordsworth heals the wound of self through the latter, Hartman claims, by "'unconscious intercourse' with a nature 'old as creation.' Nature makes the 'quiet stream' flow on."[115] Yet for Hartman, ultimately, the heroism, or doom, of the solitary is in *not* obtaining a release from self.

This places Hartman's solitaries pretty much in the position of Worringer's Gothic man. "They are doomed to live a middle or purgatorial existence which is neither life nor death, and as their knowledge increases so does their solitude."[116] The writhing rhythms of Ryder's *Siegfried* incorporate a never-to-be-realized struggle for the release from self more generally recognized within the modern canon in the screaming curves of a Munch within the same decade. Some aspects of Dickinson's poetry also draw on this "heroism":

> This Consciousness that is aware
> Of Neighbors and the Sun
> Will be the one aware of Death
> And that itself alone . . .
>
> . . .
>
> Adventure most into itself
> The soul condemned to be –
> Attended by a single Hound
> Its own Identity.[117]

Yet Dickinson and Ryder give a uniquely American twist to this problematic of the self and consciousness. In some of their works, the split within the split allows an indulgence of the transcendent self in ways that subsume consciousness, making it handmaiden to the unconscious and to the imagination. Hartman sees this as a Romantic goal: "Though every age may find its own means to convert self-consciousness into the larger energy of 'imagi-

nation,' in the Romantic period it is primarily art on which this crucial function devolves."[118] In America it is Thoreau, Hartman suggests, who prescribes "unconsciousness" for his sophisticated age, and uses the word as an equivalent of vision: "'the absence of the speaker from his speech.'"[119] Thoreau's absent speaker is of course not unlike the absent self of the American luminist painters, or Dickinson's lowered voice when her more anguished "I" is absent and she is centered in circumference, incorporating silence not only into her quiet structure but into her theme:

> Great Streets of silence led away
> To Neighborhoods of Pause –
> Here was no Notice – no Dissent
> No Universe – no Laws –
> By Clocks, 'twas Morning, and for Night
>
> The Bells at Distance called –
> But Epoch had no basis here
> For Period exhaled.[120]

Nor is it far from the subdued handling of Ryder's calm seas, so smoothed by the gently stroked pigment as to become objectified and planar, losing their artistic "speaker." The transcendent silence of these works is underscored by their small size, as modest as Dickinson's simple poem:

> Silence is all we dread.
> There's Ransom in a Voice –
> But Silence is Infinity.
> Himself have not a face.[121]

7.

In the late eighteenth century, and even a fair way into the nineteenth, the profound human and religious themes embodied in the Bible and Shakespeare seemed to require epic poetry or acres of canvas, in some sort of equivalence of Grand Style with grand size. In their sustained involvement with such sources, Dickinson and Ryder announced their continuities with earlier romantics in both Europe and America, thus aligning themselves as well with the Gothick tendencies of that period.

Yet as we know, both Dickinson and Ryder approached all their themes "in small." Why should this have happened? Why should they have undertaken even the huge and mighty themes of narrative history painting within the context of the smallest possible vehicle? It would seem not only to be a question of God in the still small voice but rather a basic apprehension of

the vast imaginative possibilities of intimacy, and of the infinite realms of thought itself.

Perhaps the clue to the near-miniaturization of the structural ground on which each worked has to do with ideas of vastness best elaborated by Baudelaire, and interpreted further by Gaston Bachelard in *The Poetics of Space*.

Bachelard notes: "It is no exaggeration to say that, for Baudelaire, the word vast is a metaphysical argument by means of which the vast world and vast thoughts are united. But actually this grandeur is most active in the realm of intimate space. For this grandeur does not come from the spectacle witnessed, but from the unfathomable depths of vast thoughts."[122] Neither for Dickinson nor for Ryder was it necessary to employ gargantuan formats for vast effects. Both understood only too well "the unfathomable depths of vast thoughts." As Bachelard puts it: ". . . since immense is not an object, a phenomenology of immense would refer us directly to our imagining consciousness."[123]

We could premise, however, that the "imagining consciousness" in Ryder and Dickinson was, on some levels, impeded by the narrative anthropomorphism of literary and Biblical themes and ideas. Though those themes, reduced to thought, could contract (only to expand again into Bachelard's grandeur that "progresses in the world in proportion to the deepening of intimacy"[124]), the bodily self still intruded. In Ryder's work, it brought with it a state of "becoming" that carried in its rhythms the existential anxieties of the conscious self: the tragic humanism of imperiled souls in *Jonah* and *The Flying Dutchman*, the specific mortal pain of the suicide behind the painting from Revelation sometimes known as *The Race Track*. In Dickinson, this state can be seen in the degree to which the suffering self speaks in such poems as:

> There is a pain – so utter –
> It swallows substance up –
> Then covers the Abyss with Trance –
> So Memory can step
> Around – across – upon it –
> As one within a Swoon –
> Goes safely – where an open eye –
> Would drop Him – Bone by Bone.[125]

Memory and trance offer some relief here, but the biologically organic, the bone, is still at deadly risk, and the poet's awareness of the pain attendant on human feeling, the mortal capability of grief, is graphically potent in the idea of dismemberment bone by bone. The existential abyss is all too close.

8.

Ultimately, it was perhaps only in Ryder's Marine paintings, and in Dickinson's poems of infinity and immortality—often also using sea imagery—that each artist could come closest to a transcendent loss of self. In such works they could realize, through a stark economy of both size and movement, through absent though present voices, the full vocal tone of vastness that Bachelard finds in Baudelaire: "The word *vast*, then, is a vocable of breath. It is placed on our breathing, which must be slow and calm. And the fact is that always, in Baudelaire's poetics, the word *vast* evokes calm, peace and serenity."[126]

The stillness of Ryder's small Marines invokes Bachelard's dream world of immensity: "Immensity is the movement of motionless man. It is one of the dynamic characteristics of quiet daydreaming."[127] The quiet daydreaming of Ryder and Dickinson brought them into that inner world deep as the sea invoked by Rilke. The sea, the archetypal symbol of the unconscious, was their route through imagination and dream to the infinite and eternal, a place of stillness and calm:

> As if the Sea should part
> And show a further Sea –
> And that – a further – and the Three
> But a presumption be –
>
> Of Periods of Seas –
> Unvisited of Shores –
> Themselves the Verge of Seas to be –
> Eternity – is Those –[128]

The pared-down brevity of such poems offers both in form and content a fitting parallel to Ryder's Marine paintings:

> If my Bark sink
> Tis to another sea –
> Mortality's Ground Floor
> Is Immortality –[129]

We are ushered in each instance into the state described by Baudelaire of a man "in the grip of a long daydream, in absolute solitude, but a solitude with an *immense horizon* and widely diffused light; in other words immensity with no other setting than itself." Bachelard elaborates this further: "When the dreamer really experiences the word immense, he sees himself

liberated from his cares and thoughts, even from his dreams. He is *no longer shut up in his weight, the prisoner of his own being . . ."*[130] (italics mine).

Through the action of the paint in some of Ryder's Marines we feel an equivalent of his own weight, the continued effort of the self to escape, a struggle between the artist and the paint itself that indicates he is still the prisoner of his own being. This is true even of the rather extraordinary *Marine* in the National Academy Museum (fig. 6.7), in which not even a boat appears, only the simple horizon of sea and sky. Ryder is reaching here toward that immense horizon of the daydream described by Baudelaire. But the horizon is not quite tight enough to counteract the viscous energy of the paint separating the light of the sky from the sea. It could be the Biblical moment of Creation, the moment of separation of light from dark. But ultimately, it refers to our world, not to eternity.

In the *Moonlight Marine* in the Metropolitan (fig. 6.8), however, paint is constricted into flat planar bands that no longer carry the blood and sap of painterly energy. The self, as corollary, ceases its struggle, becomes weightless and at the same time centered, through a stabilization of the painting's structure that imposes the calm and serenity of an eternal world.

This is even more true of the *Marine* in the Carnegie Museum, perhaps the most perfect aspiration in Ryder's art to the eternal moment. We are dealing here with Bachelard's word *vast* "considered vocally," which is "no

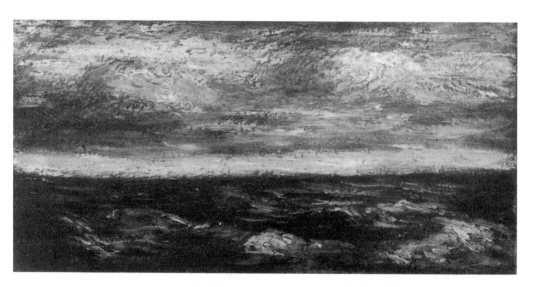

6.7 Albert Pinkham Ryder, *Marine*, 1907. Oil on wood panel, 8⁵/₈ × 17¹³/₁₆ in. (21.9 × 45.3 cm.). New York, National Academy Museum.

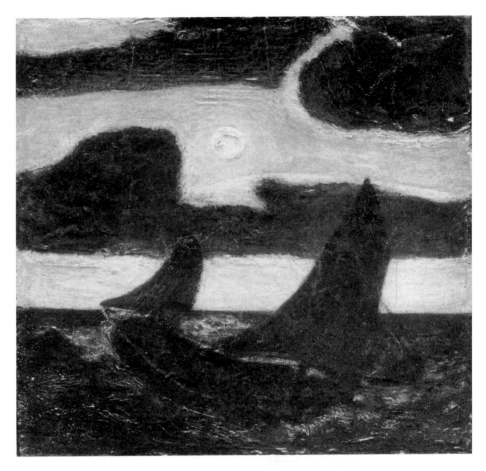

6.8 Albert Pinkham Ryder, *Moonlight Marine*, 1870–90. Oil and possibly wax on wood panel, 11¹/₂ × 12 in. (29.2 × 30.5 cm.). New York, The Metropolitan Museum of Art.

longer merely dimensional. Like some soft substance, it receives the balsamic powers of infinite calm. With it, we take infinity into our lungs, and through it, we breathe cosmically, far from human anguish."[131] Ryder's painting is precisely this: an exhalation of form which in its perfection and timelessness signals its meaning as infinity (fig. 6.9).

Such paintings are the ultimate physical incarnation of *thought*, of dream (see plate 14). They have overcome that consciousness described by Dickinson as the soul's "awful Mate" and reached that place in which, as Ryder wrote, "I have no footing." No footing is necessary within the center of this magic circle. In this vast arena the spirit floats in Dickinson's "Great Water in the West – / Termed Immortality."[132]

6.9 Albert Pinkham Ryder, *Marine*, ca. 1890. Oil on canvas mounted on panel, 12⁷/₈ × 10³/₁₆ in. (32.7 × 25.9 cm.). Pittsburgh, Pa., Carnegie Museum of Art.

Ultimately, with both Dickinson and Ryder, dream and imagination, as components of thought, are routes to the Great Water in the West, where immortality is eternal. This divine arena can only be reached occasionally, however, and the avenues are tenuous, the journey risky. Consciousness always threatens to intrude, imposing either its heroism or its doom, as the self remains fettered to its mortal preoccupations. To reach Bachelard's intimate immensity, the daydream has to get as far as possible into the imagining consciousness. Only within those vast spaces of the imagination can it accomplish Godlike miracles, in Ryder's words, *even with a thought*. In these few lines Ryder, the would-be poet, meets Dickinson on her own ground. But she might well have spoken for both of them when she wrote:

> The Soul's Superior instants
> Occur to Her – alone –
> When friend – and Earth's occasion
> Have infinite withdrawn –
>
> Or She – Herself – ascended
> To too remote a Height
> For lower Recognition
> Than her Omnipotent –
>
> This Mortal Abolition
> Is seldom – but as fair
> As Apparition – subject
> To Autocratic Air –
>
> Eternity's disclosure
> To favorites – a few –
> Of the Colossal substance
> Of Immortality[133]

Pollock and Olson: Time, Space, and the Activated Bodily Self

Many things have an epoch in which they are found at the same time in several places, just as the violets appear on every side in the spring

—Hungarian mathematician Bolyai Farkas, 1823, recorded by Charles Olson in his 1946 notebook.[1]

1.

Jackson Pollock and Charles Olson had many things in common, Herman Melville among them. Few books seem to have affected Pollock, but those that did were very significant. *Moby-Dick* was important enough for some of his paintings to have that title: *Untitled (Blue (Moby-Dick))* and *Pasiphaë* (in its original title). Possibly even more telling, he named his dog Ahab. Lee Krasner once remarked that Pollock's favorite work by Melville was *Moby-Dick*, while hers, because of the way it treated good and evil, was *Billy Budd*.[2] Is Pollock's 1945 *Portrait of H.M.* a portrait of Melville? What kinship did Pollock feel with Melville—as artist, and as man?

Olson's more profound involvement with Melville is easier to chart. Olson, author of the epic *Maximus Poems*, was one of the greatest of Melville scholars, whose imaginative *Call Me Ishmael* I find more exciting and provocative than any academic treatise on him. For Olson, Melville was a nineteenth-century prophet or forerunner of "projective space," an active principle that also fuses Pollock and Olson within their cultural moment.

Through Melville, we can also bind Olson and Pollock together in their attachment to sea places—and to other nineteenth-century figures as well. Olson's seafaring Gloucester was as central to him as was Tyre to the second-century A.D. dialectician Maximus. Olson considered Maximus and his Tyre

7.1 Jonathan Williams, *Black Mountain College, Charles Olson barechested at writing table*, 1951. Storrs, Conn., Archives & Special Collections at the Thomas J. Dodd Research Center, University of Connecticut Libraries.

"the navel of the world." If Maximus was Olson's alter ego, Gloucester was his Tyre: "Why I chose to use Maximus of Tyre as the figure of speech, figure of the speech, is that I regard Gloucester as the final movement of the earth's people. . . . The migratory act of man ended in Gloucester . . . the motion of man upon the earth has a line, an oblique, northwest-tending line, and Gloucester was the last shore in that sense"[3] (fig. 7.1).

It was also Fitz H. Lane's Gloucester.

Melville, like Ishmael, sailed "about a little," to see the "watery part of the world,"[4] and signed on to the *Acushnet* as a seaman, sailing from Fairhaven,

near New Bedford, where late in 1841 he attended services at the Seaman's Bethel on Johnny-Cake Hill. A decade later, his alleged fictional alter ego, Ishmael, began his sea journey from New Bedford, Albert Pinkham Ryder's birthplace, and proceeded along an Atlantic Ocean that beguiled Pollock, a Ryder admirer, who a century later experienced the same sea from the shore of Long Island. Overtly titled sea paintings, such as *Ocean Greyness* and *The Deep*, are only somewhat suggestive of the sea's larger importance to Pollock as a Jungian image of the unconscious that fueled his work and aesthetic, even as he tried to decipher his own personal dilemmas through Jungian analysis: "If I had to teach I would tell my students to study Jung."[5] Olson too was an admirer of Jung, including him in his famous "A Bibliography on America for Ed Dorn": "recommend, for light reading . . . mister jung. like I say (except that he ain't free to write—hides his 'creative' mss in a safe—he is the one religious i mean he is serious in his attention to the importance of life as it is solely of interest to us as it is human, like they say, of any of the new scientists of man—."[6] Since Jungian psychologists tend to privilege *Moby-Dick* as a favored subject,[7] we are back to our lynchpin— Herman Melville.

Ishmael had glimpsed "the great leviathan . . . a long, limber, portentous, black mass of something hovering in the centre . . . over three blue, dim perpendicular lines floating in a nameless yeast," in a "boggy, soggy, squitchy picture truly, enough to drive a nervous man distracted."[8] The picture on the wall of the Spouter-Inn in New Bedford might have looked forward to one by Pollock,[9] as Melville's "ambitious young artist, in the time of the New England hags . . . endeavored to delineate chaos bewitched." But that foreshadowing was only a superficial visual indicator of a far more important (and at least partly existential) self that Melville shared with his twentieth-century counterparts.

Olson also admired D. H. Lawrence's Melville, whose "bodily knowledge moves naked, a living quick among the stark elements. For with sheer physical, vibrational sensitiveness, like a marvellous wireless-station, he registers the effects of the outer world. And he records also, almost beyond pain or pleasure, the extreme transitions of the isolated, far-driven soul, the soul which is now alone, without any real human contact."[10]

Both Olson and Pollock dealt with that soul, part of a self that Pollock registered with "physical vibrational sensitiveness" in his skeins of paint, alternately angst-ridden and transcendent. Olson's Melville rode space, what

Olson called "his own space," and space, Olson claimed, was "the central fact to man born in America."[11] Pollock too rode space, as do his viewers every time they enter the boundless labyrinthian webs of his paintings. Olson saw in *Moby-Dick* an overall "space" with the properties of "projective space," a non-Euclidean space, comprised of congruence which as it developed in the nineteenth century became "a point-by-point mapping power of such flexibility that anything which stays the same, no matter where it goes and into whatever varying conditions (it can suffer deformation), it can be followed and, if it is art, led, including, what is so important to prose, such physical quantities as velocity, force and field strength."[12] Though Olson knew of Pollock's work,[13] they do not seem to have met. Yet many of his comments and ideas offer verbal parallels to Pollock's art and theory.[14]

2.

> Where is the foundling's father hidden? Our souls are like those orphans whose unwedded mothers die in bearing them; the secret of our paternity lies in their grave, and we must there to learn it.
>
> —Herman Melville, *Moby-Dick*[15]

Who were their fathers—these three men who arc from the nineteenth into the twentieth centuries and bridge art and literature so effectively? For that matter, who were their mothers? It seems pertinent that the issue of the Androgyne, as Olson called it—raised in the previous chapter with Ryder and Dickinson, and also with Whitman—arises in relation to all three: Melville, whose passion for Hawthorne was undeniable; Olson, whose anguish over sexuality fostered strange dreams of sexual transformation[16] and whose attachment to male as well as female muses and supporters endured throughout his life; and Pollock, whose machismo seems by conventional wisdom (as well as by some professional opinion) so exaggerated as to mask inclinations towards feminine impulses. Like Rilke, whose sexuality was also ambiguous, Pollock had a mother who had wanted a girl, after four boys, and kept him in petticoats and laces (which she crocheted herself) until he was three.[17] Pollock loved playing "the Mommy" in childhood games, and like his mother, when adult, baked excellent pies[18]—hardly in itself a testament to his androgyny. (Pies, however, would seem to play an interesting

part in American cultural and culinary history. Thoreau's mother, we will remember, had baked *him* pies to eat while "rusticating" at Walden.)

Melville's mother, Maria Gansevoort, cautioning her son against Original Sin and temptation, has been described as "supremely bossy."[19] Both Olson and Pollock had unusually dominant mothers, Olson's smothering her only child with overprotectiveness, summoning him with a whistle when she wanted him.[20] Both women were of Celtic stock. Mary Hines Olson's family stemmed from Cork, Ireland, where her aunt (Olson surmised from what W. B. Yeats told him as a young man) could have been Mary Hines, the blind poet Raftery's muse.[21] Pollock's mother, Stella McClure, was Scottish-Irish and German in ancestry.

The paternal figures were all disappointed men. Allan Melvill, nurturing the belief of a descent from Scottish kings, spent his life as a business failure, often in debt. At the age of eleven, young Herman had to help him move the family's belongings a step before his creditors.[22] Roy Pollock, born LeRoy McCoy, of Irish (Donegal) ancestry, had been given away by his father to the Pollock family as a child of about three after his mother's death[23] and went from one business venture to another without success, drinking heavily and sporadically leaving his family—sometimes for years at a stretch. Karl Olson, a Swedish immigrant, was a postman who got into trouble with his superiors for organizing a union. He died disappointed and bitter, unwilling to speak to his son at the end because Charles had refused to lend him a suitcase, an incident that haunted Charles Olson for the rest of his life.[24]

The filial selves resulting from these related parental circumstances shared feelings of sexual ambiguity and anxiety. Melville's experiences as a seaman (as described in *Typee* and especially in the famous *Moby-Dick* incident in bed with Queequeg), as well as his attachment to Hawthorne, indicate his openness to same-sex relationships. His awareness of failure was eloquently signaled to Hawthorne (to whom he dedicated that quintessential Man's book, *Moby-Dick*) when he wrote that were he to write "the Gospels in this century" he would still "die in the gutter."[25] Pollock's anxieties were drowned by an alcoholism that seriously affected his life and work, as well as relations with friends and peers. Olson too was extreme, in his consumption of both food and drink. Both Olson and Pollock, in their oral excesses, were governed by an overcompensating machismo of style and manner.

3.

> O my America! my new-found-land.
>
> —John Donne[26]

The *idea* of America also linked Olson and Pollock, though in different ways. For Olson, trained in the late 1930s in the new academic discipline of American Civilization at Harvard, where he worked with such giants as F. O. Matthiessen and Perry Miller,[27] New England history, the founding of Gloucester and America in the early seventeenth century, was as real and vibrant as the Gloucester landscape he inhabited and "mapped."[28] But at Harvard he also studied with Frederick Merck,[29] the author of *Manifest Destiny as Mission*, himself a student of the great Frederick Jackson Turner, whose frontier theory influenced Americanists for generations. Olson's idea of space came as much from the great expanses of the plains as from the sea: "The fulcrum of America is the Plains, half sea half land, a high sun as metal and obdurate as the iron horizon, and a man's job to square the circle."[30] But since he was a New Englander (born in Worcester, Massachusetts, first visiting Gloucester as a child of five), Olson's space was more conceptual and theoretical than Pollock's (fig. 7.2).

For Pollock, space was literal and actual. Born in Cody, Wyoming, a town founded by the great Western cowboy showman Buffalo Bill, he didn't require a body count of roughly four thousand buffalo in one year to claim his Western identity. In urban New York City, his cowboy hat and boots were enough. As Stuart Davis said to Brian O'Doherty: "Crazy fella, with those boots."[31] He carried them with him as Henry James's American pilgrim in Italy carried his "absolutely undiminished possession of the American consciousness," as the Mohammedan pilgrim carried his carpet for prayer, the carpet spread "wherever the camp was pitched."[32] In Pollock American consciousness and Western consciousness coalesced, and when he spread his metaphorical Western carpet on New York's concrete streets, his talismanic sartorial emblems reminded him and everyone else in the East that he was a Westerner, transmitting at the same time the idea of the "West as America." Pollock's years of growing up were experientially rather than theoretically Western. Though he left Wyoming as an infant, he experienced the wide expanses of Arizona and California before he experienced New York and Long Island, and the Pacific before the Atlantic, occasionally following his often absent surveyor father out into the Western terrain.[33]

7.2 Jackson Pollock, *Untitled (Self-Portrait)*, ca. 1931–35. Oil on gesso on canvas, mounted on board, $7^{1}/_{4} \times 5^{1}/_{4}$ in. (18.42 × 10.8 cm.). New York, Collection of L. S. Pollock; The Pollock-Krasner Foundation/Artists Rights Society (ARS).

Thus, though exposed early in his career to the tutelage of Thomas Hart Benton and his particular brand of American "regional" art,[34] Pollock, while discarding regionalism, still maintained his "Americanness" through his "Westernness." He could then merge European artistic influences (Picasso, Miró, Matta, Masson, Kandinsky) with the "newness" of an art form hailed nationally and internationally as "American" for its vigor, energy, and freedom from tradition.

Apart from his affinity with Melville,[35] Pollock seems to have had little interest in the specific human history of the New England that so enthralled Olson, who could write in *Maximus*: "Elizabeth Tuttle / was divorced by her husband, was / the grandmother of Jonathan Edwards, / and from whose blood Burr / Grant / Cleveland scholars / generals and clergymen / for adultery. Whose sister / murdered her child whose brother / was also a murderer."[36]

Like Olson, however, Pollock was deeply concerned from early on with archaeological prehistory—the Indians not just as figures in a stereotypical cowboy-Indian saga (though he seems to have enjoyed such tales), but as earlier cultures that offered—with their mystery, myths, magic, and relation to nature—an alternative model for *being*, to the twentieth-century industrial world in which he found himself. Thus by the 1930s, having already encountered Indians as a child in Janesville, California, he haunted the Museum of Natural History and the Heye Collection in New York[37] even before his famous introduction to Navajo sand painting at the Museum of Modern Art in 1941. The idea of prehistory, of cultures that relied on magic and intuition, was to inform not only his Abstract Expressionist works in the 1940s but those of his colleagues Gorky, Rothko, and Gottlieb.

Past time stretched back toward infinity, as did space, which—literally—could unroll like the nineteenth-century panoramas as he unfurled canvases often used, fittingly, for ship sails. In this too, he and Olson were much attuned. Olson had written, "Melville had a way of reaching back through time until he got history pushed back so far he turned time into space."[38] Olson's own concern with reaching back through time, into prehistoric and primordial cultures, was again both experiential and theoretical. In "Human Universe" he wrote that knowing such peoples was "a first law to a restoration of the human house." He backed this up with actual fieldwork, living in the Yucatan in 1951 and writing: "I have been living for some time amongst a people who are more or less directly the descendants of a culture

and civilization which was a contrary of that which we have known and of which we are the natural children. . . . O, they were hot for the world they lived in, these Maya, hot to get it down the way it was—the way it is, my fellow citizens."[39]

The ideas of myth and magic that informed the art of the New York School in the mid-1940s, and the poetry and theory of Charles Olson in the mid-'40s and early '50s were in some ways a natural response to the world in which they found themselves. As World War II ended, the atomic age began. Olson, lecturing at a Seattle conference in 1947, spoke of the post-atomic terrors of the world and of postwar man "lost in a sea of question."[40] Death could rain down from the skies and destroy the earth. The atom cloud was literally a darker cloud than mankind had ever encountered, and in earlier times of fear and anxiety, magic had propitiated the evil spirits.

European dada and surrealist practice in the teens and through the twenties had already incorporated ideas of life's absurdity and of the artist or poet's utilization of intuition and the unconscious. The early presence in New York of European dadaists such as Duchamp and Picabia and later such surrealists as Max Ernst and Matta further fertilized the artistic atmosphere, first through Stieglitz's circle and ultimately through Peggy Guggenheim's Art of This Century gallery, where Pollock had his first important show in 1943. By the mid-'40s, when Rothko and Pollock were making their mythic abstractions, the intellectual and artistic recourse to dream, myth, and magic had been exacerbated by the literal anxiety of existing in a uniquely perilous moment in the earth's history. The mythic fears of prehistoric man were rehearsed by artists who found community with peoples uncontaminated by the sophistications of a contemporary civilization that had discovered a way to end the world. (In the later words of a 1981 film about a Coca Cola bottle that fell to earth: *The Gods Must Be Crazy*.)

For Pollock, the larger context necessitating the propitiation of the gods also offered an opportunity to exorcize and silence his private demons. His personal self had already been fragile enough to result in his "voluntary" confinement for drinking at the Bloomingdale Asylum in White Plains, New York, in 1938.[41] The vulnerability of his alcoholic addiction was balanced, in a strangely compensatory way, by a powerful will: He would be THE great American artist that Clement Greenberg would soon acclaim him to be. It was a challenge to the macho older brothers with whom he had always

wrestled, to the absent alcoholic and ineffectual father who had often claimed Jackson would never amount to anything, to the great European masters (the artistic father, Picasso, especially) who had dominated the world stage. Despite a superb American artistic tradition tracing back to Copley, and including such nineteenth-century giants as Lane, Church, Homer, Ryder, and Eakins, the existence of an American art would henceforth be dated by some critics only from 1945 on. For the first time, the center of the art world would shift from Europe to America. "Jackson," as De Kooning would say, "broke the ice."[42]

4.

> History, as yet, has left in the United States but so thin and impenetrable a deposit that we may very soon touch the hard substratum of nature; and nature herself, in the Western World, has the peculiarity of seeming rather crude and immature.
>
> —Henry James[43]

What did Pollock mean by the oft-quoted statement: "I am nature"?

Allegedly it was a response to Hans Hoffman's suggestion that he work from nature. If it seemed to some like arrogance, it had long and distinguished art-historical credentials in the idea of the artist as nature's ambiguous medium. These stretched at least as far back as the Italian Renaissance, with Leonardo noting: "The painter strives and competes with nature," and "[the painter] should act as a mirror which transmutes itself into as many colors as are those of the objects that are placed before it. Thus he will seem to be a second nature." In the nineteenth century, the one American artist Pollock most admired, Albert Ryder, "saw nature springing into life upon my dead canvas. It was better than nature, for it was vibrating with the thrill of a new creation."[44] But the fullest implications of Pollock's statement bring us to a consideration of Pollock's and Olson's relation to natural forces and energies. Olson had written of a "sun-inside" experience after a noonday sleep: "I awoke free"—having had a vision of a nature that "was in me, not out there."[45]

Olson's comment "He who possesses rhythm possesses the universe"[46] could well apply to Pollock, whose rhythm was rooted in myriad sources. If we apply the concept of a Jungian collective unconscious it could be traced far back in time to the complex Celtic lacertines of his biological heritage. More recently, his childhood was screened by the constant crocheting of his

mother, who deposited examples of her own linear rhythm throughout their home. As a young adult, Pollock found additional models in the twisting forms of his mentor, Benton, who also guided him through rhythmic exercises based on El Greco and Renaissance and Baroque masters.

For those rhythms, however, to "possess the universe," certain philosophical influences should be factored in, among them his youthful interest in the theosophical teachings of Blavatsky, Shwankovsky, and Krishnamurti.[47] In theosophical theory, the artist might have passed through being a stone, a tree, or a plant, before he individuated as a person. The American Indian culture that so intrigued Pollock would have offered still another model for a oneness with nature, and for the magical, spiritual, and shamanistic overtones of such a unity.

He was also aware, through his Jungian analyst, Joseph Henderson, of the Taoist philosophy of "The Secret of the Golden Flower," the T'ai I Chin Hua Tsung Chih, a late eighth-century A.D. Chinese meditation text.[48] There we are told—according to a translation by Jung's colleague Richard Wilhelm—that a man who conserves life-energy through the "backward-flowing" process that causes it to rise instead of dissipate "may reach the stage of the Golden Flower, which then frees the ego from the conflict of the opposites, and it again becomes part of the Tao, the undivided, great One."[49]

Olson also valued the T'ai I Chin Hua Tsung Chih, which, according to his editors, Donald Allen and Benjamin Friedlander, "occupied Olson's attention to the end of his days."[50] In "Against Wisdom as Such" he quotes Wilhelm: "How plastic . . . is the thought of 'water' as seed-substance in the T'ai I Chin Hua Tsung Chih." Olson then extends the idea of plasticity to time: "And time is [plastic] in the hands of the poet. For he alone is the one who takes it as the concrete continuum it is, and who practices the bending of it. . . ." Invoking again the idea of rhythm and paralleling once more Pollock's work, he declares: "Rhythm is time (not measure as the pedants of Alexandria made it). The root is 'rhein': to flow. And mastering the flow of the solid, time, we invoke others. Because we take time and heat it, make it serve our selves, our form. Which any human being craves to do, to impress himself on it. But I didn't want to leave it at the word 'time' any more than I wanted to leave it at the word 'fire.' One has to drive all nouns, the abstract most of all, back to process—to act . . . / whatever is born or done this moment of time, has / the qualities of / this moment of / time."[51]

As Olson understood time through his interest in among others, Alfred North Whitehead (and as Pollock incorporated it, whether intuitively or deliberately), to act, to make process the center of creation is also to make time-as-rhythm-and-flow a central part of the painting or poem. Time is, of course, always a part of the art work. But the fluid time here embodied is time seen through the eyes of post-Einsteinian physics. Thus Pollock's "I am nature" can be seen as an affirmation of his sense of himself as an integral part of this cosmos in flux, governed by the same perceived natural laws.

Some contemporary scholars have preferred to make little of suggestions of universal, cosmic, or spiritual feeling in Pollock. Varnedoe notes that he did not encourage such ideas about his art as did others of the New York School—Newman and Rothko among them.[52] Nonetheless, in my view, the paintings executed from 1947 to 1950 indicate transcendental feeling, perhaps welling up from the unconscious Pollock referred to as "the source of my painting." Combine what such paintings tell us with his boast "I am nature" and his youthful concern with theosophy and American Indian shamanism. Add to this Betty Parsons's observation: "He had a sense of mystery. His religiousness was in those terms—a sense of the rhythm of the universe, of the big order—like the Oriental philosophers. . . . He had Indian friends, a dancer and his wife (the Vahtis), with whom he talked at length and who influenced him greatly."[53] Factor in also Lee Krasner's frequent comments about his "religious" nature (including his desire for a church wedding). Although, according to Krasner, he cared a lot about religious ritual,[54] his religiosity would seem to have been more ecumenically spiritual than the product of organized religion, more motivated by the same desire for connection to the Over-Soul that drew Emerson and Thoreau to Indian philosophy. Thus he could state: "My concern is with the rhythms of nature . . . the way the ocean moves. . . . The ocean's what the expanse of the West was for me." In his best moments, he felt himself part of a larger energy, that passed through him and from him into his work: "I work from the inside out, like nature."[55] So he could chide a friend for not recognizing that trees can feel pain.[56]

Olson's statement ". . . if man is once more to possess intent in his life . . . he has to comprehend his own process as intact, from outside, by way of his skin, in, and by his own powers of conversion, out again . . . man at his peril breaks the full circuit of object, image, action at any point"[57] recalls Pollock's

famous "When I am *in* my painting I'm not aware of what I'm doing. . . . It is only when I lose contact with the painting that the result is a mess. Otherwise there is pure harmony, an easy give and take, and the painting comes out well."[58]

For Olson, "The harmony of the universe, and I include man, is not logical, or better, is post-logical, as is the order of any created thing. . . ."[59] "The unconscious," claimed Olson, a great admirer not only of Whitehead but of Heraclitus, "is the universe flowing-in, inside."[60]

Pollock's manner of being in his painting was, of course, also as physical as it was emotional (spiritual) and mental. In the poured works he was literally "in" the painting, as he put it, tacking the unstretched canvas to the floor: "I am more at ease, I feel nearer, more a part of the painting. . . . I can walk around it, work from the four sides and literally be *in* the painting. This is akin to the method of the Indian sand painters of the West"[61] (fig. 7.3). Pollock's use of the whole body for this "action" is well characterized by Harold Rosenberg in his famous action-painting essay:

> A painting that is an act is inseparable from the biography of the artist. The painting itself is a "moment" in the adulterated mixture of his life—whether "moment" means the actual minutes taken up with spotting the canvas or the entire duration of a lucid drama conducted in sign language. The act-painting is of the same metaphysical substance as the artist's existence. The new painting has broken down every distinction between art and life. It follows that anything is relevant to it. Anything that has to do with action—psychology, philosophy, history, mythology, hero-worship.[62]

For Rosenberg, "Action painting has to do with self-creation or self-definition or self-transcendence, but this disassociates it from self-expression, which assumes the acceptance of the ego as it is, with its wound and its magic. Action painting is not 'personal,' though its subject matter is the artist's individual possibilities."[63]

One could argue, rightly I feel, that many of Pollock's paintings, before and after what I prefer to think of as the "transcendental" phase of 1947–50, could be said to indicate the ego's wound. But if one accepts Rosenberg's idea of the "moment," it is still pertinent to Pollock's comment that "Every good painter paints what he is."[64]

Olson's concern with the body in "Proprioception" parallels Pollock's process:

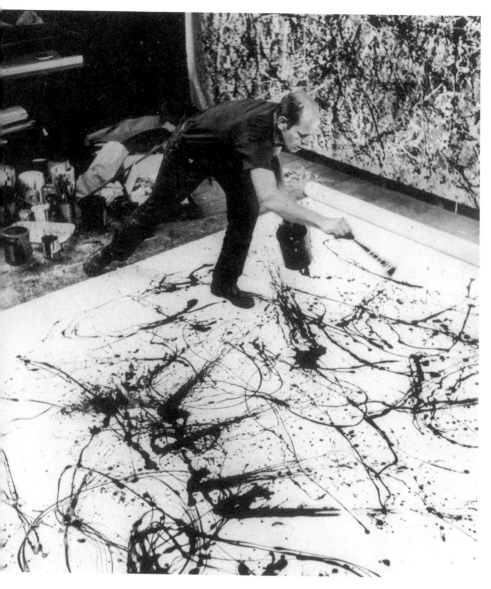

7.3 Hans Namuth, *Jackson Pollock*, 1950. Gelatin silver print on paper, 14$^{13}/_{16}$ × 13$^{13}/_{16}$ in. (37.6 × 35.1 cm.). Washington, D.C., National Portrait Gallery, Smithsonian Institution.

'ACTION'—OR, AGAIN, 'MOVEMENT'

. . .	
the soul is proprioceptive	the 'body' itself as, by movement of its own tissues, giving the data of, depth. Here, then, wld be what is left out? Or what is physiologically even the 'hard' (solid, palpable), that one's life is informed from and by one's own literal body—
. . .	that this is 'central', that is—in this ½ of the picture—what they call the SOUL, the intermediary, the intervening thing, the interruptor, the resistor. The self.
The gain:	to have a third term, so that movement or action is 'home.' Neither the unconscious nor Projection (here used to remove the false opposition of 'Conscious', 'consciousness' is self) have a home unless the DEPTH implicit in physical being— built-in space-time specifics, and moving (by movement of 'its own')—is asserted, or found-out as such. Thus the advantage of the value 'proprioception.' As such.
its own perception	The 'soul' then is equally 'physical.' Is the self, . . .[65]

Olson's three terms would be:

surface (senses) projection
cavity (organs—here read 'archtypes')
unconscious the body itself—consciousness:
implicit accuracy, from its own energy as a state of
implicit motion.[66]

Olson's and Pollock's conflation of body and self had of course been anticipated by the philosopher whose ideas so often paralleled artistic activities in America: William James, who wrote: "The individualized self, which I believe to be the only thing properly called self, is a part of the content of the world experienced. The world experienced (otherwise called the 'field of consciousness') comes at all times with our body at its centre, centre of vision, centre of action, centre of interest. . . . So far as 'thoughts' and 'feelings' can be active, their activity terminates in the activity of the body. . . . The body is the storm centre, the origin of co-ordinates, the constant place of stress in all that experience-train."[67] "My present Me," James also noted, "is felt with warmth and intimacy. The heavy warm mass of my body is there, and the nucleus of the 'spiritual me', the sense of intimate activity is there," and "The more *active-feeling* states of consciousness are . . . the more

central portions of the spiritual Me. The very core and nucleus of our self, as we know it, the very sanctuary of our life, is the sense of activity which certain inner states possess."[68]

In "Human Universe," Olson had asserted that "idealisms of any sort, like logic and like classification, intervene at just the moment they become more than the means they are, are allowed to become ways as end instead of ways to end, END, which is never more than this instant, than you on this instant, than you, figuring it out, and acting, so if there is any absolute, it is never more than this one, this instant, in action."[69] "Nothing," he maintained further, "is accident, and man, no less than nature, does nothing without plan or the discipline to make plan fact."[70]

Nothing was accident for either Olson or Pollock. Even accepting this, to watch the Namuth films is to be impressed at the amount of control Pollock exercised in the act of painting the poured canvases. Lee Krasner, perhaps the only witness apart from the filmmakers Namuth and Falkenberg, spoke of Pollock's amazing control.[71] What was the nature of that control?

It was an extreme state of trancelike concentration, the performance of an art-dance, both acrobatic and balletic, around the edges of a horizontal canvas, grounded on the earth like the sand paintings he admired. From that grounding he maintained contact with the forces and energies that poured through him, into his body, into his gestures. His waving and perfectly directed arms splattered and poured and drew with what he called liquid paint, controlling the line like a Watteau, thicker and thinner, looping gracefully upon the surface with insistent and carefully paced and spaced rhythms—a blot here, another in this open space, a streak there, another on this side. Using the act of pouring, or dripping from sticks or stiffened brushes or basters, working the canvas always as one field, he distributed his energies with a perfect awareness of placement, of density, of thick and thin, of canvas ground that served as in watercolor not only as surface but as space, offering the life breath, as well as the extended breadth.

When all fell into place, into a perfect harmony of feeling, paint, energy, rhythm, he achieved what he wanted, a painterly organism. The organic wholeness of such works is signaled by the title of one of the greatest of them: *One: Number 31, 1950*. Like Ryder before him, Pollock built the painting from tissues of paint, the layers becoming like the secretions of cells, of skin, vegetal or human.

To Ryder: "[The artist] must await the season of fruitage without haste.... An inspiration is no more than a seed that must be planted and nourished."[72] At times Pollock worked in series, administering to the needs of his growing paintings over a shorter period of time than did Ryder, weeks or even days, probably, rather than years, but the principle was the same. To make a living thing, to *grow* a painting like nature, like the gardens he enjoyed nurturing.[73]

In the huge "transcendental paintings," as in *Autumn Rhythm* (*Number 30*), 1950, or *One: Number 31, 1950* (see plates 15 and 16), the environmental feeling inundates the viewer with a controlled energy. The artist has never lost touch with the life of the work, nor has his individuated ego emerged to challenge his trancelike submersion in something larger than himself. We might posit that here he has become Emerson's transparent eyeball, "the currents of the Universal Being"[74] circulating through him. In such works, as with his earlier American predecessors, with Emerson, or Fitz H. Lane, a dose of Asian meditative philosophy adds to the mix of American and European strains that comprise his cultural heritage.

Like Ryder, Pollock was torn between the transcendent and the agon, the anthropomorphic struggle. The best of the transcendental works required a special balance within him, a freeing of the self that allowed it to become, as in Tao, like the grass and trees. Olson liked the term "objectism": "the getting rid of the lyrical interference of the individual as ego, of the 'subject' and his soul, that peculiar presumption by which western man has interposed himself between what he is as a creature of nature ... and those other creations of nature, which we may, with no derogation, call objects. For a man is himself an object ... the use of a man ... lies in how he conceives his relation to nature, that force to which he owes his somewhat small existence. If he sprawl, he shall find little to sing but himself, and shall sing ... by way of artificial forms outside himself. But if he stays inside himself, if he is contained within his nature as he is participant in the larger force, he will be able to listen, and his hearing through himself will give him secrets objects share."[75]

In the *Sounds in the Grass* series of 1946, when Pollock began to stay "inside himself," he put himself and the viewer into the grass, like an insect (*Eyes in the Heat*[76] [fig. 7.4], *Shimmering Substance*). His failures (*Croaking Movement*) are as interesting as his successes. When he got in the way, before

7.4 Jackson Pollock, *Eyes in the Heat*, 1946. Oil and enamel on canvas, 54 × 43 in. (137.2 × 109.2 cm.). New York, Peggy Guggenheim Collection, The Solomon R. Guggenheim Foundation.

and after the transcendental phase of 1947–50—when his nervous will confounded him—he could be a gauche, crablike painter.

But the will was made up of determination as well as violent anger. He *would* be *the* great American artist. Early on, he was an awkward draftsman, finding it difficult to create beautiful drawings or brushstrokes when they were tied to figuration: thus the sharp, often unattractive angles of the youthful Benton exercises. Fluidity, however, could come with the doodle, art-historically deemed an automatist recourse to the unconscious, but in lay terms, simply the free doodle of the meandering mind. Here he did some of his most graceful, fluent and delicate drawings and paintings: *Untitled* (*Blue* (*Moby-Dick*)) (fig. 7.5). And ultimately, when he used his whole body, shaman-like, magic and spirit informed the work.

7.5 Jackson Pollock, *Untitled (Blue (Moby Dick))*, 1943. Gouache and ink on fiberboard, 18³/₄ × 23⁷/₈ in. (48 × 60.5 cm.). New York, The Pollock-Krasner Foundation/Artists Rights Society (ARS).

Earlier, Bierstadt had tried to approximate the vast expanses of Western space through a frequently simplistic use of large canvases, which often did not work. Pollock, however, his recourse to the panoramic format of the nineteenth century coached further by his experiences in the studio of the Mexican muralist Siqueiros and by his admiration for Orozco, more successfully turned size into scale. The larger paintings, starting with the mural for Peggy Guggenheim in 1943–44, are celebrated for introducing into twentieth-century American painting an environmental experience that draws the viewer to participate in the act itself. In the transcendental phase, where space is transmuted into spirit, the painting absorbs the doubled selves of artist and viewer to become, as Pollock may perhaps have wished, universal or cosmic.

What are we to make of this so-called cosmic urge? T. J. Clark, writing of the paintings shown at Parsons in 1950, finds Pollock's works, both large and small, literal in size and suggests: "The hope seems to me to have been that the two opposite terms—the cosmologically large and the critically atomically compressed—would confirm one another in their literalness and cancel out the middle space between them—the space of virtuality and mere scale."[77] Rather than "mere" scale, Clark notes ultimately, concurring with Parker Tyler, "Pollock's art is one that aims constantly at a radical, incommensurable, truly elating scale—at infinite extension or intension, preposterous depth or complexity, *absolute* elevation."[78] "True scale—true elation and terror and endlessness (the scale of experience in 1950)—is reached through the medium of true size."[79] Commenting on the atomic terrors of 1950, Clark finds Pollock's 1950 paintings both Nietzschean and metaphorical.

I would argue, however, that it is the earlier expressionist works, such as *The She-Wolf* (1943), that I could call Nietzschean (see plate 17). My own feeling is that the 1950 paintings represent an oasis of calm in Pollock's personal life that coincided with a rare clarity of spirit, achieved when he was not tormented by his demons, and not drinking. For Clark, Pollock's image of the ocean is "partly to be understood as a figure of otherness and incommensurability."[80] Clark here would seem to be invoking the terribilitá of what I have called the "old" sublime of Edmund Burke. For me, on the other hand, Pollock's desire to deal with "the way the ocean moves" was an urge to penetrate and articulate the forces of nature, and in so doing, commune with them, become a part of them. "Cosmic" is perhaps too grand a

word to use here, but "cosmic ambition" seems to fit. The two "new" sub-limes of the nineteenth century as I have defined them elsewhere, represented by the quietistic Lane on the one hand, and the more rhetorical Church on the other (the small and the large of it), might also be invoked to describe the large and small of Pollock's 1950 Parsons show, but in Pollock's case, for the most part, the ultimate result reaches, I feel, toward a form of transcendent calm.[81]

The "cosmic urge" was more anthropomorphically baroque in Olson, who like Church or Whitman wanted voraciously to swallow the world. The encyclopedic expanses of Olson's references indicate that the world he would swallow would be infinite in time (geological prehistory) and space, ranging from Gloucester and its colonial beginnings to the entire planet, the earth, and, especially, the sea. George Butterick's *A Guide to the Maximus Poems* informs us that "There are almost 4000 annotations in all, identifying references ranging from local Massachusetts history to the poet's literal dreams, Algonquin legends to the cosmology of Whitehead, contemporary literary life to Arabic angelology."[82] Olson's angels and demons, however, in 1950, were waging a mighty war, resulting in what he referred to as "riot in my soul."[83] Though his love-life was in turmoil, *Maximus* was in its beginning stages, just acquiring its final title, the extraordinary correspondence (several thousand pages) with Robert Creeley had commenced, and his rich and complex theoretical parallel to Pollock's practice, "Projective Verse," was in process.

5.

> on founding: was it puritanism,
> or was it fish?
>
> —*Maximus*, Letter 10[84]

It seems art-historically serendipitous for the purposes of this book that Olson should have made Gloucester, the scene of his childhood vacations, the center of his adult world, as it was earlier for the artist he so admired—Fitz H. Lane. Ultimately, it attracted such artists as Winslow Homer, Marsden Hartley, Stuart Davis, and Edward Hopper. Olson intended the *Maximus Poems* as history, as well as poetry, and the way in which he incorporates the accounts of early Gloucester—among them Babson's 1860 *History of the Town of Gloucester, Cape Ann, Including the Town of Rockport*, and early

figures who founded the "last shore," the end of the "migratory act of man," represents a conflation of time and space (then and now) that has the value of making all of earth/world/American history immediate and present, flooding into one's awareness with each reference. Thus he writes in Letter 7 of *Maximus*, which begins:

> (Marsden Hartley's
> eyes—as Stein's
> eyes
>> Or that carpenter's
>> Who left Plymouth Plantation,
>> And came to Gloucester
>> to build boats
> . . .
>
> That carpenter is much on my mind:
> I think he was the first Maximus
>
> Anyhow, he was the first to make things,
> not just live off nature
>
> And he displays,
> in the record, some of those traits
> goes with that difference, traits present circumstances
> keep my eye on
>> for example, necessities the practice of the self,
>> that matter, that wood[85]

In "Projective Verse," Olson speaks of "objectism" standing for "the kind of relation of man to experience which a poet might state as the necessity of a line or a work to be as wood is, to be as clean as wood is as it issues from the hand of nature, to be shaped as wood can be when man has had his hand to it."[86]

This calls to mind not only Copley, whose colonial patrons seated behind glistening wooden tables followed the carpenter to Massachusetts a hundred years or so later, but Pollock, who Lee Krasner claimed loved to refinish antique furniture[87] and who sometimes incorporated small "things" such as paint tube caps and bits of glass into the surfaces of his paintings. Olson reveals his own respect for the "thing in itself" that shares the world with the human self in his theory of objectism: "a thing, any thing, impinges on us by a more important fact, its self-existence, without reference to any other thing . . . in short, the very character of it which calls our attention to it, which wants us to know more about it, its particularity."[88]

In Letter 9 of *Maximus* he writes of a plum tree:

> . . . there is no other issue than
> the moment of
> the pleasure of
> this plum,
>
> these things
> which don't carry their end any further than
> their reality in
> themselves
>
> It's the condition in men
> (we know what spring is)
> brings such self-things about
> which interests me
> as I loll today
> where I used to,
> atop Bond's Hill
>
> with both the inner, and the outer, harbor,
> the Atlantic, back of the back-shore
> the Annisquam and her marshes, Ipswich Bay
> all out before me in one view . . .[89]

Olson's view here is not so different from Pollock's on Accabonac Creek, with the Atlantic virtually at his fingertips. (His plum, however, recalls the fruits in a painting by Copley.)

The *Maximus Poems*, as saga, as extended epic, as philosophical and spiritual panorama, going back to the primordial and mythic but incorporating also the local, both historic and present, rehearse some of Pollock's themes and processes. But Pollock's world-swallowing in these instances seems, as noted earlier, curiously both larger and smaller, more abstract in its lack of particularity, ultimately more akin in spirit to the infinite quietism of the smaller panoramic-shaped Gloucester paintings of Fitz H. Lane (themselves both local and universal) into which the viewer, shrinking, enters. If Pollock's transcendental paintings recall Emerson's dream of eating the apple floating in the Ether,[90] and thus eating the world, Olson's voracious appetite, here weightier and more organic, aptly befits his alter ego Maximus, also conceived as "Bigman," and his own large, maximum stature of six feet seven, 250 pounds.

Yet if nothing was accidental for either Pollock or Olson, the act itself was not only a controlled one, for all its reliance on the unconscious self, but a pragmatic one. Here Pollock's oft-quoted query, common to many artists, "Does it work?"[91] assumes special significance if we consider the pragmatic tradition in American painting already discussed throughout this book.

Within that tradition, as I have formulated the idea, each individual art-ist solves similar problems, not handing on a tradition so much as repeating from the beginning the problem-solving process, not (as in Europe) as links on a chain, but as parallel poles of development, always reinventing the artistic wheel and arriving at the same place out of common experience. To my mind, this accounts for the similarities between Copley and Harnett, Copley and Eakins, Homer and Hopper. The pragmatic inheritors of this tradition, in attitude if not in form, were surely the Abstract Expressionists, who felt they were inventing painting as they invented themselves.

Olson, we may remember, had commented that his fellow Gloucester citizen Lane was "one of the chief definers of the American 'practice'—the word is Charles Peirce's for pragmatism—which is still the conspicuous dif-ference of American from any other past or any other present, no matter how much we are now almost the true international to which all bow and acknowledge."[92]

Pollock's painting, starting from self, having brushed "the apples off the table," to quote Rosenberg, "so that nothing would get in the way of the act of painting,"[93] was, in its ad hoc process, pragmatically at risk. In Jamesian terms, his job was to make it work. Pollock was surely thinking in terms of a formal resolution of painterly problems, as well as contentual ones, when he asked "Does it work?" "Sometimes," he volunteered in Namuth and Falkenberg's film, "I lose a painting."[94] James's philosophy, cited with earlier figures in this volume and still pertinent here, was more all-encompassing: "[Pragmatism's] only test of probable truth is what works best in the way of leading us, what fits every part of life best and combines with the collectiv-ity of experiences or demands, nothing being omitted."[95] Yet what Pollock was aiming for was in the end just as inclusive of James's dictum.

The work of art had to *work*. In Olson's mind it *was*, literally, work. And for both Olson and Pollock, the work that worked depended in large part on line. For Olson, "the line comes (I swear it) from the breath, from the breathing of the man who writes, at the moment that he writes, and thus is, it is here that, the daily work, the WORK, gets in, for only he, the man who writes, can declare, at every moment, the line its metric and its ending—where its breathing, shall come to, termination."[96] Or, as Pollock declared when asked how he knew when a painting was finished: "How do you know when you're through making love?"[97]

What both Olson and Pollock were practicing was a kind of organic pragmatism that included not only line but field, so that Pollock's all-over painting found its equivalent in Olson's "COMPOSITION BY FIELD,"[98] as opposed to inherited line, stanza, over-all form, what is the 'old' base of the non-projective." For Olson, as for Pollock, the poem itself must at all points be a high-energy construct, and, at all points, an energy-discharge: "ONE PERCEPTION MUST IMMEDIATELY AND DIRECTLY LEAD TO A FURTHER PERCEPTION . . . keep moving, keep in, speed, the nerves, their speed, the perceptions, theirs, the acts, the split second acts, the whole business, keep it moving as fast as you can, citizen . . . always one perception must must must MOVE, INSTANTER, ON ANOTHER!"[99]

This pragmatic swiftness on an open field allowed for, indeed, seemed to imply, an entranced spiritual state that could enter into the transcendent. William James himself, we remember, had encompassed such a state in his definition of pragmatism: "the oddly named thing pragmatism . . . can remain religious like the rationalisms, but at the same time, like the empiricisms . . . preserve the richest intimacy with facts."[100] He underscored his belief in the parallel existence of the pragmatic and the spiritual through his own awareness of the transcendent state, as signaled by his famous *Varieties of Religious Experience.* Olson had written to Cid Corman, the editor of *Origin*: "I don't know what I'm up to. And I must stay in that state in order to accomplish what I have to do."[101]

But that transcendent zone was easily interfered with by the hundreds of demons and anxieties that afflicted both Pollock and Olson in their lives and work, by what Olson had called, in "Projective Verse," "the lyrical interference of the individual as ego—of the 'subject' and his soul." As Edward Dahlberg, a former teacher and friend had written of Olson: "He had an ungovernable impulse to destroy himself."[102]

As indeed had Pollock. The entry of the demons brought with it the return of the specific psyche or self, transforming the impersonal transcendent into a more personal, and one might say anthropomorphic, ego. The serene and abstract self—the trancelike self in these instances—gives way to a particularism that feels pain and anxiety.

Although one might have assumed that the particularity of the individual bodily forces described by Olson and Pollock would have encapsulated the personal ego, thus ensuring its integrity—an assumption more in line with Freud's concept of the skin-ego—the transcendent state in both instances

seems to have used the body as a kind of medium, through which the larger forces could enter and finally exit, transformed by the unconscious or perhaps not-conscious via the work.

In what we might call the pre- or post-transcendent state, the conscious mind (*self*-conscious in the most literal sense of the word) along with pain and anguish—a full dose of Germanic angst—establishes a hegemony of the subjective and egoistic. Personal feeling, specificity of self-awareness are part of this.

Such feelings, and their effect on the work, are more graphically clear in Pollock's paintings than in Olson's poems. We can see the difference in the painting both before and after the transcendental works: the heavily expressionist encrustations of paint in *Pasiphaë* are powerful rather than fluid, weighty rather than weblike or gauzy, carrying personal rather than impersonal feelings to the surface. In the late *Portrait and a Dream* (1953) the pained face of the artist reappears, not so very different from the small, cramped, vulnerable self-portrait that began his career (fig. 7.6).

Pollock was surely in these instances the ultimate Existential hero. Even had we not heard the anecdote of his weeping at a performance of Beckett we would recognize him as the end of a long romantic tradition that culminated in Expressionism—from Delacroix to Van Gogh, from Melville to Beckett. The tragic nature of his death also gave Pollock access, as has often been noted, to the film tradition of James Dean in *Rebel Without a Cause*. For all that he was the great American painter, his angst was more Germanic

7.6 Jackson Pollock, *Portrait and a Dream*, 1953. Oil on canvas, 58½ × 134¾ in. (149.6 × 342.3 cm.). Dallas, Tex., Dallas Museum of Art.

or European than American—as was Melville's in such works as *Bartleby*. There was a blunt, almost bestial muteness about Pollock's anxieties as expressed in his life and work when alcoholism had a strong hold on him. If the body had enabled him to create the extraordinary transcendent masterpieces of the late 1940s and early '50s, the body's own chemistry, altered by alcohol, plunged him into the abyss of existential hopelessness before and after, and abetted the self-destructiveness that caused automobile accidents even before the last, fatal one.

With Olson, a personal expressionism does not so much characterize individual poems as interrupt the cultural panorama from time to time with explicit autobiographical power:

> Rise
> Mother from off me
> God damn you God damn me my
> Misunderstanding of you . . .[103]

Olson went to some lengths to deny that his work was only existential, and this has to be factored into our reading of it. He surely shared with the existentialists the disenchantment with a postatomic, technological world. He had, as they did, a strong sense of irony and the absurd. He wrote early on to Waldo Frank that he was pinned down "grimly upon the cold table of self."[104] And he knew, according to his biographer, Tom Clark, that "given too much reflexive attention, the self could turn into a crippling thing, the 'root of all evil.'"[105]

Like Pollock, he lived hard, over-consuming life as frantically as food and drink. Yet in the final analysis, he had worked out a philosophy that may indeed have been more than "only"[106] existential, one that substituted for the alienation between subject and things of the world (objects) to be found in Camus and Sartre, a leveling of subject and object that found salvation in his "objectism." Man was simply an object, like all the other objects, not a self pitted against things. Despite his early comment that the White Whale was more accurate than *Leaves of Grass* "Because it is America, all of her space, the malice, the root,"[107] there is something Whitmanesque about his attitude, recalling Whitman's leveling argument that there is no death or illness. And indeed, there is in much of Olson's work an embrace, a celebration of existence, that contrasts with the bleakness of much Existential philosophy. Maximus may have "turned away" from God: "I have known the

face / of God. / And turned away, / turned, / as He did, / his backside."[108] It is questionable, in the last analysis, whether Olson did.

More likely, Olson stood behind another comment made in 1969 not long before he died, shortly after man had landed on the moon (landed ironically, literally, on a potent Jungian symbol). It was a fitting comment for one devoted to the White Whale and to the fisheries of Gloucester with which America began, as well as for a sometime Jungian for whom the fish symbol might have called up not only an archetype of self, but of God: "I've found out that I believe in God and in Creation, and it doesn't matter to me what the human species as a bunch of what we call midges, coming off the marsh, do to it, do even to themselves . . . hopefully they might some day realize that that famous blue planet, as she's now revealed herself to be, is the only one with atmosphere which reflects the great Ocean—and therefore that we breathe and live here. We're little Aquarian creatures that grew up."[109]

Notes

CHAPTER 1 *Copley and Edwards: Self, Consciousness, and Thing*

1. See Perry Miller, *Jonathan Edwards* (New York, 1949; reprint Amherst: University of Massachusetts Press, 1981), 52. This early date is questioned by Wallace E. Anderson, ed., *Jonathan Edwards: Scientific and Philosophical Writings* (New Haven: Yale University Press, 1980), 15–18, 24–26. Despite much later scholarship with valuable considerations of Edwards, Perry Miller's early insights have for me withstood the test of time. See Preface to the second edition of my *Nature and Culture* (New York: Oxford University Press, 1995), vii–viii. See also the excellent set of essays in William J. Scheick, ed., *Critical Essays on Jonathan Edwards* (Boston: G. K. Hall, 1980); and Joseph A. Conforti, *Jonathan Edwards: Religious Tradition and American Culture* (Chapel Hill: University of North Carolina Press, 1995).

2. See Anderson, *Jonathan Edwards*, 36, 123–24.

3. Ibid., 147ff.

4. Ibid., 409; cf. also 163–64.

5. Ibid., 147–50.

6. Ibid., 155.

7. Ibid., 305.

8. Ibid.

9. See Jules D. Prown, *John Singleton Copley* (Cambridge, Mass.: Harvard University Press, 1966), 1:16; and Michael Baxandall, *Patterns of Intention* (New Haven: Yale University Press, 1985), 79–80.

10. Baxandall, *Patterns of Intention*, 103.

11. See *Letters and Papers of John Singleton Copley and Henry Pelham, 1739–1776* (Boston: Massachusetts Historical Society, 1914), 65–66. Letter from Copley to Benjamin West or Captain Bruce, circa 1767.

12. When Copley got to Europe, he wrote to his half-brother Henry Pelham in 1775 that he had imagined Titian's paintings were smooth, "Glossy and Delicate . . . with great attention to the smallest parts," but when he saw them, he found them otherwise. "Titiano is no ways minute, but sacrifices all the small parts to the General effect." Quoted in Barbara Novak, *American Painting of the Nineteenth Century* (New York: Harper & Row, 2nd Edition, 1979), 30.

13. See *The Writings of William James*, ed. John J. McDermott (Chicago: University of Chicago Press, 1977), 390.

14. See John Locke, *An Essay Concerning Human Understanding*, ed. Andrew Seth Pringle-Pattison (Oxford: Clarendon, 1956), 43.

15. Anderson, *Jonathan Edwards*, 379.

16. Miller, *Jonathan Edwards*, 67.

17. Ibid., 72.

18. See Christopher Fox, *Locke and the Scriblerians: Identity and Consciousness in Early Eighteenth-Century Britain* (Berkeley: University of California Press, 1988).

19. Anderson, *Jonathan Edwards*, 342.

20. James, *Writings of William James*, 284.

21. Ibid., 769.

22. Perry Miller, *Errand into the Wilderness* (New York: Harper & Row, 1964), 177.

23. Etienne Gilson, *Painting and Reality* (New York: Pantheon, 1957), 27–28.

24. Miller, *Jonathan Edwards*, 62.

25. Henry F. May, *The Enlightenment in America* (New York: Oxford University Press, 1976), 57.

26. Paul Staiti, "Accounting for Copley," in *John Singleton Copley in America*, by Carrie Rebora, Paul Staiti, et al. (New York: Metropolitan Museum of Art, 1995), 53, 54.

27. Miller, *Jonathan Edwards*, 112.

28. Anderson, *Jonathan Edwards*, 208 and n. 2. Anderson notes of indiscerpible: "Henry More uses the term in *Immortality of the Soul* to signify the indivisibility of spirits, and of the least real part of bodies."

29. See *The Notebooks of Leonardo da Vinci*, ed. Irma A. Richter (Oxford: Oxford University Press, 1952), 126. If we take Leonardo, with his astute pragmatic observation, as a scientific predecessor of Edwards, perhaps we might also factor in Perry Miller's 1949 observation that Edwards looks forward in some of his scientific insights to Alfred North Whitehead. (See Miller, *Jonathan Edwards*, 94–95.) More recently (1968), Roland Andre Delattre, in "Beauty and Theology: A Reappraisal of Jonathan Edwards" in Scheick, *Critical Essays on Jonathan Edwards*, 140, has noted: "The differences between Edwards' aesthetic philosophy of being and Whitehead's aesthetic philosophy of process do not stand in the way of Edwards sharing Whitehead's conviction that 'beauty, moral and aesthetic, is the aim of existence.'" To allow Whitehead's ideas, as they relate to those of Edwards, to enter in here offers a nice compatibility with another New Englander, Charles Olson, two centuries after Edwards, who looked to Whitehead for explanations of the physical world. See below Chapter 7.

30. Miller, *Jonathan Edwards*, 192, 52.

31. Anderson, *Jonathan Edwards*, 338.

32. James, *Writings of William James*, 768.

33. Quoted in Sacvan Bercovitch, *The Puritan Origins of the American Self* (New Haven: Yale University Press, 1975), 17.

34. Philip Greven, *The Protestant Temperament, Patterns of Child-Rearing, Religious Experience, and the Self in Early America* (Chicago: University of Chicago Press, 1977), 74.

35. Ibid., 76. Quoted in Richard L. Bushman, "Jonathan Edwards as Great Man: Identity, Conversion, and Leadership in the Great Awakening," in Scheick, *Critical Essays*, 53.

36. Greven, *Protestant Temperament*, 78.

37. Bercovitch, *Puritan Origins*, 23, 26.

38. Anderson, *Jonathan Edwards*, 346–48.

39. Ibid., 346.

40. Quoted by James, in *Writings of William James*, 635–66, from "The Prelude," Book 3.

41. *The Selected Writings of Ralph Waldo Emerson*, ed. Brooks Atkinson (New York: Modern Library, 1992) 17.
42. Miller, *Jonathan Edwards*, 48.
43. Sidney E. Ahlstrom, *A Religious History of the American People* (New Haven: Yale University Press, 1972), 309.
44. Ibid.
45. Miller, *Errand*, 195.
46. Ibid., 202–3.

CHAPTER 2 *Emerson and Lane: Luminist Time and the Transcendental Aboriginal Self*

1. Harold Bloom, "Emerson: The American Religion," in *Ralph Waldo Emerson: Modern Critical Views*, ed., intro. Harold Bloom (New York: Chelsea House, 1985), 121.
2. Perry Miller, *Errand into the Wilderness* (New York: Harper & Row, 1964), 188; see also Richard Poirier, "The Question of Genius," in *Emerson, Modern Critical Views*, 169: "No wonder it is at times extraordinarily hard to know how to take Emerson." See also Joel Porte, *Consciousness and Culture: Emerson and Thoreau Reviewed* (New Haven: Yale University Press, 2004), xiv: "The truth is that both Emerson and Thoreau could feel transcendental or descendental by turns and write accordingly."
3. *The Selected Writings of Ralph Waldo Emerson*, ed. Brooks Atkinson (New York: Modern Library, 1992), 138.
4. Sacvan Bercovitch, "Emerson the Prophet," in *Emerson, Modern Critical Views*, 41. See also *Emerson in His Journals*, ed. Joel Porte (Cambridge: Harvard University Press, 1982), 285. Three months after the death of his little son Waldo, he was clearly still in mourning when he wrote (April 1842): "I am not united, I am not friendly to myself, I bite & tear myself. I am ashamed of myself. When will the day dawn of peace & reconcilement when self-united & friendly I shall display one heart & energy to the world?"
5. Emerson, *Selected Writings*, "Experience," 315.
6. Ibid., "The Over-Soul," 236.
7. Harold Bloom, *Agon: Towards a Theory of Revisionism* (New York: Oxford University Press, 1983), 20. See also Bloom, *Emerson: Modern Critical Views*, 100–101: "Emerson's seeing, beyond observation, is more theosophical than Germanic Transcendental."

 Some revisionist scholarship has attempted—to my mind unsuccessfully—to evict Lane's "transcendental luminism" from the luminist canon and substitute instead a form of "atmospheric luminism" as practiced by the New York School. This would seem to be part of an old New England/New York skirmish that goes back to the nineteenth century. See, for example, Angela Miller, *The Empire of the Eye* (Ithaca, N.Y.: Cornell University Press, 1993), where Lane is consigned to only two footnotes; and, following her lead, Mark Mitchell's essay, "Luminism as a Modern Form," in *Luminist Horizons: The Art and Collection of James A. Suydam*, ed. Katherine A. Manthorne and Mark D. Mitchell (New York: George Braziller, 2006), 130. Katherine Manthorne's essay in the same volume (132) reminds us "that we need to reconcile the activities of the New York based artists with figures who operated largely outside the city, such as the peripatetic Heade and Lane in Massachusetts. Are we in a sense talking about a New York variation of Luminism by college-educated, refined artists in the Suydam-Kensett circle? Is this another example of what we may term the pirate mentality of New Yorkers blatantly co-opting a style from New England and adopting it to their own uses?"

8. Emerson, *Selected Writings*, "The Over-Soul," 237.

9. Ibid., 239, 238.

10. Ibid., "Self-Reliance," 141. Given theosophical theory about human metamorphosis through things, this passage would seem to support Bloom's comment (note 7).

11. John Wilmerding, *Fitz Hugh Lane* (New York: Praeger, 1971), 18. A recent reprint of Wilmerding's 1971 study changes its title to *Fitz Henry Lane*. See reprint, *Fitz Henry Lane* (Danvers, Mass: Cape Ann Historical Association in cooperation with Bradford & Bigelow, 2005), in which new evidence is presented that the artist changed his name from Nathaniel Rogers Lane to Fitz Henry Lane in 1832. As stated in the introduction to the 2005 edition, "This discovery poses a dilemma for the art world which will not be settled easily or quickly." The appendix to the 2005 edition, written and researched by the Gloucester Archives Committee, which unearthed the new material, indicates that sometime after 1915 and before 1938 the name Fitz Hugh Lane "gained prominence and acceptance." The question of when and why the name Fitz Hugh Lane appeared remains, at this writing, still open. Since the artist sometimes signed his paintings Fitz H. Lane and many institutions continue to use the earlier designation of Fitz Hugh Lane, I have decided for the sake of consistency to adopt Fitz H. Lane for the trilogy.

12. Ibid., 95.

13. See *The Crayon* I, June 6, 1855, 354.

14. Emerson, *Selected Writings*, "Self-Reliance," 142.

15. William James, *Pragmatism and Four Essays from The Meaning of Truth* (New York: New American Library, 1974), 33.

16. See Wilhelm Worringer, *Form in Gothic*, ed. Herbert Read (New York: Schocken, 1964), 35.

17. See Barbara Novak, *Nature and Culture: American Landscape and Painting 1825–75*, (New York: Oxford University Press, 1980, 1995), 255–272.

18. Quoted in Stanley Vogel, *German Literary Influences on the American Transcendentalists* (New Haven: Yale University Press, 1955), 103.

19. Quoted in Elizabeth Gilmore Holt, ed., *From the Classicists to the Impressionists: A Documentary History of Art* (Garden City, N.Y.: Anchor Books, 1966), 90.

20. Quoted in Lorenz Eitner, *Neoclassicism and Romanticism 1750–1859*, Sources and Documents in the History of Art Series, Vol. 2 (Englewood Cliffs, N.J.: Prentice-Hall, 1970), 54–55.

21. Emerson, *Selected Writings*, 428, "Plato; or The Philosopher," 428.

22. Worringer, *Form in Gothic*, 179.

23. See Perry Miller, *Errand into the Wilderness* (New York: Harper & Row, 1964), 202–3. Quoted above, Chapter 1, p. 16.

24. Emerson, *Selected Writings*, "Nature," 18.

25. Ibid.

26. Ibid., "Spiritual Laws," 172.

27. See John I. H. Baur, "American Luminism," *Perspectives USA* (Autumn 1954), 90–98; see also Bloom, *Emerson: Modern Critical Views*, 106–7; and James M. Cox, ibid., "The Circle of the Eye," 46–50.

28. Emerson, *Selected Writings*, "Nature," 6.

29. See Mary Foley, "Fitz Hugh Lane, Ralph Waldo Emerson , and the Gloucester Lyceum," in *The American Art Journal* 27, nos. 1 and 2 (1995–96), 99–101.

30. Emerson, *Selected Writings*, "Nature," 14.

31. See *The Journals of Ralph Waldo Emerson*, abr. & ed. Robert N. Linscott (New York: Modern Library, 1960), 273, 29.

32. Heinz Kohut, quoted in *Narcissism and the Text: Studies in the Literature and the Psychology of Self*, ed. Lynne Layton and Barbara Ann Schapiro (New York: New York University Press, 1986), 3.

33. See R. W. B. Lewis, *The American Adam: Innocence, Tragedy and Tradition in the 19th Century* (Chicago: University of Chicago Press, 1965), 13–27.

34. Quentin Anderson, *The Imperial Self* (New York: Random House, Vintage, 1971), 47.

35. Emerson, *Selected Writings*, "Self-Reliance," 144.

36. See Joel Porte, *Emerson in His Journals*, 378.

37. See John J. Babson, *History of the Towns of Gloucester, Capestown, Cambridge* (1860; reissued Peter Smith, Gloucester, 1972), 598 ff. Statistics relating to the fisheries indicate that mackerel, halibut, and codfish were the most lucrative catches. See also Porte, *Emerson in His Journals*, 377: "When I got into the P. coach in old times, a passenger would ask me 'How's fish'?" (August 1847).

38. James Jackson Jarves, *The Art-Idea*, ed. Benjamin Rowland (Cambridge, Mass.: Harvard University Press, 1960), 205.

39. See *The Journal of Henry D. Thoreau*, ed. Bradford Torrey and Francis H. Allen (New York: Dover, 1962), 1:56 (June 26, 1840).

40. Emerson, *Selected Writings*, "The Over-Soul," 239.

41. See Thoreau, *Journal of Thoreau*, 1:200 (June 3, 1851).

42. Maurice Merleau-Ponty, *The Phenomenology of Perception* (London: Routledge & Kegan Paul, 1976), 415.

43. Ibid.

44. Emerson, *Selected Writings*, "Self-Reliance," 143.

45. Ibid., "The Over-Soul," 239.

46. Samuel Beckett, *Stories and Texts for Nothing* (New York: Grove, 1967), 112.

47. Thomas Mann, *The Magic Mountain* (New York: Vintage, 1969), 547.

48. See Thoreau, *Journal of Thoreau*, 1:37 (April 4, 1839).

49. Emerson, *Selected Writings*, "Nature," 9, 18.

50. Ibid., "The Over-Soul," 238.

51. Ibid., "Nature," 17.

52. Ibid., "The Poet," 296.

53. Jonathan Edwards, *Images or Shadows of Divine Things*, ed. Perry Miller (New Haven: Yale University Press, 1948), 63.

54. Porte, *Emerson in His Journals*, 286.

55. Emerson, *Selected Writings*, "Spiritual Laws," 172.

56. Quoted by Poirier in Bloom, *Emerson: Modern Critical Views*, 176, from "Intellect."

57. Ibid., "Self-Reliance," 150.

CHAPTER 3 *Thoreau and Indian Selfhood: Circles, Silence, and Democratic Land*

1. C. J. Jung, *Aion: Researches into the Phenomenology of the Self*, tr. R. F. C. Hull, Bollingen Series 20 (Princeton: Princeton University Press, 1959), 223–24. Jung's idea of the wholeness with which he associates both self and circle may have stemmed from, or at least been reinforced by, his contacts with primal peoples in both Africa and New Mexico. When he built his tower retreat at Bollingen, Switzerland, in 1923, he initially planned a round structure with a hearth in the center: "I had more or less in mind an African hut where the fire, ringed by a few stones, burns in the middle, and the whole life of the family revolves around this center. Primitive huts concretize an idea of wholeness in which all sorts of small domestic animals likewise participate" (C. G. Jung,

Memories, Dreams, Reflections, ed. Aniela Jaffe [New York: Vintage Books, 1965], 223–26). Though ultimately he modified his plans, adding larger sections, the whole complex became for him "a symbol of psychic wholeness" which gave him the feeling of being "reborn in stone." At Bollingen, he wrote, "At times I feel as if I am spread out over the landscape and inside things, and am myself living in every tree, in the plashing of the waves, in the clouds and the animals that come and go, in the procession of the seasons." Since such a comment is not unlike the beliefs of American Indians in an interrelatedness with nature and world, he may have felt such affinities on his visit to the Pueblo Indians in Taos (ibid., 246–53), recognizing that the Indians lived "cosmologically meaningful lives" and that their ritual actions as "the sons of Father Sun" helping their father to go daily across the sky, as his Indian host Ochwiay Biano (Mountain Lake) put it, raised the "individual to the dignity of a metaphysical factor."

2. In dealing with the diverse cultures of the first Americans, I have tried to stress the commonalities of religious and philosophical beliefs within the Indian worldview. See Ralph T. Coe, *Sacred Circles: Two Thousand Years of North American Indian Art*, Exhibition Catalogue (Kansas City, Mo.: Nelson Gallery of Art, 1977), 14–15. Coe notes that "the circle often stood for unity in the Indian view, a symbol of tribal unity and a link with the universe.... The title ...—Sacred Circles—is admittedly a compression of form into content. How can one unify the concepts behind the diverse cultures of a people that spoke 650 dialects, with ecologies as varying as the tundra, and the southern forests?" Faced with the necessity of synthesis, Coe finds unifying principles in the ubiquitous use of the circle: "The round medicine lodges of the Ankara on the upper Missouri River were oriented strongly to the four cardinal points ... the lodges were designed to imitate the universe.... The sundance lodges of the Plains Indians were similarly round, though more open to the weather.... Indian time was continuity and measure did not interrupt it. The world view was basically circular, not linear." Despite the widely disparate Native cultures, with different languages, origins, and religious rituals, Joseph Epes Brown in *The Spiritual Legacy of the American Indian* (New York: Crossroads, 1982), x–xi, has suggested that it is possible to define a range of fundamental principles "central to and operative within any one Native American culture," shared principles underlying sacred concepts specific to each of nature's manifestations and also to what could be called "sacred geography." Brown refers to such principles as a model of "the multiple dimensions of the sacred which come together in an organic manner in any one Native American culture." Noting that "to ignore the diversity of origin, place, language and resulting cultural forms, as is so often done under a plethora of stereotypes, does a great disservice to the American Indian peoples and their history," he nonetheless suggests that over time and through the intensification of intertribal contacts, even the diverse Plains and Prairie tribes developed a style of life and thought "expressing a commonality of religiocultural traits."

In *Seeing With a Native Eye*, a collection of essays on Native American Religion, ed. Walter Holden Capps (New York: Harper & Row, 1976), Joseph Epes Brown again refers to a "common language of the sacred" (28). Here, too, N. Scott Momaday (84–85) has said that "when the native American looks at nature, it isn't with the idea of training a glass upon it, or pushing it away so that he can focus upon it from a distance. In his mind, nature is not something apart from him. He conceives of it, rather, as an element in which he exists. He has existence within that element, much in the same way we think of having existence within the element of air." Cf. Emerson, "Art," in *The Selected Writings of Ralph Waldo Emerson*, ed. Brooks Atkinson (New York: Modern Library, 1992), 281: "A true announcement of the law of creation, if a man

were found worthy to declare it, would carry art up into the king of nature, and destroy its separate and contrasted existence." Momaday (ibid.) tells a wonderful story about a friend who became ill with pneumonia and was told he needed a red ant ceremony. After he was cured, he wondered why that particular ceremony was prescribed for him. His father-in-law told him that obviously there were red ants in his system that had to be taken out by a seer. The friend said, "'Surely you don't mean that there were red ants inside of me.' His father-in-law looked at him for a moment, then said, 'Not ants, but ants.'" "Unless you understand the distinction," Momaday notes, "you might have difficulty understanding something about the Indian view of the natural world."

3. See Emerson, *Selected Writings*, 252–62.

4. Robert F. Sayre, *Thoreau and the American Indians* (Princeton: Princeton University Press, 1977). See especially Chapter 4, "A Book about Indians?", 101–22.

5. Ms., Morgan Library, New York, Henry David Thoreau, "Extracts Relating to the Indians," Vol. 7. I am grateful to the Morgan Library for making this material available to me.

6. Ibid.

7. See Emerson, *Selected Writings*, 819–20, where he points out in his funeral address after Thoreau's death that "His visits to Maine were chiefly for love of the Indian. . . . In his last visit to Maine he had great satisfaction from Joseph Polis, an intelligent Indian of Oldtown, who was his guide for some weeks." And (817) "He knew how to act immovable, a part of the rock he rested on. . . ."

8. Sayre, *Thoreau and the American Indian*, 97.

9. See T. C. McLuhan, *Touch the Earth* (New York: Simon & Schuster, A Touchstone Book, 1971), 42, where Black Elk's birthdate is given as 1863. See also Joseph Epes Brown, *The Sacred Pipe* (Norman: University of Oklahoma Press, 1989), xiv. Brown, who lived with Black Elk and his family in the winter of 1947, gives his birthdate as 1862.

10. McLuhan, *Touch the Earth*, 42. See also Brown, *Spiritual Legacy*, 35.

11. Sayre, *Thoreau and the American Indian*, xii, asserts: "I firmly agree with earlier scholars who have shown that Thoreau's real literary and intellectual heritage was the classics, East Indian philosophy, the great prose stylists of the seventeenth century, travel literature, and the English romantic poets. 'The Indian' of savagism served Thoreau in other ways."

12. Ibid., 129.

13. Ibid.

14. See R. C. Zaehner, ed., *Hindu Scriptures* (London: J. M. Dent, Everyman's Library, 1966), viii.

15. See illustration (p. 47), Mandan Painted Buffalo Robe, ca. 1845, where the thin "crooked" white lines have been read as suggesting "a symbolic reference to sacred power radiating from the design" (Thaw Collection Object Worksheet, New York State Historical Association, Fenimore House Museum, Cooperstown, N.Y.).

16. Emerson, *Selected Writings*, 239.

17. Ibid., 252.

18. Ibid., 441, 443–44.

19. For a full presentation of Black Elk's words see John G. Neihardt (Flaming Rainbow), *Black Elk Speaks* (New York: Pocket Books, 1972). Black Elk, an Oglala Sioux, spoke in Sioux. His words were translated by his son and dictated to Neihardt in the early 1930s. The book was first printed in 1932.

20. Ibid., 164. Quoted also in McLuhan, *Touch the Earth*, 42, and Sayre, *Thoreau and the American Indian*, 59.

21. Emerson, *Selected Writings*, 45.

22. *The Journal of Henry D. Thoreau*, ed. Bradford Torrey and Francis H. Allen (New York: Dover Publications, 1962), 2:1423 (February 3, 1859).

23. Emerson, *Selected Writings*, 117.

24. Ibid., 131.

25. Ibid., 241.

26. Quoted in Mircea Eliade, *The Sacred and The Profane: The Nature of Religion* (Harcourt, Brace, 1939), 36.

27. Ibid., 46.

28. Mircea Eliade, *Symbolism: The Sacred and The Arts*, ed. Diane Apostolos-Cappadona (New York: Crossroad Publishing, 1985), 118.

29. Catlin included engravings after these paintings in his *Letters and Notes on the Manners, Customs, and Condition of the North American Indians*, 1841, 2 vols. See 8th edition (London: Henry G. Bohn, 1851), plates 47, 48, 67, 69.

30. On November 8, 1855, Thoreau wrote to Cholmondeley after receiving the books: "...what was that which dimmed the brightness of the day, like the apex of Cotopaxi's cone, seen against the disk of the sun by the voyager of the South American coast. 'Bhagvat Geeta'! whose great unseen base I can faintly imagine spreading beneath." One wonders if he had seen or heard of one of Church's Cotopaxi paintings by then. See Arthur Christy Papers, Book One, Columbia University Rare Book and Manuscript Library, copied by Dr. Christy from a transcript of Thoreau's papers in Sophia Thoreau's hand in the W. T. H. Howe collection. The Christy papers include a list of the books Thoreau received from Cholmondeley, including eight volumes of the *Mandukya Upanishad* and also a list of books borrowed from the Harvard Library, which included Asian books such as the *Sama Veda* and Wilkins's *Bhagvat Geeta*, along with Schoolcraft on the Indian Tribes and the Jesuit Relations of 1637 and 1638. On October 26, 1856, Thoreau wrote Cholmondeley again: "They are the nucleus of my library.... The books have long been shelved in cases of my own construction made partly of the driftwood of our river... Alcott and Emerson, besides myself, have been cracking some of the nuts... all the Vedantic literature is priceless." Ibid. My thanks to the library and to Mary Dobbie for making this material available.

31. Thoreau, *Journal*, 1:111 (1845).

32. See Henry David Thoreau, *A Week on the Concord and Merrimack Rivers, Walden; or, Life in the Woods, The Maine Woods, Cape Cod* (New York: The Library of America, 1985), 840–45.

33. Thoreau, *Journal*, 1:34 (December 15, 1838).

34. Ibid., 56.

35. Zaehner, *Hindu Scriptures*, 191, 276.

36. Ibid., 234.

37. See Charles A. Eastman (Ohiyesa), *The Soul of The Indian: An Interpretation* (Lincoln: University of Nebraska Press, 1980), 89. Quoted in McLuhan, *Touch the Earth*, 110.

38. Quoted in Henry David Thoreau, *The Maine Woods*, foreword by Richard F. Fleck (New York: Harper & Row, 1987), Introductory Note, lii (Letter of August 18, 1857, to Mr. Blake).

39. Thoreau, *Journal*, 1:114 (August 23, 1845).

40. Thoreau, *The Maine Woods*, 248.

41. Quoted in ibid., xxxi.

42. Sayre, *Thoreau and the American Indian*, 90–91.

43. Thoreau, *Journal*, 1:85 (August 6, 1841).

44. Ibid., 87 (August 28, 1841).

45. Ibid., 111 (1845).

46. *Indian Oratory*, compiled by W. C. Vanderwerth, foreword by William R. Carmack (Norman: University of Oklahoma Press, 1987), 101. See also John Ehle, *Trail of Tears: The Rise and Fall of the Cherokee Nation* (New York: Doubleday Anchor, 1958), 315, for the report of an Englishman, George W. Featherstonhaugh, who traveled among the Cherokee in 1837: "A whole Indian nation abandons the pagan practices of their ancestors, adopts the Christian religion, uses books printed in their own language, submits to the government of their elders, builds houses and temples of worship, relies upon agriculture for their support, and produces men of great ability to rule over them, and to whom they give a willing obedience. Are not these the great principles of civilization? They are driven from their religion and social state then, not because they cannot be civilized, but because a pseudo set of civilized beings, who are too strong for them, want their possessions." See also for the poignant reaction of a poet today, William Jay Smith, *The Cherokee Lottery* (Willimantic, Conn.: Curbstone Press, 2000).

47. J. Hector St. John de Crevecoeur, *Letters from an American Farmer* (New York: E. P. Dutton, 1957), 210.

48. Henry Nash Smith, *Virgin Land* (New York: Vintage Books, 1950), 205.

49. Thoreau, *A Week on the Concord*, 492–93.

50. Quoted in Sayre, *Thoreau and the American Indian*, 169.

51. Thoreau, *Journal*, 1:81.

52. Ibid., 129–30.

53. Smith, *Virgin Land*, 211–13.

54. Thoreau, *Journal*, 1:130.

55. Quoted in Perry Miller, "Nature and the National Ego," in *Errand into the Wilderness* (New York: Harper & Row, 1964), 210.

56. Vanderwerth, *Indian Oratory*, 27.

57. Ibid., 87.

58. McLuhan, *Touch the Earth*, 85.

59. Vanderwerth, *Indian Oratory*, 126.

60. See William Cronon, *Changes in the Land: Indians, Colonists, and the Ecology of New England* (New York: Hill & Wang, 1983), 56.

61. Alexis de Tocqueville, *Journey to America*, tr. George Lawrence and ed. J. P. Mayer (Garden City, N.Y.: Doubleday, 1971), 354.

62. Cronon, *Changes in the Land*, 161.

63. McLuhan, *Touch the Earth*, 53.

64. Thoreau, *A Week on the Concord*, 44.

65. See Neihardt, *Black Elk Speaks*, 166; also McLuhan, *Touch the Earth*, 152.

66. See also John R. Stilgoe, *Common Landscapes of America, 1580 to 1845* (New Haven: Yale University Press, 1982), 43, who traces the development of New England town plans from a 1635 document, "The Ordering of Towns," which proposes "a plantation of six concentric zones set within a territory six miles square; the meetinghouse, 'the center of the whole circumference,' is the point about which the ideal plantation is ordered." Stilgoe notes (99) ". . . the six-mile-square town persisted in New England thinking as an attractive epitome of the cherished landschaft of memory and as a practical size for a meetinghouse-focused settlement, although the square shape itself received less support. . . ." Ultimately, however, he traces the persistence of that thinking into the grid of what he terms "checkerboard America," observing (101) that by 1784, "New York specified that each township be six miles square. . . ." I find it of some interest here that white America chose to perpetuate the measured square, rather

than the concentric circles which were also part of the anonymous New Englander's concept of "The Ordering of Towns."

67. Sayre, *Thoreau and the American Indian*, 61–62.
68. Thoreau, *A Week on the Concord*, 46.
69. Ibid., 126.
70. Zaehner, *Hindu Scriptures*, 72.
71. Thoreau, *A Week on the Concord*, 110–111.
72. Ibid., 116.
73. Zaehner, *Hindu Scriptures*, 291.
74. Thoreau, *A Week on the Concord*, 123.
75. Thoreau, *Journal*, 1:31–32 (August 13, 1838).
76. Ibid., 104 (March 23, 1842).
77. Brown, *Spiritual Legacy*, 78.
78. Thoreau, *A Week on the Concord*, 318.
79. Thoreau, *Journal*, 1:34 (December 15, 1838).
80. Ms., Morgan Library, "Extracts," Vol. 7.
81. Thoreau, *Journal* (1837–47), 129.
82. See Brown, *The Sacred Pipe*, 42, where he speaks of the liberation from the ego in leaving the darkness of the Oglala Sioux purification lodge and going out into the only reality, Wakan-Tanka, represented by the light of day. Cf. Emerson, *Selected Writings*, 238: "From within or behind, a light shines through us upon things, and makes us aware that we are nothing, but the light is all."
83. See also Calvin Luther Martin, *The Way of the Human Being* (New Haven: Yale University Press), 1999. Writing about Yup'ik Eskimo belief (139) Martin refers to the Yup'ik idea of the "co-mingling, the seamlessness, the possession even, of oneself by the wholeself."

CHAPTER 4 *Whitman and Church: Transcendent Optimism and the Democratic Self*

1. Alexis de Tocqueville, *Democracy in America* (New York: Vintage, 1945), 1:301.
2. See Quentin Anderson, *The Imperial Self* (New York: Vintage, 1971), 160.
3. See *Walt Whitman: Poetry and Prose*, sel. Justin Kaplan (New York: Library of America, 1982), "Song of Myself," 246.
4. See Stephen E. Whicher, "Whitman's Awakening to Death," ed. R. W. B. Lewis (New York: Columbia University Press, 1962), 1–27.
5. Whitman, *Poetry and Prose*, 190.
6. Ibid., "One's-Self I Sing," 165.
7. Tocqueville, *Democracy in America*, 1:253.
8. There was, of course, a distinction between the receptions of Whitman and Church by their respective audiences. Church was a huge public success, attracting paying crowds to the exhibitions of his paintings as a kind of theater. Whitman, on the other hand, never commanded the attention of the large public he felt he was writing for.
9. Whitman, *Poetry and Prose*, "Democratic Vistas," 949.
10. Quoted in Didier Anzieu, *The Skin Ego: A Psychoanalytic Approach to the Self* (New Haven: Yale University Press, 1989), 85.
11. Whitman, *Poetry and Prose*, "Song of Myself," 215, 217.
12. Ibid., 217.
13. Ibid., 210.
14. Irving Howe, in *American Newness: Culture and Politics in the Age of Emerson* (Cambridge: Harvard University Press, 1986), 37, speaks of "a strange passiveness in

Whitman." Howe reminds us that Whitman carried "the Emersonian vision into new settings ... the commercial city of mobs, toughs, loners, stragglers, and strangers." In mainstream American landscape painting of the same period, there are only hints of growing urban incursions on the landscape, and most of these are relegated to a minuscule role within the context of nature, and glossed over with the glow of progress, as for example, Durand's "Progress" of 1853. See Barbara Novak, *Nature and Culture* (New York: Oxford University Press, 1980, 1995), Ch. 8, "Man's Traces: Axe, Train, Figure," especially 198, for a consideration of the moral blindness of the age, especially that of the painters. Whitman embraced more ambiguities in his writing than did the painters. In his words: "I am he who knew what it was to be evil; / I too knitted the old knot of contrariety...." (Whitman, *Poetry and Prose*, 311, in "Crossing Brooklyn Ferry"). Whitman's inclusion of the degradations of the cities, of prostitution and disease, of the moral abuses of slavery, was outside the range of the painters' concerns. Nature, however, for both the poet and the painters, had a cleansing and restorative effect.

15. See David S. Reynolds, *Walt Whitman's America* (New York: Alfred A. Knopf, 1995), 397.

16. Ibid.

17. Richard Chase, "Go-Befores and Embryons," in *Leaves of Grass: One Hundred Years After*, ed. Milton Hindus (Stanford, Calif.: Stanford University Press), 47: "He allowed early biographies of himself to be published (he even collaborated more or less in their composition) which contained misleading information: such as that the author of *Leaves of Grass* had, by 1855, traveled throughout the United States and therefore, knew at firsthand the geographical phenomena the poems celebrate."

18. Whitman, *Poetry and Prose*, "Song of Myself," 217.

19. Ibid., "Preface to *Leaves of Grass*," 7.

20. Ibid., "Democratic Vistas," 960.

21. Ibid., "Preface to *Leaves of Grass*," 7.

22. Ibid., "By Blue Ontario's Shore," 470.

23. Ibid., "Preface to *Leaves of Grass*," 5.

24. Rob Wilson, *American Sublime* (Madison: University of Wisconsin Press, 1991), 144.

25. Whitman, *Poetry and Prose*, 5.

26. Ibid., 287, from "Salut au Monde." Also quoted by David Daiches, "Walt Whitman: Impressionist Prophet," in Hindus, *Leaves of Grass: One Hundred Years After*, 115.

27. Whitman, *Poetry and Prose*, "Song of Myself," 211.

28. This quote and the ones in the previous paragraph from Mark Twain, *The Letters of Mark Twain*, Vol. 1, 1853–1866 (Berkeley: University of California Press, 1988), 116, letter of March 18, 1861, to Orion Clemens. I am grateful to Margaret Sanborn for this reference.

29. Whitman, *Poetry and Prose*, "For You O Democracy," 272.

30. Ibid., "Song of the Exposition," 348.

31. See Howe, *American Newness*, 70.

32. See *The Portable Walt Whitman*, selected and with notes by Mark Van Doren (New York: Viking, 1973), xxv, where Van Doren, in his Introduction, calls it "a powerful indictment of the shortcomings of American democracy in Whitman's time, as well as an eloquent reminder of what democracy at its best is supposed to mean...."

33. Whitman, *Poetry and Prose*, 935–36.

34. Ibid., 942. Whitman (ibid., 958), recognizes the paradox, speaking of "democracy, the leveler, the unyielding principle of the average" joined to "another principle, equally unyielding, closely tracking the first, indispensable to it, opposite (as the sexes are

opposite)," whose existence confronts and modifies the other, "often clashing, paradoxical, yet neither of highest avail without the other. . . ." He names this second principle: "individuality, the pride and centripetal isolation of a human being in himself—identity—personalism."

35. Ibid., 947.
36. Quoted in Perry Miller, *The Life of the Mind in America: From the Revolution to the Civil War* (New York: Harcourt, Brace & World, 1965), 57.
37. See *The Natural Paradise: Painting in America 1800–1950* (New York: Museum of Modern Art, 1976), 44. See also Sarah Cash, *The Ominous Hush: The Thunderstorm Paintings of Martin Johnson Heade* (Fort Worth: Amon Carter Museum, 1994).

 There is no doubt that the artists were saddened and troubled by the war. Church and other colleagues at the Tenth Street Studio were distressed, for example, by Gifford's familial tragedies and losses during the war, including that of his brother Edward, a captain in the Union army, who died of typhoid fever after escaping from a Confederate prison camp in New Orleans. The question, however, is how much it was manifested in their paintings. My contention is that in their works, and in the many benign paintings produced during that period, they evaded the unpleasant as much as possible. That denial of evil runs through much of American culture to the present.

38. See Angela Miller, *The Empire of the Eye: Landscape Representation and American Cultural Politics, 1825–75* (Ithaca, N.Y.: Cornell University Press, 1993), 128–36.

 The idea of Cotopaxi as a reference to the Civil War goes at least as far back at David Huntington, the savior of Olana and Church's first major scholar. See especially Huntington's essay in the *American Light* catalogue (Washington, D.C.: National Gallery of Art, 1980), 155–87, where he admits (180) that "painting an Andean scene, Church would speak of the war only in the form of parable. Hardly a clue is offered in his printed sheet for Cotopaxi's viewers. . . . Church made no prescription as to how Cotopaxi might be interpreted." Yet he concludes (187) by suggesting: "To think of Cotopaxi as the Guernica of our Civil War is to be close to the mark."

 Gifford had enlisted in the Seventh Regiment of the New York State National Guard, stationed in Washington, D.C., and in Baltimore. But Kevin Avery has reminded us that "privileged by his wealth, which enabled him to avoid the military draft, Church like many of his artistic colleagues had been spared direct involvement in the conflict." See *Treasures from Olana: Landscapes by Frederic Edwin Church* (Hudson, N.Y.: The Olana Partnership, 2005), 44. Church's intentions with regard to Cotopaxi and the war remain, I feel, problematic.

39. Ibid., 135–36. See also Franklin Kelly, with Stephen Jay Gould, John Anthony Ryan, and Debora Rindge, *Frederic Edwin Church* (Washington, D.C.: National Gallery of Art, 1989), 62. Kelly takes the same tack: "Church had begun 'Rainy Season in the Tropics' when some of the bloodiest battles of the Civil War were being fought, but finished it after the war had ended. In it he reaffirmed with almost visionary intensity his hope for the nation. The rainbow, emblem of God's covenant with mankind, symbolically joins the separated halves of the landscape, just as the conclusion of the war reunited the fragmented nation." Kelly (n. 147) also observes: "[T]he religious implications of the painting would have been even more obvious had Church not painted out the church he originally included at the left end of the rainbow." One can argue, however, that Church had frequently painted churches as a natural part of the landscape whenever he came upon them earlier in South America well before the war, and that quite apart from its symbolism, considered himself a master of the rainbow as a natural phenomenon, taking great pride in this special gift and helping other artists

with their "bows." Ruskin had even been fooled by Church's rainbow in Niagara (1857). See Novak, *Nature and Culture*, 299–300, n. 46. Thus it seems a bit hazardous to read into *Rainy Season* a serendipitous symbolic coincidence of its termination with the end of the war.

40. The two drawings on the back of the 1863 letter from his mother, in the collection of Olana State Historical Site, clearly indicate the early inspiration and genesis of *Rainy Season*. See *Nature Observed, Nature Interpreted*, catalogue ed. Dita Amory and Marilyn Symmes (New York: National Academy of Design with Cooper-Hewitt National Design Museum, Smithsonian Institution, 1995), 52–54. Marilyn Symmes observed (54), "The 1863 drawings . . . indicate that the rainbow was a part of the original conception, which predates the personal and national events that affected Church's life. Thus, the post–Civil War significance generally attributed to this painting may be more than Church originally intended." Symmes writes, "He probably did this more finished study by May 1863, when there was a public announcement about the tropical picture commissioned by Marshall O. Roberts. . . ." See Symmes, n. 3, for further discussion of the dating. Though Miller fails to mention preliminary drawings, Kelly reproduces the scaled-off study in the Cooper-Hewitt National Design Museum and dates it 1863–66. Though he does state clearly that Church began the painting earlier, while the war was raging, he adheres to his interpretation of the painting as a redemptive postwar affirmation.

41. See Novak, *Nature and Culture*, 67–77, for an elaboration of my views on Church and Creation. For a judicious placing of the 1862 *Cotopaxi* within the development of Church's volcano paintings, see also Katherine E. Manthorne, *Tropical Renaissance: North American Artists Exploring Latin America, 1839–1879* (Washington, D.C.: Smithsonian Institution Press, 1989), 67–81.

42. See David C. Huntington, *The Landscapes of Frederic Edwin Church* (New York: Braziller, 1966), 51–52.

43. See Novak, *Nature and Culture*, 75–76.

44. Horace Traubel, *With Walt Whitman in Camden (March 28–July 14, 1888)* (Boston: Small, Maynard, 1906), 157.

45. See Whitman, *Poetry and Prose*, "Democratic Vistas," 985n.

46. See Whitman, *Portable Walt Whitman*, Introduction, xxiii, xxii, where he is quoted. Van Doren here speaks of Whitman's hard-won effort to love death. I feel that his interest in Swedenborgianism should be factored in as well. (See Justin Kaplan, *Walt Whitman: A Life* [New York: Simon & Schuster, 1980], 192–23.) The Swedenborgian awareness of spirit nourished and helped found the American Spiritualist Church. Possibly it offered Whitman the spiritual center he sought, which would redeem the greed and mispractices indicated in "Democratic Vistas" and enable all of being to be melted into one idea that was, at core, spiritual. His investigation and probable acceptance of the idea of life after death could well have been a factor in Whitman's ability to accept death as beautiful. See also Whitman, *Poetry and Prose*, "Democratic Vistas," 984–85n.: "The culmination and fruit of literary artistic expression and its final fields of pleasure for the human soul, are in metaphysics, including the mysteries of the spiritual world, the soul itself, and the question of the immortal continuation of our identity."

47. Whitman, *Poetry and Prose*, 449.

48. Ibid., 453.

49. David S. Reynolds, *Beneath the American Renaissance* (Cambridge, Mass.: Harvard University Press, 1989), 519, 520.

50. Reynolds, *Whitman's America*, 252.

51. See H. T. Tuckerman, *Book of the Artists* (1867; reprint, New York: James F. Carr, 1966), 380.

52. Whitman, *Poetry and Prose*, "Song of the Open Road," 300.

53. Ibid., "Song of Myself," 241.

54. Ibid., 244.

55. Ibid., "A Woman Waits for Me," 258–59. The issue of sexuality in Whitman is especially pertinent here. Church's sexual behavior, like that of most of the landscape painters, seems to have been steeped in bourgeois convention. One of the few small scandals involved Bierstadt running off with Fitz Hugh Ludlow's wife, Rosalie, after he and Ludlow had traveled west together in 1863. But Ludlow was a hash addict, so Bierstadt had public morality on his side. By and large, however, and in contrast to their more Bohemian European counterparts, the American painters were dominated by puritan restraint.

 Whitman's sexuality, of course, dominates the way in which he is often seen, from the shocking effect on his 1855 audience of his first publication of *Leaves of Grass* to present gender-oriented scholars. Despite the veils of anecdote with which he attempted to obfuscate his sexuality (most especially the mythic claim to six illegitimate children and the ministrations of a mysterious woman in New Orleans), his celebration of homoerotic *adhesiveness* pervades his work. The evidence suggests that he was not even bisexual but probably simply homosexual, though even this he tended to deny (see Reynolds, *Beneath the American Renaissance*, 326–28, and his suggestion that adhesiveness, or same-sex affection, was a phrenological term of the day which could refer to comradely rather than homosexual love). See also Richard Ellman, *Oscar Wilde* (New York: Vintage, 1988), 171, for Wilde's contention that "Whitman had made no effort to conceal his homosexuality from him." I am indebted to Mary W. Blanchard for this reference.

 The overtones of rough sex in "A Woman Waits For Me": "I do not hurt you any more than is necessary for you . . . I listen to no entreaties," have been seen as suggestive of rape. But he speaks in the same poem of the woman who knows and avows the deliciousness of her sex, dismissing himself from "impassive women" and going instead to the women who will "understand me, and do not deny me," stating firmly: "They are not one jot less than I am." Though there is an element of force in his tone—"I cannot let you go. I would do you good"—it is also possible that he conceived of the sexual act in terms of combative and not necessarily polite energies—"I press with slow rude muscle"—and speaks at the end of the "loving crops from the birth, life, death, immortality, I plant so lovingly now." Though Kaplan, *Whitman: A Life*, 285n., quotes an early acquaintance from Huntington who claimed, "He seemed to hate women," it is of some interest that one of Whitman's most fervent admirers was Laura Curtis Bullard, a leading suffragette, who saw him as a champion of women's rights and equality. See Reynolds, *Beneath the American Renaissance*, 392: "The link between Bullard and Whitman may have been even more significant than one of mutual appreciation: Whitman's broadly progressive attitude toward women—embracing the political, the passional, the economic, and the literary aspects of the woman question—greatly resembled Bullard's."

56. Whitman, *Poetry and Prose*, "Song of Myself," 211.

57. Quoted in R. W. B. Lewis, *The American Adam* (Chicago: University of Chicago Press, 1955), 43.

58. See Louis L. Noble, *The Heart of the Andes*, New York, 1859. Broadside, 4–5.

59. See Tuckerman, *Book of the Artists*, 371–72.

60. Whitman, *Poetry and Prose*, "Democratic Vistas," 957.

61. Maurice Merleau-Ponty, *The Phenomenology of Perception* (London: Routledge & Kegan Paul, 1976), 411.

62. Whitman, *Poetry and Prose*, "Democratic Vistas," 956.

63. Ibid., "Song of Myself," 239.

64. Ibid., "Democratic Vistas," 965.

65. Ibid., "Song of Myself," 238.

66. See Leslie A. Fiedler, "Image of Walt Whitman," in Hindus, *Leaves of Grass: One Hundred Years After*, 73.

67. Even democracy dwindled, Whitman felt, before "the idea of All, with the accompanying idea of eternity, and of itself, the soul, buoyant, indestructible, sailing space forever, visiting every region, as a ship the sea. And again lo! the pulsations in all matter, all spirit, throbbing forever—the eternal beats, eternal systole and diastole of life in things—wherefrom I feel and know that death is not the ending, as was thought, but rather the real beginning—and that nothing ever is or can be lost, nor ever die, nor soul, nor matter." Whitman, *Poetry and Prose*, "Democratic Vistas," 988.

68. Ibid., "Song of Myself," 206.

69. Ibid., 241.

70. Ibid., "Democratic Vistas," 960.

CHAPTER 5 *Homer and James: The Pragmatic Self Made Concrete*

1. See John Elof Boodin, "What Pragmatism Is and Is Not," in *William James as I Knew Him*, ed. Linda Simon (Lincoln: University of Nebraska Press, 1996), 228.

2. See R. W. B. Lewis, *The Jameses* (New York: Farrar, Straus & Giroux, 1991), 98.

3. For Agassiz, see Barbara Novak, *Nature and Culture* (New York: Oxford University Press, 1980, 1995), 62–65.

4. See Harold Bloom, *Agon: Towards a Theory of Revisionism* (New York: Oxford University Press, 1983), 20.

5. *The Writings of William James*, ed. John J. McDermott (Chicago: University of Chicago Press, 1977), 379.

6. Ibid.

7. Ibid.

8. See Barbara Novak, *Nineteenth-Century American Painting: The Thyssen-Bornemisza Collection* (New York: The Vendome Press, 1986), 24–27.

9. See *William James: Pragmatism and Other Writings*, ed. Giles Gunn (New York: Penguin, 2000), xxi.

10. Novak, *Nature and Culture*, 62.

11. See Perry Miller, *Jonathan Edwards* (Amherst: University of Massachusetts Press, 1981), 48. See also above, Chapter 1.

12. See Nicolai Cicovsky Jr., Franklin Kelly, et al., *Winslow Homer* (Washington, D.C.: National Gallery of Art, 1995), 393. Exhibition Catalogue.

13. James Jackson Jarves, *The Art-Idea* (1864; reprint ed. Benjamin Rowland Jr., Cambridge, Mass.: Harvard University Press, 1960), 205.

14. Herman Melville, *Moby-Dick*, ed. Harrison Hayford and Hershel Parker (New York: W. W. Norton, 1967), 235. See also Novak, *Nineteenth-Century American Painting*, 37–38, where these thoughts were first advanced.

15. Cicovsky, Kelly, et al., *Homer*, 27, 102–3, 122; also Chronology, 394.

16. Ibid., 104

17. Ibid., 102, 197–99. See Cat. 105 and 106. I would isolate these works as among the very few in which stroke and color in Homer's art might be read as conveying inner feelings and displaying strong personal emotions of "self."

18. See Patricia Junker, "Expressions of Art and Life in the Artist's Studio in an Afternoon Fog," in *Winslow Homer in the 1890's: Prout's Neck Observed* (Rochester, N.Y.: University of Rochester Memorial Gallery, 1990), 50.

19. See Philip C. Beam, *Winslow Homer at Prout's Neck* (Boston, Little, Brown, 1966), 39.

20. See also Junker, *Homer in the 1890s*, 114: ". . . in responding to his harsh environment at Prout's Neck, Homer was more likely to be optimistic, even ebullient, than otherwise. His nature allowed him to rise above difficulties, often with humorous comments that preserved his sense of balance and allowed him to enjoy life. He was especially appreciative of his excellent health."

21. See Elizabeth Johns, *Winslow Homer: The Nature of Observation* (Berkeley: University of California Press, 2002), 114.

22. Beam, *Homer at Prout's Neck*, 185–87.

23. William James, *Writings*, 379.

24. Ibid., 380.

25. Conversation with the author in the 1960s.

26. See Cicovsky, Kelly, et al., *Homer*, 367. Johns, *Winslow Homer*, 145, claims that Homer, with this comment, "played on the gullibility of his admirers, knowing that his pronouncements would be solemnly reported in the press." But the statement was made in utter seriousness, since this is standard artistic procedure for judging the "gestalt" of a work.

27. Homer kept in touch with Boston artist friends and visited his family in Belmont, Massachusetts, but James's family did not move from Newport to Boston until 1864.

28. Collection, Houghton Library, Harvard University. See Linda Simon, *Genuine Reality: A Life of William James* (Chicago: University of Chicago Press, 1998), unpaged, following 230.

29. Ibid., 28.

30. Lewis, *The Jameses*, 96.

31. Henry James's criticism of Homer, quoted in Lloyd Goodrich, *Winslow Homer* (New York: Macmillan, 1944), 53–54.

32. William James, *Writings*, 73.

33. F. O. Matthiessen, *The James Family* (New York: Knopf, 1947), 341.

34. Lewis, *The Jameses*, 183ff.

35. Ibid., 205–6.

36. William James, *Writings*, 296–97.

37. Ibid., 297.

38. See Linda Simon, ed., *William James Remembered* (Lincoln: University of Nebraska Press, 1996), 247, where Horace Kallen claims that though James accepted some aspects of Bergson's ideas, "there are very definite differences, in fact, antagonisms, between the systems of the two men." John Boodin (ibid., 227) states that "Bergson . . . did not seem to figure in James' imagination until the former's publication of his *Creative Evolution*. . . . It was the concrete wealth of material and brilliancy of style of *Creative Evolution* which attracted James and which led him in his generous extravagance to speak of Bergson as master. How impossible that parentage is one can realize when one recalls that *The Will to Believe and Other Essays* had been out as a book (not to mention the dates of the chapters) since 1899. James' philosophy was already fairly before the world." In his lectures at Manchester College, Oxford, of 1908–09, James confessed (*Writings*, 562) that "Bergson's originality is so profuse that many of his

ideas baffle me entirely. I doubt whether any one understands him all over, so to speak. . . ." Yet he thought Bergson's style so straightforward that "it seduces you and bribes you in advance to become his disciple. It is a miracle, and he a real magician." "Dive back into the flux itself," James notes (ibid., 573) that Bergson tells us, "if you wish to *know* reality . . . turn your face toward sensation, that flesh-bound thing which rationalism has always loaded with abuse." See also ibid., 297, where James states in the lecture that followed the preceding one on Bergson, "it was only after reading Bergson that I saw that to continue using the intellectualist method was itself the fault." In the published version of the lectures as *A Pluralistic Universe* (1909) he refers to Bergson's "Matière et Memoire" on the relations of consciousness to action.

39. See Cicovsky, Kelly, et al., *Homer*, 251ff. Cicovsky notes that even with the leaping trout paintings, some critics were aware of the cruelty of the hook.

40. See ibid., 251. Cicovsky finds in such works that Homer was painting "indictments of . . . inhumane savagery" and links them to the Darwinian "order of nature." The question for me then becomes how much Homer deplored Darwinian savageries and expressed criticism of them in his art, or how much he took them as a "fact" of nature. See also David Tatham, "Trapper, Hunter and Woodsman: Winslow Homer's Adirondack Figures," *American Art Journal* 22, no. 4 (1990): 41–67; and David Tatham, "The Two Guides: Winslow Homer at Keene Valley, Adirondacks," *American Art Journal* 20, no. 2 (1988): 20–34. See also Judith Hayward, "Nature and Progress: Winslow Homer's Oils 1880–1900 (Ph.D. dissertation, Columbia University, 2002), 170ff. for a sensitive consideration of the Adirondack works.

41. Cicovsky, Kelly, et al., *Homer*, 274–78. The catalogue entry for *Huntsman and Dogs* stresses the critic Alfred Trumble's reaction, which notes that the type of huntsman is "lout and brutal in the extreme." Trumble, however, also found the painting "a cold and unsympathetic work."

42. Simon, *William James Remembered*, 175.

43. See Novak, *Nature and Culture*, 225. Whittredge wrote in his *Autobiography* on returning to America from Europe: ". . . how different was the scene before me from anything I had been looking at for many years! The forest was a mass of decaying logs and tangled brush wood, no peasants to pick up every vestige of fallen sticks to burn in their miserable huts, no well-ordered forests, nothing but the primitive woods with their solemn silence reigning everywhere."

44. Simon, *William James Remembered*, 179.

45. Ibid.

46. Ibid., 181.

47. Ibid., 194.

48. See Junker, *Winslow Homer in the 1890's*, 114.

49. See Cicovsky, Kelly, et al., *Homer*, 10. Though the authors claim that "there is a vast amount of primary material available on Homer," comments that would enlighten us as to his personal feelings, sense of self, and artistic practice and theory remain few. One of the best archival sources is the Homer Collection in the Bowdoin College Museum of Art, in Brunswick, Maine.

50. Ibid., 365.

51. Ibid., 366.

52. Ibid., 363. This is one of Homer's most extended comments about his work, frequently quoted in the literature.

53. William James, *Writings*, 312.

54. Ibid., 17.

55. Ibid., 27.

56. Ibid., 29.

57. Ibid., 33.

58. Ibid., 27.

59. See *The Selected Writings of Ralph Waldo Emerson*, ed. Brooks Atkinson (New York: Modern Library, 1992) in "Nature" (13): "Particular natural facts are symbols of particular spiritual facts" (17), "The world is emblematic" (18), Emerson quotes "every object rightly seen unlocks a new faculty of the soul."

60. William James, *Writings*, 183.

61. Ibid., 241.

62. Ibid., 181–82.

63. See Heinz Kohut, quoted in *Narcissism and the Text: Studies in the Literature and the Psychology of Self*, ed. Lynne Layton and Barbara Ann Schapiro (New York: New York University Press, 1986), 3: "Some of the most intense narcissistic experiences relate to objects; objects, that is, which are either used in the service of the self and of the maintenance of its instinctual investment, or objects which are themselves experienced as part of the self. I shall refer to the latter as *self-objects*."

64. Charles Olson, *Muthologos: The Collected Interviews and Lectures*, ed. George F. Butterick. Writing Series No. 35 (Bolinas, Calif.: Four Seasons Foundation, 1978–79), 47.

65. See Junker, *Winslow Homer in the 1890's*, 142. To Charles Homer, Jr., November 25, 1899. See also ibid., 59–62, for a consideration of the presence in Homer's library of George Chaplin Child's *The Great Architect: Benedicite, Illustrations of The Power, Wisdom and Goodness of God as Manifested in His Works*. Homer had received an 1871 edition from a friend, John Gourlie, in 1872 and kept the book in his library throughout his life. Junker, 62, suggests that Child's concepts of benevolent design in nature may have helped to shape Homer's late vision of the sea even in nature's "darkest, coldest, and most foreboding aspects." If true, this may have been some vestigial accommodation of certain earlier ideas of providential design to Homer's secular awareness of Darwinian brutalities. Taking her lead from Junker's work, Elizabeth Johns, *Winslow Homer*, has also emphasized this material.

66. William James, *Writings*, 771.

67. Ibid., 781.

68. Ibid., 390.

69. Ibid., 586.

70. Mircea Eliade, *The Sacred and the Profane: The Nature of Religion* (New York: Harper & Row, 1959), 155–56.

71. Mircea Eliade, *The Myth of the Eternal Return* (Princeton: Princeton University Press, 1991), 4. See also Emerson in *Emerson in His Journals*, ed. Joel Porte (Cambridge, Mass.: Harvard University Press, 1982), 241: ". . . the rock seemed good to me. I think we can never afford to part with Matter. How dear and beautiful it is to us! As water to our thirst, so is this rock to our eyes & hands & feet, It is firm water; it is cold flame."

72. Quoted in James Olney, *Metaphors of Self: The Meaning of Autobiography* (Princeton: Princeton University Press, 1972), 281.

CHAPTER 6 *Dickinson and Ryder: Immortality, Eternity, and the Reclusive Self*

1. William Homer and Lloyd Goodrich, *Albert Pinkham Ryder: Painter of Dreams* (New York: Abrams, 1989), 80.

2. Ibid., 110. Louise Fitzpatrick was a friend, neighbor, and pupil who along with her husband, Charles, cared for Ryder at 308 West 15th Street and again at 308 West 16th

Street in New York. He died ultimately in their home at 26 Gerry Avenue, Elmhurst, Long Island.

3. See *The Complete Poems of Emily Dickinson*, ed. Thomas H. Johnson (Boston: Little, Brown, 1960), 154, poem 325.

4. Homer and Goodrich, *Albert Pinkham Ryder*, 185, "Paragraphs from the Studio of a Recluse."

5. Ibid., 186.

6. Ibid., 212. I don't dwell here on Ryder's poems because they are too few in number and too questionable (for the most part) in quality to submit them to comparison with Dickinson's. Like Cole, however, who Dickinson evidently admired, Ryder was a painter who wrote poems. See also Judith Farr, "Dickinson and the Visual Arts," in *The Emily Dickinson Handbook*, ed. Gudrun Grabher, Roland Hagenbüchle, and Cristanne Miller (Amherst: University of Massachusetts Press, 1998), 61–92, for influences and parallels with Cole and also Church.

7. Dickinson, *Complete Poems*, 176, poem 370.

8. See Sandra M. Gilbert and Susan Gubar, *The Madwoman in the Attic* (New Haven: Yale University Press, 1979), 58, 85–86.

9. In one story, an opera singer, in another, a violinist whose playing so moved him that he proposed marriage. See Homer and Goodrich, *Albert Pinkham Ryder*, 79; also Elizabeth Broun, *Albert Pinkham Ryder* (Washington, D.C.: Smithsonian Institution Press, 1990), 87–90.

10. Ryder had many friends from his early days at the National Academy of Design and his membership in the Society of American Artists. He maintained warm relationships with such figures as the sculptors Theodore Baur and Olin Warner and the painter J. Alden Weir. See Homer and Goodrich, *Albert Pinkham Ryder*, "Ryder and His Friends," 31 ff.

11. See Jack L. Capps, *Emily Dickinson's Reading, 1836–1886* (Cambridge, Mass.: Harvard University Press, 1966), 86.

12. Dickinson, *Complete Poems*, 94, poem 199.

13. See "A Woman in White: Emily Dickinson's Yarn of Pearl," in Gilbert and Gubar, *Madwoman*, 581–650.

14. Dickinson, *Complete Poems*, 123–24, poem 271.

15. Gilbert and Gubar, *Madwoman*, 587ff.

16. Denis De Rougemont, *Love in the Western World* (Princeton: Princeton University Press, 1983), 42.

17. Ibid., 46.

18. Ibid., 41.

19. See *The Letters of Emily Dickinson*, ed. Thomas J. J. Johnson and Theodora Ward (Cambridge, Mass.: Harvard University Press, 1958), 2:373–74, Letter 233.

20. See Richard B. Sewall, *The Life of Emily Dickinson*, Vol. 2. on the Master Letters (New York: Farrar, Straus & Giroux, 1974), 512 ff.

21. See ibid., 444ff., for a consideration of Emily Dickinson and Charles Wadsworth. See also William R. Sherwood, *Circumference and Circumstance: Stages in the Mind and Art of Emily Dickinson* (New York: Columbia University Press, 1968), 69ff.

22. See Sewall, *Life of Emily Dickinson*, for Dickinson's relation with Samuel Bowles, 463ff., and Otis P. Lord, 642ff. See also Jay Leyda, *The Years and Hours of Emily Dickinson* (New Haven: Yale University Press, 1960), 2:34, for suggestions that an unnamed love also existed somewhere in the South where Emily visited and "met her fate." Also married. See also Roland Hagenbüchle, "Dickinson and Literary Theory," in Grabher, Hagenbüchle, and Miller, *The Emily Dickinson Handbook*, 382, which offers

other theories about the identity of the "Master": "Is the 'Master' a biographical person? And if so who is it? Is it really the same person in each of these poems? Or is it perhaps the Soul's 'Oversoul'? The mind's male animus? The self's creative alter ego? Is it (in some sense) Christ or Dickinson's appropriation of Christ? The looked for and always desired but infinitely deferred "Other"? A messenger of Eros or of Thanatos—or both? All we can safely say is that The 'Master' stands for what the lyric self lacks, desires, and fears. Biographical, psychological, cultural and existential aspects converge in this evasive figure. . . . What we cannot ignore . . . is the fact that the lyric self yearns to bind this Eros/Thanatos figure to itself either by submission or by an act of overpowering."

23. Dickinson, *Complete Poems*, 318, poem 640: "So we must meet apart – / You there – I – here – / With just the Door ajar / That Oceans are – and Prayer / And that White Sustenance – / Despair."
24. See Johnson and Ward, *Letters*, 2:374, letter 233.
25. See Leyda, *Years and Hours*, 16.
26. See Homer and Goodrich, *Albert Pinkham Ryder*, 12, and Broun, *Albert Pinkham Ryder*, 13, who states that Ryder was not born in the house on Mill Street but moved there when he was about eleven and that Bierstadt might have met Ryder on his brief return in 1857–58, though the possibility is remote.
27. Dickinson, *Complete Poems*, 132, poem 285: "Because I see – New Englandly – / the Queen, discerns like me – / Provincially –."
28. Gaston Bachelard, *The Poetics of Space* (New York: Orion Press, 1964), 150.
29. See Johnson and Ward, *Letters*, 2:489, letter 364.
30. Ibid., 609, letter 551.
31. Capps, *Emily Dickinson's Reading*, 82.
32. See Dickinson, *Complete Poems*, 234, poem 486: "I was the slightest in the House" and Johnson and Ward, *Letters*, 2:409, letter 265, to Thomas H. Higginson: "I have a little shape – it would not crowd your Desk –." See also *Complete Poems*, 494–95, poem 1094: "Themself are all I have – / Myself a freckled – be – / I thought you'd choose a Velvet Cheek / Or one of Ivory – / Would you – instead of Me?"
33. See Johnson and Ward, *Letters*, 1:13, letter 6, to Abiah Root: "I am growing handsome very fast indeed! I expect I shall be the belle of Amherst when I reach my 17th year." Also Leyda, *Years and Hours*, 1:92.
34. Dickinson, *Complete Poems*, 486, poem 1071.
35. See Jacques Lacan, *The Four Fundamental Concepts of Psycho-Analysis* (New York: W. W. Norton, 1981), 84.
36. See Gilbert and Gubar, *Madwoman*, 595.
37. See Broun, *Albert Pinkham Ryder*, 10.
38. Gilbert and Gubar, *Madwoman*, 58.
39. Dickinson, *Complete Poems*, 234, poem 486.
40. Ibid., 133, poem 288.
41. Sewall, *Life of Emily Dickinson*, 1:154
42. Sacvan Bercovitch, *The Puritan Origins of the American Self* (New Haven: Yale University Press, 1979), 14.
43. Dickinson, *Complete Poems*, 226, poem 470, and 114, poem 249.
44. Bercovitch, *Puritan Origins*, 18.
45. George Frisbie Whicher, *This Was a Poet* (New York: Scribner's, 1938), 156.
46. Dickinson, *Complete Poems*, 153, poem 324.
47. See ibid., 511, poem 1138; 297, poem 605, "The Spider holds a Silver Ball / In unperceived Hands – / And dancing softly to Himself / His Yarn of Pearl – unwinds –." See

also Barton Levi St. Armand, *Emily Dickinson and Her Culture: The Soul's Society* (Cambridge, Eng.: Cambridge University Press, 1984), 31ff., for a superb consideration of Emily Dickinson and spiders. Also, Gilbert and Gubar, *Madwoman*, 631ff. See above, Chapter 1, pp. 5–6, for Jonathan Edwards and spiders.

48. See Homer and Goodrich, *Albert Pinkham Ryder*, 16, and Broun, *Albert Pinkham Ryder*, 10. Broun suggests that Ryder's mother and grandmother may have belonged to a pietist sect.

49. Homer and Goodrich, *Albert Pinkham Ryder*, 16.

50. See Barbara Novak, *American Painting of the Nineteenth Century* (1969; New York: Harper & Row, 1979), 52–53.

51. Dickinson, *Complete Poems*, 618, poem 1459.

52. Capps, *Emily Dickinson's Reading*, 65.

53. Ralph Waldo Emerson, *Essays and Lectures* (New York: Library of America, 1983), 721.

54. Quoted in *The Psychoanalytic Review* 76, no. 3 (Fall 1989): 454.

55. Capps, *Emily Dickinson's Reading*, 63.

56. Dickinson, *Complete Poems*, 127, poem 277.

57. Ibid., 363, poem 741.

58. See Novak, *American Painting of the Nineteenth Century*, 48.

59. Quoted in Capps, *Emily Dickinson's Reading*, 62. See also Broun, *Albert Pinkham Ryder*, 90ff. Broun notes that Ryder "made a pilgrimage to Stratford-upon-Avon as part of his 1882 trip to Europe."

60. Quoted in Charles Olson, "Call Me Ishmael," in *Charles Olson: Collected Prose*, ed. Donald Allen and Benjamin Friedlander (Berkeley: University of California Press, 1997), 37.

61. Ibid., 18.

62. See Bachelard, *The Poetics of Space*, 183.

63. Ibid.

64. Dickinson, *Complete Poems*, 76, poem 162.

65. Edward F. Edinger, *Melville's Moby-Dick: A Jungian Commentary* (New York: New Directions, 1978), 22.

66. Dickinson, *Complete Poems*, 98–99, poem 214.

67. See Broun, 122ff. for a consideration of Ryder's technical and experimental processes.

68. See Lloyd Goodrich, *Albert P. Ryder* (New York: Braziller, 1959), 24.

69. See Leyda, *Years and Hours*, 2:66.

70. See Gaston Bachelard, *On Poetic Imagination and Reverie* (Dallas: Spring Publications, 1987), 79.

71. See Dickinson, *Complete Poems*, 6–7, poem 4.

72. Ibid., 39, poem 76.

73. Sewall, *Life of Emily Dickinson*, 1:126.

74. Dickinson, *Complete Poems*, 195, poem 410.

75. Quoted in Sewall, *Life of Emily Dickinson*, 2:522, n.6, letter to Bowles ca. August 1862. See also Johnson and Ward, *Letters*, 2:416, letter 2.

76. Dickinson, *Complete Poems*, 312, poem 632.

77. Ibid., 143, poem 303. After her father's death in 1874 she wrote to Higginson: "I am glad there is Immortality – but would have tested it myself before entrusting him." See Sewall, *Life of Emily Dickinson*, 2:562.

78. Dickinson, *Complete Poems*, 243, poem 501.

79. Bachelard, *On Poetic Imagination and Reverie*, 105.

80. Dickinson, *Complete Poems*, 131, poem 284.

81. Goodrich, *Albert P. Ryder*, 22.

82. See *Psychoanalytic Review* 76, no. 3 (Fall 1989): 437.
83. Ibid., 425.
84. Dickinson, *Complete Poems*, 12–13, poem 14.
85. See Carolyn G. Heilbrun, *Toward a Recognition of Androgyny* (New York: Harper & Row, 1973), 29.
86. Ibid., 25. See also Homer and Goodrich, *Albert Pinkham Ryder*, 80, who note of Ryder: "Kenneth Hayes Miller thought that he was adrogynous, 'that there were elements of both man and woman in him, that he was sufficient until [*sic*] himself.'" Miller compared him to "Thomas Mann's idea of Jehovah, a spiritual being standing far above gender and worldly desires."
87. Dickinson, *Complete Poems*, 180, poem 378.
88. See Goodrich, *Albert P. Ryder*, 22.
89. See Johnson and Ward, *Letters*, 2:412, letter 268.
90. Sherwood, *Circumference and Circumstance*, 219.
91. Ibid., 219–20.
92. Ibid., 219. See also Charles R. Anderson, *Emily Dickinson's Poetry: Stairway of Surprise* (New York: Holt, Rinehart & Winston, 1960), 55.
93. Sherwood, *Circumference and Circumstance*, 181.
94. *The Selected Writings of Ralph Waldo Emerson*, ed. Brooks Atkinson (New York: Random House, Modern Library, 1992), "Circles," 252.
95. Ibid., 260.
96. Ibid., "The Over-Soul," 239.
97. Ibid., 241.
98. Sherwood, *Circumference and Circumstance*, 194.
99. Ibid.
100. See Johnson and Ward, *Letters*, 2:430, letter 288 to Sue Gilbert, ca. 1864.
101. Emerson, *Selected Writings*, "The Over-Soul," 239–40.
102. C. G. Jung, *Aion: Researches into the Phenomenology of the Self*, trans. R. F. C. Hull, Bollingen Series 20 (Princeton, N.J.: Princeton University Press, 1979), 195.
103. Ibid., 190.
104. Dickinson, *Complete Poems*, 423, poem 894.
105. Ibid., 197, poem 413.
106. Ibid., 58, poem 125.
107. Wilhelm Worringer, *Form in Gothic* (New York: Schocken Books, 1964), 158–59.
108. Ibid.
109. Ibid., 81.
110. Dickinson, *Complete Poems*, 94, poem 201. See also Broun, *Albert Pinkham Ryder*, 316–17. In Ryder's poem "The Phantom Ship" (for his *Flying Dutchman* painting) he speaks also of "that hopeless soul / Doomed forever in that ship to roll," and ends "The sailor finds there eternal night / Neath the waters he shall ever sleep / And ocean will the secret keep."
111. Goodrich, *Albert P. Ryder*, 24.
112. See below, Chapter 7.
113. Geoffrey H. Hartman, "Romanticism and Anti-Self-Consciousness," in *Romanticism and Consciousness: Essays in Criticism*, ed. Harold Bloom (New York: W. W. Norton, 1970), 50.
114. Ibid., 51.
115. Ibid., 55.
116. Ibid., 51.
117. Dickinson, *Complete Poems*, 399, poem 822.

118. Hartman, "Romanticism," 52.

119. Ibid., 56.

120. Dickinson, *Complete Poems*, 517, poem 1159.

121. Ibid., 548, poem 1251.

122. Bachelard, *Poetics of Space*, 192.

123. Ibid., 184.

124. Ibid., 195.

125. Dickinson, *Complete Poems*, 294, poem 599.

126. Bachelard, *Poetics of Space*, 196.

127. Ibid., 184.

128. Dickinson, *Complete Poems*, 342, poem 695.

129. Ibid., 542, poem 1234.

130. Bachelard, *Poetics of Space*, 195.

131. Ibid., 197.

132. Dickinson, *Complete Poems*, 356, poem 726.

133. Ibid., 144, poem 306.

CHAPTER 7 *Pollock and Olson: Time, Space, and the
Activated Bodily Self*

1. Tom Clark, *Charles Olson: The Allegory of a Poet's Life* (New York: W. W. Norton, 1991), 114.

2. Conversation with the author.

3. George F. Butterick, *A Guide to the Maximus Poems of Charles Olson* (Berkeley: University of California Press, 1980), 7.

4. Herman Melville, *Moby-Dick* (New York: Modern Library, 1926), 1.

5. See Jeffrey Potter, *To a Violent Grave: Jackson Pollock* (New York: Putnam, 1985), 197 (Pollock to Nicholas Carone). See also Pollock's statement: "We're all of us influenced by Freud, I guess. I've been a Jungian for a long time," quoted in Selden Rodman, "Jackson Pollock," in *Conversations with Artists* (New York: Devon-Adair, 1957), 82. The extent of Jung's influence on Pollock has been fiercely debated. See especially Kirk Varnedoe with Pepe Karmel, *Jackson Pollock* (New York: Museum of Modern Art, 1998), 29, 80, nn. 44–51, 104–5. Varnedoe (29) claims, "Nobody who knew him thought he was the type to read Jung in any serious way, and both of his analysts have said that they didn't discuss Jungian theories with him." For an extended discussion of Jung and Pollock see also Michael Leja, *Reframing Abstract Expressionism* (New Haven: Yale University Press, 1993), especially Chapter 3, "Jackson Pollock and the Unconscious," 121ff. Lee Krasner was very disturbed when Pollock's drawings, originally owned by his Jungian analyst, were exhibited, and did not want them to be shown. (Conversation with the author, who spent several days with Krasner at Springs at that time, 1970.) The house was in turmoil, and Harold Rosenberg was called in for support and advice.

6. Charles Olson, "A Bibliography on America for Ed Dorn," in *Collected Prose: Charles Olson*, ed. Donald Allen and Benjamin Friedlander, intro. by Robert Creeley (Berkeley: University of California Press, 1997), 301. See also 300: "Frobenius—anything; Jung, in fact, also. . . ."

7. See especially James Kirch, "Herman Melville in Search of the Self," in *Psychological Perspectives* 7, no. 1 (Spring 1976), 54–74. I am indebted to Ann McCoy for this reference.

8. Melville, *Moby-Dick*, 11.

9. Ibid., 10. Cited by Brian O'Doherty in *American Masters: The Voice and the Myth* (New York: Ridge Press, 1974), 90, 105.

10. D. H. Lawrence, *Studies in Classic American Literature*, n.p., n.d., quoted in Ann Charters, *Olson/Melville: A Study in Affinity* (Berkeley: Oyez, 1968), 33.

11. Olson, *Collected Prose*, "Call Me Ishmael," 18, 17.

12. Ibid., "Equal That Is to the Real Itself," 123.

13. Ibid., 124: "At this end I am thinking of such recent American painting as Pollock's, and Kline's. . . ." See also 400, n. 124, where Olson is quoted in a 1966 television interview: "I believe that the American painters, namely Mr. Pollock and Mr. Kline, in 1948—and I'm of their time—solved the problem of how to live." Olson did of course know Kline, who was a visitor at Black Mountain in the summer session of 1952. See Clark, *Charles Olson*, 225–26.

14. Robert Creeley, looking back to 1950, pointed this out in 1965. See Robert Creeley, ed., *Selected Writings of Charles Olson* (New York: New Directions, 1966), "Introduction," 7, on Olson's "Projective Verse" and the idea of "open-field" verse: "If one reads Jackson Pollock's comments on his painting at that time, he can note for himself the obvious parallel." See also B. H. Friedman, *Jackson Pollock: Energy Made Visible* (New York: McGraw-Hill, 1972), 216, where Creeley is quoted as swinging at a "very solid man" to reassert his place at the bar in the Cedar Bar, and then being introduced to him: "God! It was Jackson Pollock!"

15. Quoted from *Moby-Dick*, "The Gilder," in Olson, *Collected Prose*, "Call Me Ishmael," 102.

16. Tom Clark, *Charles Olson*, 136.

17. Steven Naifeh and Gregory White Smith, *Jackson Pollock* (New York: Clarkson N. Potter, 1989), 48.

18. Ibid., 69. See also Helen A. Harrison, *Such Desperate Joy: Imagining Jackson Pollock* (New York: Thunder's Mouth Press/Nation Books, 2000), 67, statement by Lee Krasner: "One thing I will say about Pollock; the one time I saw temperament in him was when he baked an apple pie, and it didn't work. He loved to bake. . . . He was very fastidious about his baking—marvelous bread, cakes, and pies."

19. Hershel Parker, *Herman Melville: A Biography*, Vol. 1, 1819–1851 (Baltimore: Johns Hopkins University Press, 1996), 795.

20. Clark, *Charles Olson*, 7.

21. Ibid., 13.

22. Parker, *Herman Melville*, 1.

23. Naifeh and Smith, *Jackson Pollock*, 26. See also Chronology in Varnedoe, *Jackson Pollock*, 315, which says Roy Pollock was two years of age when adopted. He was, it seems, closer to his third birthday.

24. Clark, *Charles Olson*, 28.

25. Quoted in Parker, *Herman Melville*, 843.

26. See *The Complete Poetry of John Donne*, ed. John T. Shawcross (New York: Doubleday Anchor, 1967), 58.

27. Clark, *Charles Olson*, 38–39.

28. Creeley, *Selected Writings*, 9–10, refers to "a sense of meaning" which Olson used at the Berkeley Poetry Conference the summer of 1965: "'*That which exists through itself is what is called the meaning.*' He also noted as a usable context for that 'mapping' or measure of how one is where one is, these four terms:
 earth
 Imago Mundi
 history
 Anima Mundi."

29. Clark, *Charles Olson*, 47.

30. Olson, *Collected Prose*, "Call Me Ishmael," 17. Cf. above, Chapter 3 on the Indian circle and the white man's square. Cf. also C. G. Jung, in *Aion: Researches into the Phenomenology of the Self*, trans. R. F. C. Hull, Bollingen Series 20 (Princeton: Princeton University Press, 1979), vol. 9, part 2, 264, where Jung quotes the alchemist Michael Maier on the squared circle, relating it to the homo quadratus: "the four-square man, who remains himself 'come weal come woe.'"

31. Quoted in O'Doherty, *American Masters*, 85.

32. See Henry James, *William Wetmore Story and His Friends* (2 vols. 1903; 2 vols. in 1, New York: Da Capo, 1969), 1:27–28. Quoted in Barbara Novak, *Nature and Culture* (New York: Oxford University Press, 1980), 203.

33. Naifeh and Smith, *Jackson Pollock*, 110 ff.

34. See Varnedoe, *Jackson Pollock*, 23 ff. for an account of Pollock's connection with Benton for most of the decade of the '30s.

35. Pollock's interest in Melville may stem from an American literature course he took in California in his teens. See Naifeh and Smith, *Jackson Pollock*, 144.

36. See Charles Olson, *The Maximus Poems*, ed. George F. Butterick (Berkeley: University of California Press, 1995), 98–99.

37. Varnedoe, *Jackson Pollock*, 32. See also 80, n. 62, quoting Pollock's friend Ossorio: "He had 15 volumes published by the Smithsonian on American anthropology—he once pulled it out from under his bed to show me."

38. Olson, *Collected Prose*, "Call Me Ishmael," 19.

39. Ibid., "Human Universe," 158, 166.

40. Clark, *Charles Olson*, 124.

41. Varnedoe, *Charles Olson*, 319.

42. Quoted in O'Doherty, *American Masters*, 89.

43. See Henry James, *Hawthorne* (New York: Doubleday-Dolphin, n.d.), 18.

44. See *The Notebooks of Leonardo da Vinci*, ed. Irma A. Richter (New York: Oxford University Press, 1982), 216. See Lloyd Goodrich, *Albert P. Ryder* (New York: Braziller, 1959), 13.

45. Clark, *Charles Olson*, 51.

46. Olson, *Collected Prose*, "Human Universe," 162.

47. Naifeh and Smith, *Jackson Pollock*, 127–29.

48. Ibid., 333. See also 432 and 862n., which cites Elizabeth Langhorne's identification of the yellow shape in Pollock's "The Moon Woman Cuts the Circle" as the Golden Flower and refers to the translation by Cary Baynes, a friend of Helen Marot, who was in turn a friend of the Bentons and then of Pollock. Marot, through Baynes, recommended the Jungian psychoanalyst Joseph Henderson to Pollock (see 326). Henderson, according to Naifeh and Smith, might also have fortified Pollock's Indian interests (see 337). Pollock's concern not only with the golden flower but, more overtly in his work, with the moon has preoccupied those scholars who emphasize the moon's metaphorical role in Jungian psychology as the anima or feminine unconscious. See Leja, *Reframing Abstract Expressionism*, 157ff. Leja has called attention to the Moon Woman's Jungian significance as "the goddess of creative inner activity and especially of art." He quotes Krasner on Pollock: "The moon had a tremendous effect on him . . . he painted a series of moon pictures, and spoke about it often. . . ." Leja, 170–71, also refers here to Pollock's friend Reggie Wilson, who "connected Pollock's interest in the moon with his attraction to the paintings of Albert Pinkham Ryder: 'As a lot of us were, he was very moved by the work of Ryder, and he had a thing about the moon.'" See above, Chapter 6, for my discussion of Ryder, Dickinson, and the moon.

The moon has its place of course in Olson's imagery as well. In "Human Universe" he wrote: "Or to be a man and a woman as Sun was, the way he had to put up with Moon, from start to finish the way she was, the way she behaved, and he up against it because he did have the advantage of her, he moved more rapidly." See Olson, *Collected Prose*, 164. See also, in his poem "The K":

> Take then, my answer:
> there is a tide in a man
> moves him to his moon and,
> though it drop him back
> he works through ebb to mount
> the run again and swell
> to be tumescent I.

Quoted from "The K," in Thomas F. Merrill, *The Poetry of Charles Olson* (Newark: University of Delaware Press, 1982), 146. Merrill's study stresses Jung's importance for Olson, cf. especially 199, where he links Jung's Collective Unconscious to Olson's "Human Universe." Merrill also (207) connects Olson's sense of self with Jung's concept that the "self is not only the centre, but also the whole circumference which embraces both the conscious and the unconscious; it is the center of this totality, just as the ego is the center of consciousness" and suggests (208) that Maximus be considered "as an archetype of Self, for we can then see that he is not merely Olson's *conscious* awareness but that he includes as well the circumference bounding the conscious and unconscious of not only Charles Olson, but the collective archetypes of all mankind." See above, the issue of the circumference in Chapter 6 and circles in Chapter 3.

49. See *The Secret of the Golden Flower*, trans. and explained by Richard Wilhelm, Foreword and Commentary by C. G. Jung (1931; New York: Harcourt Brace Jovanovich, 1962), 65. Wilhelm translated the text from the Chinese into German for a 1929 edition. It was then translated into English by Cary Baynes in 1931.

50. See Olson, *Collected Prose*, 430 n. 263. See also Clark, *Charles Olson*, 280–81, who notes that "The Golden Flower . . . represented a mystical solar quality; its botanical equivalent was a magical plant described by medieval alchemists as akin to Homer's *moly*, a drug capable of inducing shamanic spells. 'The Black Chrysanthemum/Ocean . . . the Black Gold Flower' became a kind of spell or rune for him, a potent source of poetic associations." Cf. Jung, *Aion*, 264, identifying gold with self, sun, circle and God: "According to Michael Maier, the gold, another synonym for the self, comes from the *opus circulatorium* of the sun. This circle is 'the line that runs back upon itself' (like the serpent that with its head bites its own tail), wherein that eternal painter and potter, God, may be discerned. . . . Independently of Western tradition, the same idea of the circular *opus* can be found in Chinese alchemy: 'When the light is made to move in a circle, all the energies of heaven and earth, of the light and the dark, are crystallized,' says the text of the Golden Flower."

51. Olson, *Collected Prose*, "Against Wisdom as Such," 263.

52. See Varnedoe, *Jackson Pollock*, 29.

53. Quoted in Friedman, *Jackson Pollock*, 181.

54. Lee Krasner in conversations with this author. See also *Such Desperate Joy*, 64. Statement by Lee Krasner: "When we were married Jackson wanted a church wedding; not me. He wanted it and he had it. Jackson's mother was anti-religious, that's a fact. Violently anti-religious. I felt that Jackson, from many things he did, felt a great loss there. He was tending more and more to religion. I felt that went back to his mother's lack of it. You know, in high school he used to listen to Krishnamurti's lectures."

55. Friedman, *Jackson Pollock*, 228.

56. Potter, *To a Violent Grave*, 60.

57. Olson, *Collected Prose*, "Human Universe," 162.

58. Quoted in Varnedoe, *Jackson Pollock*, 48, from *Possibilities* I (Winter 1947–48), 79. See 82, n. 118. It was this passage to which Creeley specifically referred when making his comments about the parallels between Olson and Pollock.

59. Olson, *Collected Prose*, "Human Universe," 156.

60. Ibid., "Proprioception," 183.

61. Varnedoe, *Jackson Pollock*, 48.

62. See Harold Rosenberg, *The Tradition of the New* (New York: Grove, 1961), 27–28. Carter Ratcliff, in *The Fate of Gesture: Jackson Pollock and Postwar American Art* (New York: Farrar, Straus & Giroux, 1996), 111–12, suggests that Rosenberg, in referring to "apocalyptic wallpaper" in his essay, "had made it obvious to Krasner that he had aimed his charge of vacuity at the sprawl of Pollock's biggest, most ambitious canvases. She was enraged." Ratcliff also notes that Pollock "chose to be flattered by 'The American Action Painters.' His name for the essay was 'Rosenberg's piece on me.'" Even if, as Ratcliff suggests, Rosenberg himself preferred De Kooning as his action hero, Pollock was right. The essay itself can in many ways readily be applied to him. In all events, Rosenberg and his wife remained good friends of Krasner's. She often spoke to this author about them.

63. Rosenberg, *Tradition of the New*, 28.

64. Rodman, *Conversations with Artists*, 82.

65. Olson, *Collected Prose*, 182.

66. Ibid., 183.

67. *The Writings of William James*, ed. John J. McDermott (Chicago: University of Chicago Press, 1977), 284. See above Chapter 1, as applied to Copley.

68. See Gerold E. Meyers, ed., *William James Writings, 1878–1899* (New York: Library of America, 1992). 178, 198.

69. Olson, *Collected Prose*, "Human Universe," 157.

70. Ibid., 159.

71. See Friedman, *Jackson Pollock*, 184.

72. See Goodrich, *Albert P. Ryder*, 22, where Ryder's sense of the organic nature of his works is evident in his use of metaphor: "The canvas I began ten years ago I shall perhaps complete today or to-morrow. It has been ripening under the sunlight of the years that come and go. . . ."

73. This same organic quality—of a seed brought to fruit—can be seen in Olson's process of writing *Maximus* over a period of almost twenty years.

74. See Emerson, "Nature," in The *Selected Writings of Ralph Waldo Emerson*, ed. Brooks Atkinson (New York: Modern Library, 1992), 6.

75. Olson, *Collected Prose*, "Projective Verse," 247.

76. Cf. Charles Olson, *The Maximus Poems*, ed. Charles F. Butterick (Berkeley: University of California Press, 1983), 33, Letter 6: "There are no hierarchies, no infinite, no such many as mass, there are only / eyes in all heads, / to be looked out of. . . ." A case could be made that Pollock's *Eyes in the Heat* is already approaching transcendence, but the ubiquitous presence of the eyes offers enough bodily ego to warrant comparison with Olson's comment.

77. T. J. Clark, "Pollock's Smallness" in *Jackson Pollock: New Approaches*, ed. Kirk Varnedoe and Pepe Karmel (New York: Museum of Modern Art, 1999), 21.

78. Ibid., 22.

79. Ibid.

80. Ibid.

81. See Novak, *Nature and Culture*, Chapter 2 "Grand Opera and the Still Small Voice," 29, and Chapter 3, "Changing Concepts of the Sublime," 34–44. See also above Chapters 2 and 4 for characterizations of the different transcendences of Lane and Church. Church reached transcendent sublimity occasionally through struggle and action that ultimately broke through to an equalizing calm. Lane reached it in a more serene and reposeful way. For the most part, Pollock's distillations of feeling in 1950 seem to me to achieve that rare repose.

 Lee Krasner once told me that it was only several years after an experience that she was able to discharge its emotional content in a painting. There is a methodological argument to be made here about the relative weight of the artist's personal feelings within the larger context of his time. Though, as I note above (143), the general background of post-atomic nuclear terror was present in 1950, those of us who were young adults in 1950 did not always feel the "terror" of the moment. "The times," in other words, did not always dictate our inner urges and creative expression, nor did we so directly reflect them. As suggested above (Chapter 4), in light of much recent scholarly propensity to read "into" art from outward circumstance, instead of from the work "out" to contexts that might illuminate our readings, this is a problem worth reflecting on.

82. Butterick, *Guide to the Maximus Poems*, ix.

83. Clark, *Charles Olson*, 153.

84. Olson, *Maximus*, 49, Letter 10.

85. Olson, *Maximus*, Letter 7, 34–35.

86. Olson, *Collected Prose*, "Projective Verse," 247.

87. Conversations with the author.

88. Olson, *Collected Prose*, "Human Universe," 157–58.

89. Olson, *Maximus*, Letter 9, 46–47.

90. See Joel Porte, *Emerson in His Journals* (Cambridge, Mass.: Harvard University Press, 1982), 249.

91. Friedman, *Jackson Pollock*, 87. See also Harrison, *Such Desperate Joy*, 65, Lee Krasner's statement: "In discussing the paintings he would ask 'Does it work?' Or in looking at mine, he would comment 'It works' or 'it doesn't work!' He may have been the first artist to use the word 'work' in that sense."

92. See John Wilmerding, *Fitz Hugh Lane* (New York: Praeger, 1971), 95. Olson's affinity for Lane is frequently signaled by his references to the Gloucester artist throughout *Maximus*. See especially, 592–94: "The earth is dug down to low—Lane / cldn't paint it but he understood, es- / pecially in full moonlight or near full though / equally it is true in the day when / the tide is all the way out there . . . / —10 Lb. Island enormous in the / height so severely suddenly ac- / quired Dunkums Point & Rocks / as if tonight Lane himself were / painting Moonlight on the / At Low Water Harbor / Scene . . . / I celebrate what Fitz Hugh Lane / too/ saw / hobbling about like cats & I on / his weed-crippled legs on *his* side of / the same shore I look out full on the / Harbor, Lane Hawthorne's / sweet contemporary . . . / a day or time when only one / & 4th condition God himself makes / necessary to a vision I no more than Lane / can give the art to. . . ."

 Though Butterick, *Guide to the Maximus Poems*, 721, notes that Olson is probably thinking here of Lane's *Moonlight on a Bay*, later attributed (1971) by Wilmerding to Lane's student Mary B. Mellen, for Olson, at that point, the painting was by Lane, and he continually celebrated Lane in his poems. See also Butterick, 382–84, where he quotes from Olson's "An 'Enthusiasm'" (*Archaeologist of Morning*), 226–28: "Lane painted true color, and drew / true lines, and 'View' as a prin- / ciple he has also made

true as a- / gainst too easy (Dutch) or even a / more brilliant landscape Turner, / Constable (Guardi Canalletto Tie- / polo even behind theirs). . . ." Butterick also quotes from a poem entitled "To Celebrate What He Stands On . . ." in Olson's papers, which reminds us that Olson often referred to Lane's "Phoenician eye VIEW."

93. Rosenberg, *Tradition of the New*, 26.

94. Hans Namuth and Paul Falkenberg, 1950 film on Jackson Pollock, shown at the Museum of Modern Art, New York, November 1, 1998–February 2, 1999.

95. William James, *Writings*, 390.

96. Olson, *Collected Prose*, "Projective Verse," 242.

97. Varnedoe, *Jackson Pollock*, 55.

98. Olson, *Collected Prose*, "Projective Verse," 239.

99. Ibid., 240.

100. William James, *Pragmatism and Four Essays on the Meaning of Truth* (New York: American Library, 1974), 33.

101. See Merrill, *Poetry of Charles Olson*, 22.

102. Ibid., 19.

103. Quoted in Merrill, *Poetry of Charles Olson*, 130–31.

104. See Creeley, *Selected Writings*, 4: "We are not here involved with existentialism, despite the apparent closeness of sympathies at times" and 8: "What we have as place is defined in 'The Resistance' and again it is not only existential."

105. Clark, *Charles Olson*, 57.

106. Ibid.

107. Olson, *Collected Prose*, "Call Me Ishmael," 20. See also Robert von Hallberg, *Charles Olson: The Scholar's Art* (Cambridge, Mass.: Harvard University Press, 1978), 81, where William Carlos Williams, in whose poetic lineage Olson has often been placed along with Pound, is quoted: "And how he wrote the poem down on the page was very interesting to me. And the shorter lines. Anti-Whitman. It's a good example of what happened to Whitman. Olson's line is very much more in the American idiom." I would maintain that the shorter lines may be anti-Whitman, but the spirit is not so far away.

108. See Olson, *Maximus*, 92.

109. See Charles Olson, *Muthologies: The Collected Lectures and Interviews*, ed. George F. Butterick (Bolinas, Calif.: Four Seasons Foundation, 1979), 2:156. Interview with Herbert A. Kenny, August 1969. See also Olson, *Maximus*, "Maximus From Dogtown-1," 172:

> The sea was born of the earth without sweet union of love Hesiod says
> But that then she lay for heaven and she bare the thing which encloses
> every thing. Okeanos the one which all things are and by which nothing
> is anything but itself, measured so
> screwing earth, in whom love lies which unnerves the limbs and by its
> heat floods the mind and all gods and men into further nature
> Vast earth rejoices,
> deep-swirling Okeanos steers all things through all things,
> everything issues from the one, the soul is led from drunkenness
> to dryness, the sleeper lights up from the dead,
> the man awake lights up from the sleeping

Selected Bibliography

Primary Sources

The Morgan Library. Henry David Thoreau, "Extracts Relating to the Indians." Arthur Christy Papers, Columbia University Rare Book and Manuscript Library.

Publications

Ahlstrom, Sidney E. *A Religious History of the American People*. New Haven, Conn.: Yale University Press, 1972.

Anderson, Charles R. *Emily Dickinson's Poetry: Stairway of Surprise*. New York: Holt, Rinehart & Winston, 1960.

Anderson, Quentin. *The Imperial Self*. New York: Random House, Vintage, 1971.

Anderson, Wallace E., ed. *Jonathan Edwards: Scientific and Philosophical Writings*. New Haven, Conn.: Yale University Press, 1980.

Anzieu, Didier. *The Skin Ego: A Psychoanalytic Approach to the Self*. New Haven, Conn.: Yale University Press, 1989.

Babson, John J. *History of the Towns of Gloucester, Capestown, Cambridge*. 1860. Reprint, Gloucester, Mass.: Peter Smith, 1972.

Bachelard, Gaston. *On Poetic Imagination and Reverie*. Dallas: Spring Publications, 1987.

———. *The Poetics of Space*. New York: Orion Press, 1964.

Baur, John I. H. "American Luminism." *Perspectives USA* 9 (Autumn 1954).

Baxandall, Michael. *Patterns of Intention*. New Haven, Conn.: Yale University Press, 1985.

Beam, Philips C. *Winslow Homer at Prout's Neck*. Boston: Little, Brown, 1966.

Bercovitch, Sacvan. "Emerson the Prophet." In Bloom, *Ralph Waldo Emerson: Modern Critical Views*, 29–44.

———. *The Puritan Origins of the American Self*. New Haven, Conn.: Yale University Press, 1976.

Bloom, Harold. *Agon: Towards a Theory of Revisionism*. New York: Oxford University Press, 1983.

———, ed. "Emerson: The American Religion." In *Ralph Waldo Emerson: Modern Critical Views*, 97–121.

———, ed. *Ralph Waldo Emerson: Modern Critical Views*. New York: Chelsea House, 1985.

Boodin, John Elof. "William James As I Knew Him." In *William James Remembered*, edited
 by Linda Simon. Lincoln: University of Nebraska Press, 1966, 207–32.

Broun, Elizabeth. *Albert Pinkham Ryder*. Washington, D.C.: Smithsonian Institution Press,
 1990. Exhibition Catalogue.

Brown, Joseph Epes. "The Roots of Renewal." In Capps, *Seeing with a Native Eye*, 25–34.

———. *The Sacred Pipe*. Norman: University of Oklahoma Press, 1989.

———. *The Spiritual Legacy of the American Indian*. New York: Crossroad Publishing, 1982.

Bushman, Richard. "Jonathan Edwards as Great Man: Identity, Conversion and Leadership
 in the Great Awakening." In Scheick, *Critical Essays on Jonathan Edwards*, 41–64.

Butterick, Charles. *A Guide to the Maximus Poems of Charles Olson*. Berkeley: University of
 California Press, 1980.

Capps, Jack L. *Emily Dickinson's Reading, 1836–1886*, Cambridge, Mass.: Harvard University
 Press, 1966.

Capps, Walter Holden, ed. *Seeing With a Native Eye: Essays on Native American Religion*.
 New York: Harper & Row, 1976.

Cash, Sarah. *The Ominous Hush: The Thunderstorm Paintings of Martin Johnson Heade*.
 Fort Worth: Amon Carter Museum, 1994. Exhibition Catalogue.

Catlin, George. *Letters and Notes on the Manners, Customs and Conditions of the North
 American Indians*. 2 vols. London: Henry G. Bohn, 1841. 8th edition, 1851.

Charters, Ann. *Olson/Melville: A Study in Affinity*. Berkeley, Calif.: Oyez, 1968.

Chase, Richard. "Go-Befores and Embryons." In Hindus, *Leaves of Grass: One Hundred Years
 After*, 32–54.

Cicovsky, Nicolai, Jr., and Franklin Kelly. *Winslow Homer*. With contributions by Judith
 Walsh and Charles Brock. Washington, D.C.: National Gallery of Art, 1995. Exhibition
 Catalogue.

Clark, T. J. "Pollock's Smallness." In Varnedoe and Karmel, *Jackson Pollock: New Approaches*,
 15–30.

Clark, Tom. *Charles Olson: The Allegory of a Poet's Life*. Berkeley, Calif.: North Atlantic
 Books, 2000.

Coe, Ralph T. *Sacred Circles: Two Thousand Years of North American Indian Art*. Kansas City,
 Mo.: Nelson Gallery of Art, 1977. Exhibition Catalogue.

Conforti, Joseph A. *Jonathan Edwards: Religious Tradition and American Culture*. Chapel
 Hill: University of North Carolina Press, 1995.

Copley, John Singleton. *Letters and Papers of John Singleton Copley and Henry Pelham, 1739–
 1776*. Boston: Massachusetts Historical Society, 1914.

Cox, James M. "The Circles of the Eye." In Bloom, *Ralph Waldo Emerson: Modern Critical
 Views*, 45–60.

The Crayon 1 (June 6, 1855).

Creeley, Robert ed. *Selected Writings of Charles Olson*. New York: New Directions, 1966.

Cronon, William. *Changes in the Land: Indians, Colonists, and the Ecology of New England*.
 New York: Hill & Wang, 1983.

Da Vinci, Leonardo. *The Notebooks of Leonardo da Vinci*. Edited by Irma A. Richter. New
 York: Oxford University Press, 1952.

De Crevecoeur, J. Hector St. John. *Letters from an American Farmer*. New York: Dutton,
 1957.

Delattre, Roland Andre, "Beauty and Theology: A Reappraisal of Jonathan Edwards." In
 Scheick, *Critical Essays on Jonathan Edwards*, 136–150.

Delbanco, Andrew. *Melville: His Work and World*. New York: Alfred A. Knopf, 2005.

De Rougemont, Denis. *Love in the Western World*. Princeton, N.J.: Princeton University
 Press, 1983.

Dickinson, Emily. *The Complete Poems of Emily Dickinson.* Edited by Thomas H. Johnson. Boston: Little, Brown, 1960.

———. *The Emily Dickinson Handbook.* Edited by Gudrun Grabher, Roland Hagenbüchle, and Cristanne Miller. Amherst: University of Massachusetts Press, 1998.

Eastman, Charles A. (Ohiyesa). *The Soul of the Indian: An Interpretation.* Lincoln: University of Nebraska Press, 1980.

Edinger, Edward. *Melville's Moby-Dick: A Jungian Commentary.* New York: New Directions, 1978.

Edwards, Jonathan. *Images or Shadows of Divine Things.* Edited by Perry Miller. New Haven, Conn.: Yale University Press, 1948.

Ehle, John. *Trail of Tears: The Rise and Fall of the Cherokee Nation.* New York: Doubleday Anchor, 1958.

Eliade, Mircea. *The Myth of the Eternal Return.* Princeton, N.J.: Princeton University Press, 1991.

———. *The Sacred and the Profane: The Nature of Religion.* New York: Harcourt Brace, 1959.

———. *Symbolism, The Sacred and The Arts.* Edited by Diane Apostolos-Cappadona. New York: Crossroad Publishing, 1985.

Emerson, Ralph Waldo. *Essays and Lectures.* Selected by Joel Porte. New York: The Library of America, 1983.

———. *The Journals of Ralph Waldo Emerson.* Abridged and edited by Robert N. Linscott. New York: Random House, Modern Library, 1960.

———. *The Selected Writings of Ralph Waldo Emerson.* Edited by Brooks Atkinson. New York: Random House, Modern Library, 1992.

Farr, Judith. "Dickinson and the Visual Arts." In Dickinson, *The Emily Dickinson Handbook,* 61–92.

Fiedler, Leslie A. "Images of Walt Whitman." In Hindus, *Leaves of Grass: One Hundred Years After,* 55–73.

Fox, Christopher. *Locke and the Scriblerians: Identity and Consciousness in Early Eighteenth-Century Britain.* Berkeley: University of California Press, 1988.

Friedman, B. H. *Jackson Pollock: Energy Made Visible.* New York: McGraw-Hill, 1974.

Gilbert, Sandra M., and Susan Gubar. *The Madwoman in the Attic.* New Haven, Conn.: Yale University Press, 1980.

Gilson, Etienne. *Painting and Reality.* New York: Pantheon, 1957.

Goodrich, Lloyd. *Albert P. Ryder.* New York: Braziller, 1959.

———. *Winslow Homer.* New York: Macmillan, 1944.

Greven, Philip. *The Protestant Temperament: Patterns of Child-Rearing, Religious Experience and the Self in Early America.* Chicago: University of Chicago Press, 1977.

Hallberg, Robert von. *Charles Olson: The Scholar's Art.* Cambridge, Mass.: Harvard University Press, 1978.

Hartman, Geoffrey H. "Romanticism and Anti-Self-Consciousness." In *Romanticism and Consciousness: Essays in Criticism,* edited by Harold Bloom. New York: W. W. Norton, 1970, 46–56.

Harrison, Helen A., ed. *Such Desperate Joy: Imagining Jackson Pollock.* New York: Thunder's Mouth Press/Nation Books, 2000.

Hayward, Judith. "Nature and Progress: Winslow Homer's Oils, 1880–1900." Ph.D. diss., Columbia University, 2002.

Heilbrun, Carolyn G. *Toward a Recognition of Androgyny.* New York: Harper & Row, 1971.

Hindu Scriptures. Edited by R. C. Zaehner. London: J. M. Dent, Everyman's Library, 1966.

Hindus, Milton, ed. *Leaves of Grass: One Hundred Years After*. Stanford, Calif.: Stanford University Press, 1955.

Homer, William, and Lloyd Goodrich. *Albert Pinkham Ryder*. New York: Abrams, 1989.

Howe, Irving. *American Newsness: Culture and Politics in the Age of Emerson*. Cambridge, Mass.: Harvard University Press, 1986.

Huntington, David. *The Landscapes of Frederic Edwin Church*. New York: Braziller, 1966.

Indian Oratory. Compiled by W. C. Vanderworth, foreword by William R. Carmack. Norman: University of Oklahoma Press, 1987.

James, Henry. *Hawthorne*. 1879. Reprint, New York: Doubleday, Dolphin, n.d.

———. *William Wetmore Story and His Friends*. 2 vols. 1903; 2 vols in 1, New York: Da Capo Press, 1969.

James, William. *Pragmatism and Four Essays From the Meaning of Truth*. New York: New American Library, 1974.

———. *Pragmatism and Other Writings: William James*. Edited by Giles Gunn. New York: Penguin, 2000.

———. *William James: Writings, 1878–1899*. Edited by Gerold E. Meyers. New York: Library of America, 1992.

———. *The Writings of William James*. Edited by John McDermott. Chicago: University of Chicago Press, 1977.

Jarves, James Jackson. *The Art-Idea*. Edited by Benjamin Rowland. Cambridge, Mass.: Harvard University Press, 1960. Originally published 1864.

Johns, Elizabeth. *Winslow Homer: The Nature of Observation*. Berkeley: University of California Press, 2002.

Johnson, Thomas J., and Theodora Ward, eds. *The Letters of Emily Dickinson*. Cambridge, Mass.: Harvard University Press, 1958.

Jung, C. G. *Aion: Researches into the Phenomenology of the Self*. Bollingen Series 20. Translated by R. F. C. Hull. Princeton, N.J.: Princeton University Press, 1959.

———. *Memories, Dreams, Reflections*. Edited by Aniela Jaffe. New York: Vintage Books, 1965.

Junker, Patricia. "Expressions of Art and Life in the Artist's Studio in an Afternoon Fog." In *Winslow Homer in the 1890's: Prout's Neck Observed*. Rochester, N.Y.: University of Rochester Memorial Gallery, 1990, 34–65.

Kaplan, Justin. *Walt Whitman: A Life*. New York: Simon & Schuster, 1980.

Kelly, Franklin. *Frederic E. Church and the National Landscape*. Washington, D.C.: Smithsonian Institution Press, 1998. Exhibition Catalogue.

———. *Frederic Edwin Church*. With Steven Jay Gould, John Anthony Ryan, and Debora Rindge. Washington, D.C.: National Gallery of Art, 1989. Exhibition Catalogue.

Lacan, Jacques. *The Four Fundamental Concepts of Psycho-Analysis*. Edited by Jacques Alain Miller. Translated by Alan Sheridan. New York: W. W. Norton, 1981.

Layton, Lynne, and Barbara Ann Schapiro, eds. *Narcissism and the Text: Studies in the Literature and The Psychology of Self*. New York: New York University Press, 1986.

Lewis, R. W. B. *The American Adam*. Chicago: University of Chicago Press, 1955. Reprint 1965.

———. *The Jameses*. New York: Farrar, Straus & Giroux, 1991.

———, ed. *The Presence of Walt Whitman*. New York: Columbia University Press, 1962.

Leja, Michael. *Reframing Abstract Expressionism*. New Haven, Conn.: Yale University Press, 1993.

Leyda, Jay. *The Years and Hours of Emily Dickinson*. 2 vols. New Haven, Conn.: Yale University Press, 1960.

Locke, John. *An Essay Concerning Human Understanding*. Edited by Andrew Seth Pringle-Pattison. Oxford: Clarendon Press, 1956.

Manthorne, Katherine E. *Tropical Renaissance: North American Artists Exploring Latin America, 1839–1879*. Washington, D.C.: Smithsonian Institution Press, 1989.

Martin, Calvin Luther. *The Way of the Human Being*. New Haven, Conn.: Yale University Press, 1999.

Matthiessen, F. O. *The James Family*. New York: Alfred A. Knopf, 1947.

May, Henry F. *The Enlightenment in America*. New York: Oxford University Press, 1976.

McLuhan, T. C. *Touch the Earth*. New York: Simon & Schuster, Touchstone, 1971.

Melville, Herman. *Moby-Dick*. Edited by Harrison Hayford and Hershel Parker. New York: W. W. Norton, 1967.

———. *Moby-Dick*. Berkeley: University of California Press, Arion, 1979.

Merleau-Ponty, Maurice. *The Phenomenology of Perception*. London: Routledge & Kegan Paul, 1976.

Merrill, Thomas F. *The Poetry of Charles Olson*. Newark: University of Delaware Press, 1982.

Miller, Angela. *The Empire of the Eye: Landscape Representation and American Cultural Politics 1825–75*. Ithaca, N.Y.: Cornell University Press, 1993.

Miller, Perry. *Errand into the Wilderness*. New York: Harper & Row, 1964.

———. *Jonathan Edwards*. 1949. Reprint, Amherst: University of Massachusetts Press, 1981.

———. *The Life of the Mind in America: From the Revolution to the Civil War*. New York: Harcourt, Brace & World, 1965.

Momaday, N. Scott. "Native American Attitudes to the Environment." In Capps, *Seeing With a Native Eye*, 79–85.

Naifeh, Steven, and Gregory White Smith. *Jackson Pollock*. New York: Clarkson N. Potter, 1989.

The Natural Paradise: Painting in America 1800–1950. Edited by Kynaston McShine. Essays by Barbara Novak, Robert Rosenblum, John Wilmerding. New York: Museum of Modern Art, 1976. Exhibition Catalogue.

Nature Observed, Nature Interpreted. Edited by Dita Amory and Marilyn Symmes. New York: National Academy of Design with Cooper-Hewitt National Design Museum, Smithsonian Institution, 1995. Exhibition Catalogue.

Neff, Emily Ballew. *John Singleton Copley in England*. Essay by William L. Pressley. Houston: Museum of Fine Arts in association with Merrill Holberton, London, 1995. Exhibition Catalogue.

Neihardt, John G. (Flaming Rainbow). *Black Elk Speaks*. New York: Pocket Books, 1972.

Noble, Louis L. *The Heart of the Andes*. Broadside. New York, 1859.

Novak, Barbara. *American Nineteenth-Century Painting: The Thyssen-Bornemisza Collection*. Entries by Elizabeth Garrity Ellis, Katherine E. Manthorne, Kenneth W. Maddox, and Kathleen Pyne. New York: The Vendome Press, 1986.

———. *American Painting of the Nineteenth Century: Realism, Idealism and the American Experience*. 1969. 2nd ed. New York: Harper & Row, 1979.

———. *Nature and Culture: American Landscape and Painting, 1825–75*. New York: Oxford University Press, 1980. 2nd ed. 1995.

O'Doherty, Brian. *American Masters: The Voice and the Myth*. New York: Ridge Press, 1974. Reprint, New York: Universe Books, 1988.

Olney, James. *Metaphors of Self: The Meaning of Autobiography*. Princeton, N.J.: Princeton University Press, 1972.

Olson, Charles. *Collected Prose: Charles Olson*. Edited by Donald Allen and Benjamin Friedlander. Introduction by Robert Creeley. Berkeley: University of California Press, 1997.

————. *Muthologos: Collected Interviews and Lectures.* Edited by George T. Butterick. 2 vols. Bolinas, Calif.: Four Seasons Foundation, 1978–79.

Parker, Hershel. *Herman Melville: A Biography.* Vol. 1, 1819–1851. Baltimore: Johns Hopkins University Press, 1996.

Poirier, Richard. "The Question of Genius." In Bloom, *Emerson: Modern Critical Views,* 163–86.

Porte, Joel. *Consciousness and Culture: Emerson and Thoreau Reviewed.* New Haven, Conn.: Yale University Press, 2004.

————, ed. *Emerson in His Journals.* Cambridge, Mass.: Harvard University Press, 1982.

Potter, Jeffrey. *To a Violent Grave: Jackson Pollock.* New York: Putnam, 1985.

Prown, Jules D. *John Singleton Copley.* 2 vols. Cambridge, Mass.: Harvard University Press, 1966.

The Psychoanalytic Review 76, no. 3 (Fall 1989).

Ratcliff, Carter. *The Fate of the Gesture: Jackson Pollock and Postwar American Art.* New York: Farrar, Straus & Giroux, 1996.

Rebora, Carrie, Paul Staiti, Erica E. Hirshler, and Theodore E. Stebbins, with contributions by Morrison H. Heckscher, Aileen Ribeiro, and Marjorie Shelley. *John Singleton Copley in America.* New York: Metropolitan Museum of Art, 1995. Exhibition Catalogue.

Reynolds, David. *Beneath the American Renaissance.* Cambridge, Mass.: Harvard University Press, 1989.

Reynolds, David S. *Walt Whitman's America.* New York: Alfred A. Knopf, 1995.

Rodman, Selden. *Conversations with Artists.* New York: Devon-Adair, 1957.

Rosenberg, Harold. *The Tradition of the New.* New York: Grove Press, 1961.

St. Armand, Barton Levi. *Emily Dickinson and Her Culture: The Soul's Society.* Cambridge: Cambridge University Press, 1984.

Sayre, Robert F. *Thoreau and the American Indians.* Princeton, N.J.: Princeton University Press, 1977.

Scheick, William, ed. *Critical Essays on Jonathan Edwards.* Boston: G. K. Hall, 1980.

The Secret of the Golden Flower. Translated and explained by Richard Wilhelm. Foreword and commentary by C. G. Jung. 1931. Reprint, New York: Harcourt Brace Jovanovich, 1962.

Sewall, Richard B. *The Life of Emily Dickinson.* 2 vols. New York: Farrar, Straus & Giroux, 1974.

Sherwood, William R. *Circumference and Circumstance: Stages in the Mind and Art of Emily Dickinson.* New York: Columbia University Press, 1968.

Simon, Linda. *Genuine Reality: A Life of William James.* Chicago: University of Chicago Press, 1998.

————, ed. *William James Remembered.* Lincoln: University of Nebraska Press, 1996.

Smith, Henry Nash. *Virgin Land.* New York: Vintage Books, 1950.

Smith, William Jay. *The Cherokee Lottery.* Willimantic, Conn.: Curbstone Press, 2000.

Staiti, Paul. "Character and Class." In Rebora, et al., *John Singleton Copley in America,* 53–77.

Stilgoe, John R. *Common Landscapes of America, 1580 to 1845.* New Haven, Conn.: Yale University Press, 1982.

Thoreau, Henry David. *The Journal of Henry D. Thoreau.* Edited by Bradford Torrey and Francis H. Allen. 2 vols. New York: Dover Publications, 1962.

————. *The Maine Woods.* Foreword by Richard F. Fleck. New York: Harper & Row, 1987.

————. *The Selected Journals of Henry David Thoreau.* Edited by Carl Bode. New York: New American Library, 1967.

————. *A Week on the Concord and Merrimack Rivers, Walden: or Life in the Woods, The Maine Woods, Cape Cod.* New York: The Library of America, 1985.

Tocqueville, Alexis de. *Democracy in America*. 2 vols. New York: Vintage Press, 1945.

———. *Journey to America*. Translated by George Lawrence and edited by J. F. Mayer. Garden City, N.Y.: Doubleday, 1971.

Tatham, David. "Trapper, Hunter and Woodsman: Winslow Homer's Adirondack Figures." *American Art Journal* 22, no. 4 (1990): 41–67.

———. "The Two Guides: Winslow Homer at Keene Valley, Adirondacks." *American Art Journal* 20 (1998): 20–34.

Traubel, Horace. *With Walt Whitman in Camden* (March 28–July 14, 1888). Boston: Small, Maynard, 1906.

Tuckerman, Henry T. *Book of the Artists*. 1867. Reprint, New York: James F. Carr, 1966.

Varnedoe, Kirk, with Pepe Karmel. *Jackson Pollock*. New York: Museum of Modern Art, 1998. Exhibition Catalogue.

———, and Pepe Karmel, eds. *Jackson Pollock: New Approaches*. New York: Museum of Modern Art, 1999.

Vogel, Stanley. *German Literary Influences on the American Transcendentalists*. New Haven, Conn.: Yale University Press, 1955.

Whicher, George Frisbie. *This Was a Poet*. New York: Scribner's, 1938.

Whicher, Stephen E. "Whitman's Awakening to Death." In Lewis, *The Presence of Walt Whitman*, 1–27.

Whitman, Walt. *The Portable Walt Whitman*. Edited by Mark Van Doren. New York: Viking, 1973.

———. *Walt Whitman: Poetry and Prose*. Selected by Justin Kaplan. New York: Library of America, 1982.

Wilmerding, John. *Fitz Hugh Lane*. New York: Praeger, 1971. Reprint, *Fitz Henry Lane*. Danvers, Mass.: Cape Ann Historical Association in cooperation with Bradford & Bigelow, 2005.

———. *Paintings by Fitz Hugh Lane*. Contributions by Elizabeth Garrity Ellis, Franklin Kelly, Earl A. Powell III, and Eric Ronnberg, Jr. Washington, D.C.: National Gallery of Art, 1988. Exhibition Catalogue.

Wilson, Rob. *American Sublime*. Madison: University of Wisconsin Press, 1991.

Worringer, William. *Form in Gothic*. Edited by Herbert Read. New York: Schocken Press, 1964.

Illustration Credits

Author's Note: Scholarly discoveries have recently indicated that the name Fitz Henry Lane is a more proper identification for the artist traditionally known as Fitz Hugh Lane. Since the artist sometimes signed his paintings Fitz H. Lane, and many institutions presently continue to use the earlier designation, I have decided for the sake of consistency to adopt the name Fitz H. Lane.

COLOR PLATES

1. John Singleton Copley, *Mrs. Ezekiel Goldthwait (Elizabeth Lewis)*, 1771. Museum of Fine Arts, Boston. Bequest of John T. Bowen in memory of Eliza M. Bowen, 41.84. Photograph © 2006 Museum of Fine Arts, Boston.

2. Fitz H. Lane, *Brace's Rock, Eastern Point, Gloucester*, ca. 1864. John Wilmerding Collection, Promised Gift, Image © 2006 Board of Trustees, National Gallery of Art, Washington, D.C.

3. Fitz H. Lane, *Boston Harbor at Sunset*, ca. 1850–65. Museum of Fine Arts, Boston. M. and M. Karolik Collection of American Paintings, 1815–1865, by exchange, 66.339. Photograph © 2006 Museum of Fine Arts, Boston.

4. Frederic Edwin Church, *Heart of the Andes*, 1859. The Metropolitan Museum of Art, Bequest of Margaret E. Dows, 1909 (09.95). Photograph, all rights reserved. The Metropolitan Museum of Art, New York.

5. Frederic Edwin Church, *Cotopaxi*, 1862. Founders Society Purchase, Robert H. Tannahill Foundation Fund, Gibbs-Williams Fund, Dexter M. Ferry, Jr., Fund, Merrill Fund, Beatrice W. Rogers Fund, and Richard A. Manoogian Fund. Photograph © 1985 The Detroit Institute of Arts.

6. Frederic Edwin Church, *Rainy Season in the Tropics*, 1866. Fine Arts Museums of San Francisco, Museum purchase, Mildred Anna Williams Collection, 1970.9.

7. Winslow Homer, *Croquet Scene*, 1866. Friends of American Art Collection; the Goodman Fund, 1942.35. Reproduction, The Art Institute of Chicago.

8. Winslow Homer, *Sunset Fires*, 1880. Westmoreland Museum of American Art, Greensburg, Pa. Gift of the William A. Coulter Fund, 1964.36.

9. Winslow Homer, *The Turtle Pound*, 1898. Brooklyn Museum, New York. Sustaining Membership Fund, Alfred T. White Memorial Fund, and the A. Augustus Healy Fund, 23.98.

10. Winslow Homer, *Early Morning after a Storm at Sea*, 1902. © The Cleveland Museum of Art, Gift of J. H. Wade, 1924.195.

11. Winslow Homer, *West Point, Prout's Neck*, 1900. Sterling and Francine Clark Art Institute, Williamstown, Mass.

12. Albert Pinkham Ryder, *Jonah*, ca. 1885–95. Smithsonian American Art Museum, Washington, D.C. Gift of John Gellatly.

13. Albert Pinkham Ryder, *The Flying Dutchman*, completed by 1887. Smithsonian American Art Museum, Washington, D.C. Gift of John Gellatly.

14. Albert Pinkham Ryder, *Under a Cloud*, ca. 1900. The Metropolitan Museum of Art, Purchase, Gift of Alice E. Van Orden, in memory of her husband, Dr. T. Durland Van Orden, 1988 (1988.353). Photograph © 1989 The Metropolitan Museum of Art, New York.

15. Jackson Pollock, *Autumn Rhythm (Number 30)*, 1950. The Metropolitan Museum of Art, George A. Hearn Fund, 1957 (57.92). © 2006 The Pollock-Krasner Foundation/Artists Rights Society (ARS), New York. Photograph © 1985 The Metropolitan Museum of Art, New York.

16. Jackson Pollock, *One: Number 31, 1950*. The Museum of Modern Art, New York. Sidney and Harriet Janis Collection Fund (by exchange) (7.1968) © 2006 The Pollock-Krasner Foundation/Artists Rights Society (ARS), New York. Digital image © The Museum of Modern Art/Licensed by SCALA/Art Resource, N.Y.

17. Jackson Pollock, *The She-Wolf*, 1943. The Museum of Modern Art, New York, Purchase, 1982 (82.19). © 2006 The Pollock-Krasner Foundation/Artists Rights Society (ARS), New York. Digital Image © The Museum of Modern Art/Licensed by SCALA/Art Resource, N.Y.

CHAPTER 1

1.1 John Singleton Copley, *Self-Portrait*, 1769. Courtesy, Winterthur Museum and Country Estate, Winterthur, Del. (Page 4)

1.2 Joseph Badger, *Reverend Jonathan Edwards (1703–1758) B.A. 1720, M.A. 1723*, ca. 1750–55. Yale University Art Gallery, New Haven, Conn., Bequest of Eugene Phelps Edwards. (Page 4)

1.3 John Smibert, *Dean Berkeley and His Entourage (The Bermuda Group)*, 1728–39. Yale University Art Gallery, New Haven, Conn., Gift of Isaac Lothrop. (Page 5)

1.4 John Singleton Copley, *Mrs. John Winthrop*, 1773. The Metropolitan Museum of Art, Morris K. Jesup Fund, 1931 (31.109). Photograph, all rights reserved, The Metropolitan Museum of Art, New York. (Page 9)

1.5 John Singleton Copley, *Mrs. Richard Skinner (Dorothy Wendell)*, 1772. Museum of Fine Arts, Boston. Bequest of Mrs. Martin Brimmer, 06.2428. Photograph © 2006 Museum of Fine Arts, Boston. (Page 13)

CHAPTER 2

2.1 *Ralph Waldo Emerson*, 1854. Daguerreotype. Courtesy of the Ralph Waldo Emerson Memorial Association, Houghton Library, Harvard University, Cambridge, Mass. (Page 18)

2.2 *Fitz H. Lane's House at Duncan's Point*, Gloucester, Mass. Photograph, collection of the author. (Page 20)

2.3 Fitz H. Lane, *The Western Shore with Norman's Woe*, 1862. Cape Ann Historical Association, Gloucester, Mass. (Page 22)

2.4 Caspar David Friedrich, *View of a Harbor (Der Hafen)*, 1815. Stiftung Preuâische Schlosser und Gärten Berlin-Brandenburg/Gerhard Murza, 1994. (Page 23)

2.5 Caspar David Friedrich, *Mist (Nebel)*, 1807. Österreichische Galerie Belvedere, Vienna, Austria. (Page 25)

2.6 Fitz H. Lane, *Gloucester Harbor at Sunset*, ca. 1856–59. Private collection. (Page 27)

CHAPTER 3

3.1 Benjamin Maxham. *Henry David Thoreau*, 1856. Daguerreotype. Courtesy Concord Free Public Library, Concord, Mass. (Page 36)

3.2 Sophie Thoreau (sister). Thoreau's Cabin at Walden, detail of title page, *Walden, or, Life in the Woods* (Boston: Ticknor and Fields, 1854). Courtesy Concord Free Public Library, Concord, Mass. (Page 38)

3.3 Buffalo Robe, ca. 1845; Mandan, North Dakota. Fenimore Art Museum, Cooperstown, New York, inv. no. T50. (Page 47)

CHAPTER 4

4.1 Thomas Eakins, *Walt Whitman (1819–1892)*, 1888. Courtesy of the Pennsylvania Academy of the Fine Arts, Philadelphia. General Fund, acc. no. 1917.1. (Page 52)

4.2 Matthew Brady, *Frederic Church*, ca. 1860. Olana State Historic Site, New York State Office of Parks, Recreation and Historic Preservation, acc. no. OL.1990.61. (Page 55)

4.3 Frederic Edwin Church, *Scene on the Magdalene*, 1854. National Academy Museum, New York. Bequest of James A. Suydam, 1865 (232-P). (Page 59)

4.4 Frederic Edwin Church, *The Icebergs*, 1861. Dallas Museum of Art, Dallas, Texas, anonymous gift. (Page 59)

4.5 Frederic Edwin Church, *Wild Sugar Cane, Jamaica*, 1865. Cooper-Hewitt, National Design Museum, Smithsonian Institution, New York, Gift of Louis P. Church, 1917-4-677. Photo: Matt Flynn. (Page 60)

4.6 Frederic Edwin Church, *The Andes of Ecuador*, 1855. Reynolda House, Museum of American Art, Winston-Salem, N.C. (Page 62)

4.7 Frederic Edwin Church, *Our Banner in the Sky*, 1861. Terra Foundation for American Art, Daniel J. Terra Collection. Photo: Terra Foundation for American Art, Chicago/Art Resource, N.Y. (Page 69)

CHAPTER 5

5.1 John La Farge, *William James*, ca. 1859. National Portrait Gallery, Smithsonian Institution, Washington, D.C.; gift of William James IV, acc. no. NPG.91.6. (Page 78)

5.2 Napoleon Sarony, *Winslow Homer taken in N.Y. 1880*. Bowdoin College Museum of Art, Brunswick, Me., Gift of the Homer Family. (Page 80)

5.3 Winslow Homer, *The Old Mill (The Morning Bell)*, 1871. Yale University Art Gallery, New Haven, Conn. Bequest of Stephen Carlton Clark, B.A., 1903. (Page 86)

5.4 Anonymous American photographer, *The "Ark" & W.H.'s Studio ca. 1884*. Bowdoin College Museum of Art, Brunswick, Me. Gift of the Homer Family. (Page 86)

5.5 William James, *Portrait of John La Farge*, ca. 1859. By permission of the Houghton Library, Harvard University, Cambridge, Mass. (Page 88)

5.6 William James, *Self-Portrait*, ca. 1866. By permission of the Houghton Library, Harvard University, Cambridge, Mass. (Page 91)

5.7 Winslow Homer, *Huntsman and Dogs*, 1891. Philadelphia Museum of Art: The William L. Elkins Collection, 1924 (E1924-3-8). (Page 93)

5.8 Winslow Homer, *The Fallen Deer*, 1892. Museum of Fine Arts, Boston. The Hayden Collection-Charles Henry Hayden Fund, 23.443. Photograph © 2006 Museum of Fine Arts, Boston. (Page 93)

5.9 Winslow Homer, *A Garden in Nassau*, 1885. Daniel J. Terra Collection, 1994.10. Photo: Terra Foundation for American Art, Chicago/Art Resource, N.Y. (Page 95)

5.10 Winslow Homer, *Inside the Bar*, 1883. The Metropolitan Museum of Art, Gift of Louise Ryals Arkell, in memory of her husband, Bartlett Arkell, 1954 (54.183). Photograph, all rights reserved, The Metropolitan Museum of Art, New York. (Page 97)

CHAPTER 6

6.1 Marsden Hartley, *Albert Pinkham Ryder*, 1938. The Metropolitan Museum of Art, New York, Edith and Milton Lowenthal Collection, Bequest of Edith Abrahamson Lowenthal, 1991 (1992.24.4). (Page 104)

6.2 *Emily Dickinson*. Daguerreotype. Amherst College Archives and Special Collections, by permission of the Trustees of Amherst College, Amherst, Mass. (Page 106)

6.3 Albert Pinkham Ryder, *Constance*, 1896. Museum of Fine Arts, Boston. A. Shuman Collection, 45.770. Photograph © 2006 Museum of Fine Arts, Boston. (Page 108)

6.4 Albert Pinkham Ryder, *The Race Track (Death on a Pale Horse)*, ca. 1886–1908. © The Cleveland Museum of Art, Purchase from the J. H. Wade Fund, 1928.8. (Page 115)

6.5 Albert Pinkham Ryder, *The Forest of Arden*, 1888–97?; reworked 1908? The Metropolitan Museum of Art, Bequest of Stephen C. Clark, 1960 (61.101.36). Photograph, all rights reserved, The Metropolitan Museum of Art, New York. (Page 116)

6.6 Albert Pinkham Ryder, *Self-Portrait*, ca. 1878. Courtesy of Daniel W. Dietrich II. (Page 125)

6.7 Albert Pinkham Ryder, *Marine*, 1907. National Academy Museum, New York (1111-P). (Page 130)

6.8 Albert Pinkham Ryder, *Moonlight Marine*, 1870–90. The Metropolitan Museum of Art, Samuel D. Lee Fund, 1934 (34.55). Photograph, all rights reserved, The Metropolitan Museum of Art, New York. (Page 131)

6.9 Albert Pinkham Ryder, *Marine*, ca. 1890. Carnegie Museum of Art, Pittsburgh, Pa. Howard N. Eavenson Memorial Fund for the Howard H. Eavenson Americana, Collection. (Page 132)

CHAPTER 7

7.1 Jonathan Williams, *Black Mountain College, Charles Olson barechested at writing table*, 1951. Archives & Special Collections at the Thomas J. Dodd Research Center, University of Connecticut Libraries, Storrs, Conn. (Page 136)

7.2 Jackson Pollock, *Untitled (Self-Portrait)*, ca. 1931–35. Coll. L. S. Pollock, New York. © 2006 The Pollock-Krasner Foundation/Artists Rights Society (ARS), New York. Photo: Bridgeman-Giraudon/Art Resource, N.Y. (Page 141)

7.3 Hans Namuth, *Jackson Pollock*, 1950. National Portrait Gallery, Smithsonian Institution, Washington, D.C.; gift of the Estate of Hans Namuth, acc. no. NPG.95.155. © Estate of Hans Namuth. (Page 148)

7.4 Jackson Pollock, *Eyes in the Heat*, 1946. The Solomon R. Guggenheim Foundation, New York, Peggy Guggenheim Collection, 1976, 76.2553.149. © 2006 The Pollock-Krasner Foundation/Artists Rights Society (ARS), New York. (Page 152)

7.5 Jackson Pollock, *Untitled (Blue (Moby Dick))*, 1943 © 2006 The Pollock-Krasner Foundation/Artists Rights Society (ARS), New York. (Page 153)

7.6 Jackson Pollock, *Portrait and a Dream*, 1953. Dallas Museum of Art, Dallas, Tex. Gift of Mr. and Mrs. Algur H. Meadows and the Meadows Foundation, Incorporated. © 2006 The Pollock-Krasner Foundation/Artists Rights Society (ARS), New York. (Page 160)

Index

Note: Page numbers in *italics* indicate photographs and illustrations.